The Oil Painter's Handbook

**Patricia Monahan and
Jenny Rodwell**

STUDIO
VISTA

ACKNOWLEDGEMENTS

The authors and publishers would like to thank the following artists who have allowed us to use their work in this book: Alastair Adams, p. 185; Humphrey Bangham, pp. 183, 200–201; Lionel Bulmer, pp. 50–51, 96–97; Fred Dubery, p. 98; Antony Dufort, pp. 188–189; Margaret Green, pp. 10–11, 97; Brenda Holtam, pp. 94–95, 184–185; Ken Howard, pp. 100–101; Jack Millar, pp. 180–181; Suzanne O'Riley, p. 182; Richard Pikesley, pp. 12–13; Celeste Radloff, pp. 97, 118–119; Norman Shawcross, p. 181; Ian Sidaway, pp. 15, 178–179; Stan Smith, p. 19; Alan Stones, pp. 186–187; Margaret Thomas, p. 14.

Special thanks to Winsor & Newton for technical advice and their generous help with materials; to Humphrey Bangham, Suzanne O'Riley, Ian Sidaway, Adrian Smith, Stan Smith, Martin Stamford and Albany Wiseman for their artwork and step-by-step demonstrations; and to Fred Munden for taking the photographs.

STUDIO VISTA
a Cassell imprint
Wellington House, 125 Strand
London WC2R 0BB

First published in this edition 1995

British Library Cataloguing in Publication Data
A catalogue record for this book is available from the British Library
ISBN 0-289-80137-0
The moral rights of the authors have been asserted

Distributed in the United States by
Sterling Publishing Co. Inc.
387 Park Avenue South, New York, NY 10016–8810

Distributed in Australia by
Capricorn Link (Australia) Pty Ltd.
2/13 Carrington Road, Castle Hill
NSW 2154

Typeset by Litho Link Ltd, Welshpool, Powys, Wales
Printed in Hong Kong by Dah Hua Printing Co Ltd

CONTENTS

●

OIL PAINTING

STILL LIFE IN OILS

PAINTING PORTRAITS IN OILS

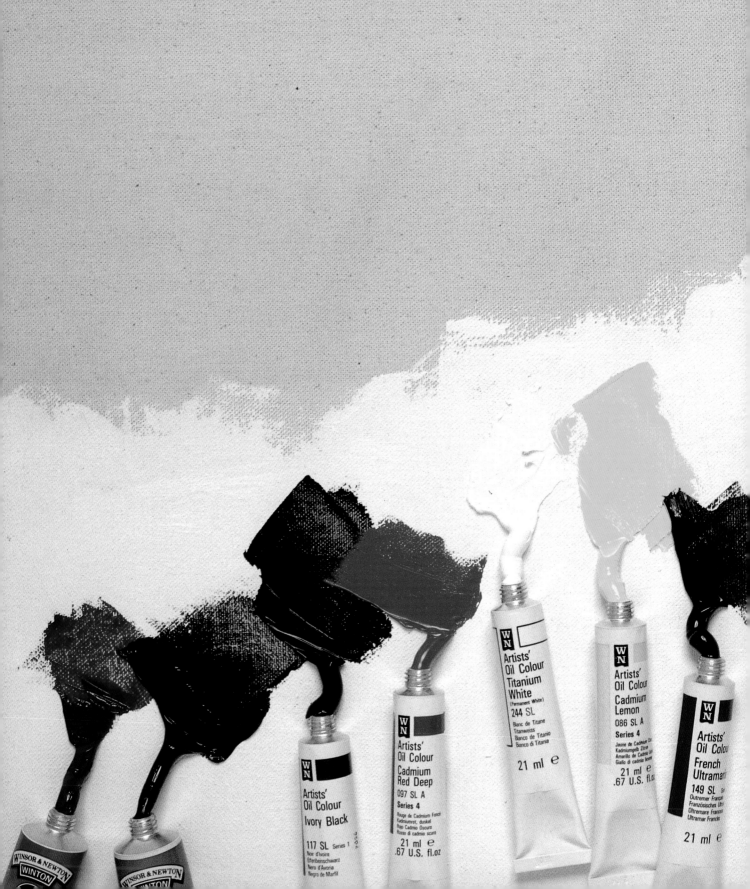

Oil Painting
Patricia Monahan

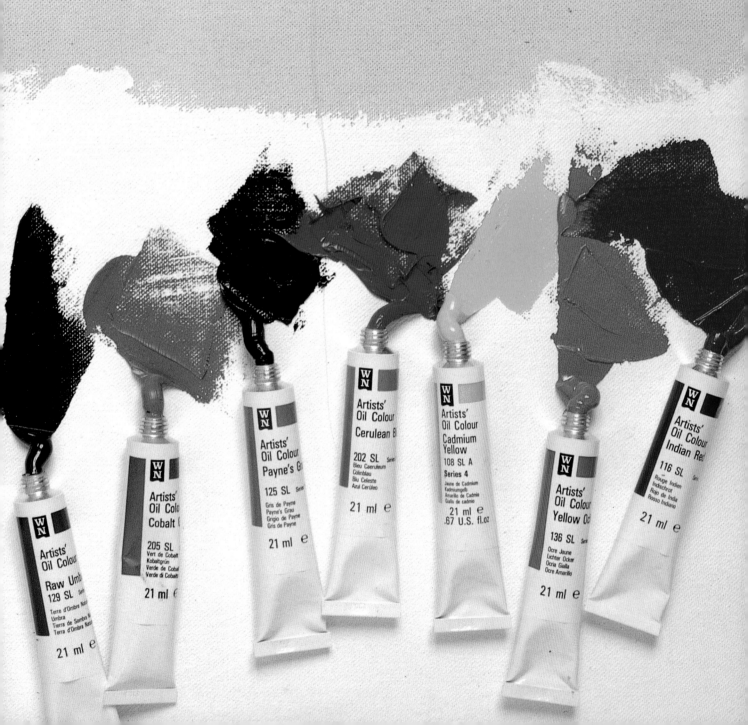

The world of oils

OIL PAINT has a richness, brilliance and intensity which are unmatched by any other medium. When oil first started to be used as a binder for pigment, some time in the fifteenth century, the new medium was admired for its jewel-like colours and smooth, almost glassy surface from which all evidence of the brush had been obliterated. Writers remarked upon the 'inner light' and luminosity of the new medium, which allowed light to be reflected back from the underpainting, through layers of transparent glazes. Later artists favoured a more expressive and personal approach, one in which the mark of the brush and evidence of the way the paint had been applied became important parts of the final image.

Artists today use a variety of approaches, building up thick, textured surfaces or thin veils of translucent colour, creating paint surfaces which are matt or glossy, thick or thin, textured or smooth, opaque or transparent. Oil provides the artist with an almost limitless range of possibilities, and once you have learnt to handle and enjoy this most rewarding of media, you will be limited only by your own ingenuity and imagination.

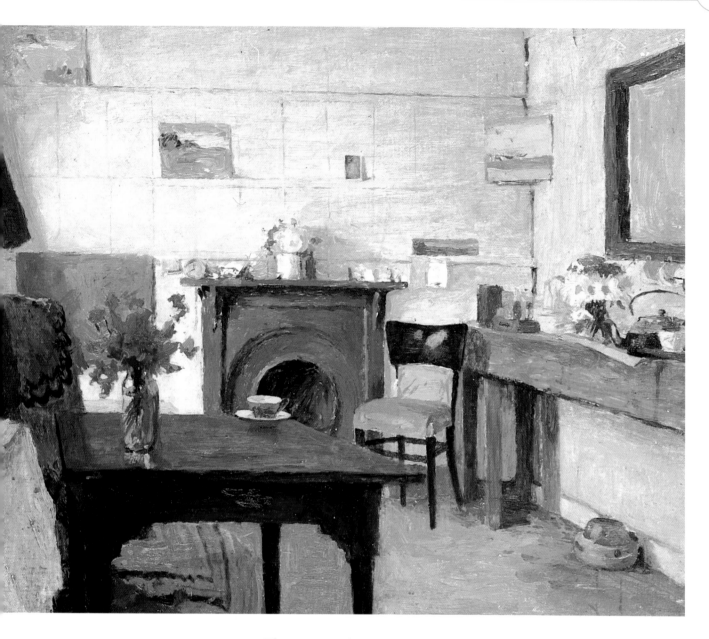

This intimate, domestic and very personal painting is by the artist Margaret Green. It is a view of a studio she once had, by the sea. The fireplace was a very intense blue, and the bright yellow chair was there in the studio when she took it over. The wonderful blue and yellow, together with the red of the flowers on the table, sing against the basic white and neutral tones of the room. The most ordinary subject becomes special when seen through the eyes of an artist.

THE PLEASURE OF PAINT

This book assumes no knowledge of painting or drawing, so if you are thinking, 'I can't draw', or, 'I haven't picked up a paint brush since I was eleven', this book is for you. However, it is also designed for those of you who have tried drawing or painting in another medium but haven't yet used oil.

What we do assume is that everyone is capable of handling paint and producing a visual image and, more importantly, that everyone can enjoy the experience. A lot of people think you need special talent to paint but this is no more true than thinking you need special ability to walk, to talk or to write. Everyone can paint and draw; after all, we all did so as children. Unfortunately, as we grow older, we lose our initial confidence and rely more and more on other people's assessments of our work – one thoughtless criticism from a teacher or parent and we vow never to paint again. We also tend to become over-concerned with the end product and lose our enjoyment of the 'process' of painting.

Painting should be a journey of exploration, discovery and pleasure. The artist sets off in a particular direction but ends up somewhere else, having learned a great deal and been entertained along the way. Great artists never lose that spirit of inquiry and are prepared to take risks and even to make mistakes. This is why their work is always fresh and stimulating – take Pablo Picasso (1881–1973), for example.

▷ *Richard Pikesley's paintings are characterized by lovely pearly colours, the soft light which suffuses them and the delicate but determined way in which he handles the paint. Richard says that his paintings are often 'triggered by light and the way it falls across forms and creates a sort of abstraction which is not necessarily the same as the forms themselves'. He says he likes 'that contradiction'. For many years he painted all his landscapes on site, but now he completes them in the studio. This allows him time to elaborate the painting. There is a risk in this approach because 'the thing that triggered you to do the painting in the first place might be something very simple which is best dealt with very simply. The great danger of studio painting is that it can become too fussy'.*

There are so many levels on which you can enjoy oil painting. There is something very special about the dazzling white of a newly primed canvas, the smell of paint and the springiness of a new brush. There is also the intellectual stimulation of composition, finding a subject that means something to you, looking for balance and harmony, and wrestling with the theoretical aspects of colour and perspective. And there is the pure sensual pleasure of paint, the way it moves on the canvas, streaking and dripping, building up into ridges and furrows or barely staining the surface.

In this book I try to convey that sense of enjoyment because I believe it is the best way to ensure that you will persevere until you produce paintings that give you pleasure and satisfaction.

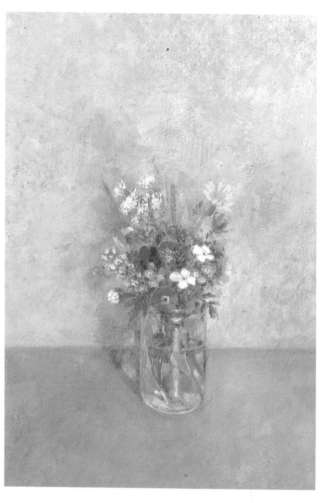

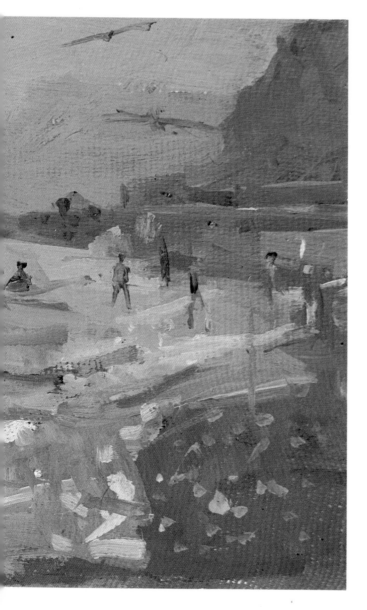

△ *The artist Jenny Rodwell is interested in small, intimate subjects – delicate china cups, a part of an interior or a bunch of wild flowers. She works on a small scale and uses a low-key palette. The paintings are not brightly coloured but they are nevertheless full of colour. The colours Jenny uses are slightly muted and relate to one another harmoniously. She 'draws' by making very precise observations of the changes of tone within the subject, so that the image emerges from the canvas. As her paintings are small, she works with thin paint and is not concerned with surface texture. She sometimes uses pencil to add darker tones, as in the background of this painting.*

ABOUT THIS BOOK

Oil is a remarkably flexible and responsive medium. You can record your responses to a scene in a single sitting, or use a layered technique to develop a work in a series of considered stages over days, months or years. You can work into the wet paint, overpaint dry paint, scratch back into the paint surface, or even scrape it off and start again. You can work with brushes, knives, rags or even your fingers. Your work can be detailed, restrained and small-scale, or big, bold and expressive. You can paint figurative subjects or abstracts, flowers, people or animals, the view from your window or a collection of dishes – the choice is yours.

In this chapter, as throughout the book, I show the work of different artists to illustrate some of these approaches, subjects and concerns. This will give you a flavour of the limitless possibilities of oil paint and I trust that you'll find something to inspire you. For example, the three paintings of flowers on pages 13, 14 and 15 differ in almost every respect – shape, size, composition, the approach to colour and the way the paint is handled. All they share is the fact that they are paintings of flowers in oil on canvas.

I go on to look at materials and equipment and to review some of the products on the market. The rest of the book broadly divides into two sections. In the first I illustrate and describe simply and clearly the basic techniques, also defining the most helpful and frequently used terms. You'll get more from these sections if you have some paint to hand and start experimenting on cheap surfaces such as paper or card. It is important that you get used to the feel of the paint and the way it responds to the brush, the surface and different methods of handling. See how it feels when you use the paint straight from the tube; now try diluting it with a little turpentine; and next add a little linseed oil. You can read every book on painting techniques, but there is no substitute for the 'hands-on' experience – and anyway, it's more fun.

In the final section of the book I illustrate three step-by-step projects which incorporate the techniques and approaches discussed elsewhere. These projects allow you to 'look over the artist's shoulder', to see a work in progress and to learn from that experience. Although you might want to copy some of these projects, you'll learn much more by setting up or finding an equivalent subject of your own but then approaching it in the same way as the artist.

I recommend that you start by working broadly, using a larger brush than you might normally choose. Many people are inhibited when they start to paint, but by adopting a bold, rather 'attacking' approach you can overcome any beginner's block and start to learn about painting. As you become more confident and skilled, you will evolve your own approach. You may decide that big brushes and swirling colour are for you, or you may feel that a restrained approach on a smaller scale is better suited to your personality and intentions.

▽ *The artist Margaret Thomas describes* Bluebells and Donkey *as 'an attempt to harness the casual, while at the same time exploiting the inherent characteristics of familiar and loved objects, strictly in terms of oil paint.'*

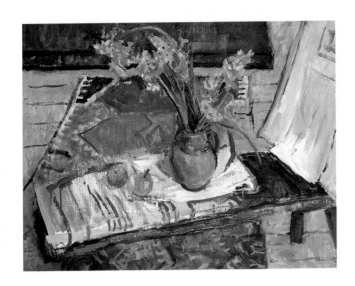

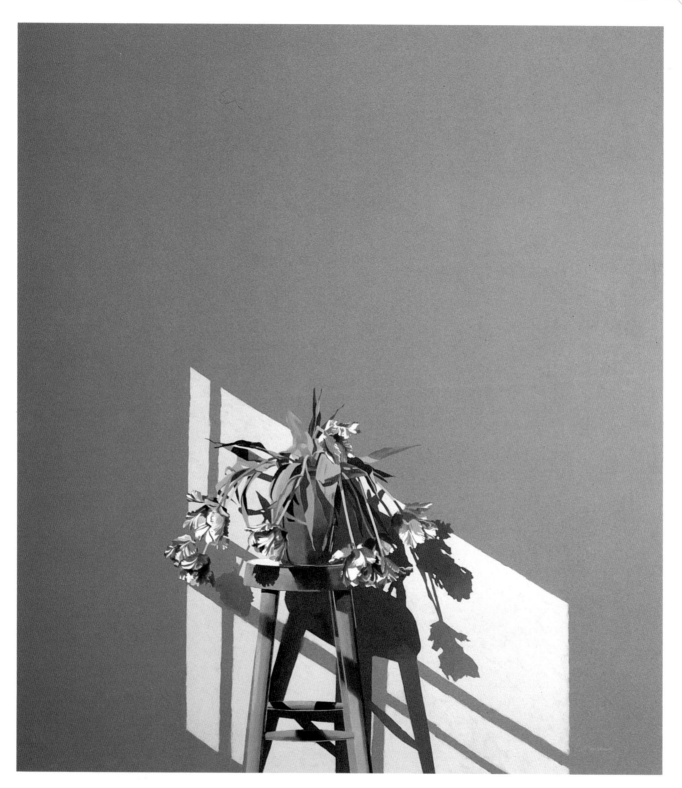

△ Here is a dramatic approach to the subject of flowers. The artist, Ian Sidaway, has worked on a large scale and has chosen to make a study of full-blown tulips, just before the petals start to drop. The main elements of the painting are placed within the bottom half of the work, so that the large area of neutral grey becomes an important part of the composition. The pattern of shadows provides yet another theme. The paint surface is flat and matt, the edges of the images crisp and clean. By carefully orchestrating the separate elements, the artist has made a beautiful image from an apparently simple subject.

EXPLORING A SUBJECT

In this series of four small paintings all made on the same day, the artist, Ian Sidaway, was exploring an idea which he hoped to work up into a larger painting. He often uses photographs for reference, taking photos especially for this purpose, though his paintings are never direct copies. In this case he first made a number of drawings and watercolour sketches, taking images from a variety of sources. Some of the figures were photographed in the sea in France, others in a pool in the United States.

As you can see, he is moving the figure around, seeing what happens, sometimes apparently breaking compositional rules by placing it off to one side. However, he uses various devices to create a harmonious image, balancing the swimmer by areas of darker tone, reflections or the pattern of ripples. The water is treated in a variety of ways – in one case, an abstract tracery of lines; in others, more realistically and loosely rendered. He abandoned the idea of working the painting up on a larger scale; he had done all he wanted with the subject and felt it would not work so well as a larger piece.

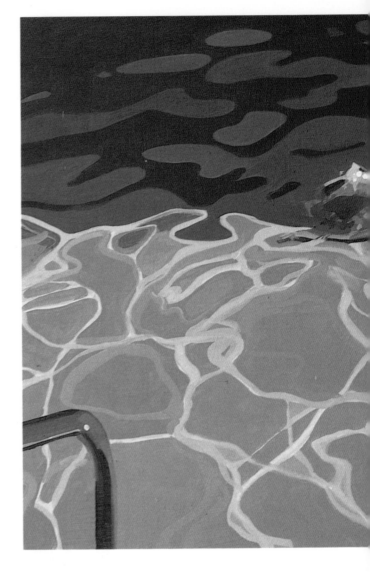

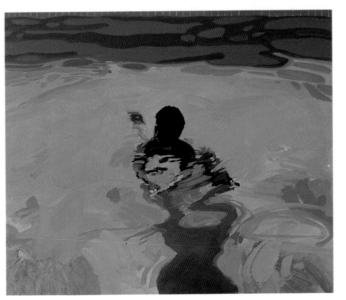

△ *In this study the pattern-making qualities of the waves are explored.*

◁ *Here the swimmer is placed almost dead centre, with darker areas balancing the picture. The paint surface is energetically handled.*

▷ *Because the artist describes the surroundings in greater detail, this picture has a less abstract quality.*

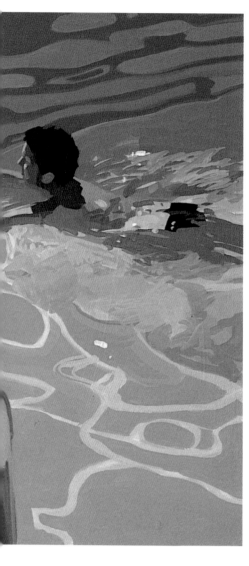

△ *This study has a more three-dimensional quality because the edge of the pool is included.*

DRAWING AND SKETCHING

To be a good artist you must learn to look and really 'see' the world around you. 'Of course I can see', you may say, but can you? We often think we 'know' what things look like, but as soon as you pick up a pencil and start to draw, you'll find that peculiar things happen – a table you thought was square suddenly isn't, an object you know to be round looks flat, and a seated figure looks, well, impossible. To interpret the visual world in paint, you must first learn to 'see' it, and one of the very best ways of doing this is to draw . . . constantly.

All artists draw constantly. They draw to increase their understanding of what they see, to record a passing idea and as a record of their daily life. For many artists their sketch books are their most valuable possession, the source of all their art.

So let's start. Look around and focus on some familiar object in the room – a chair, for example. Now really look at it and get to know it. Remove from your mind all preconceived ideas of what a chair is and see it as an abstract object. First, see it as a pattern of lights and darks. Half close your eyes to emphasize the tonal constrasts. If you have a pen or pencil to hand, put down the dark areas with quick, scribbly lines – don't worry how it looks, just get it down. When you've finished, look at it and you'll find that those apparently abstract blobs of light and dark do describe a chair.

Now, half closing your eyes again, draw the spaces around the chair, the space between the chair and a nearby table, for example. Continue in this way, working quickly, and again you'll find that you've recorded another aspect of the object we call a chair.

Next, study the quality of the edges. Notice the way a plane in shadow has a sharp edge when seen against a light area and a soft edge when seen against a dark area. Now look at the colours. A good way of making yourself really see them is to allow your eyes to travel over the surface of the chair and describe the colours to yourself. For

instance, at this moment I'm looking at a typist's swivel chair seen against the light. I know the seat is covered in a medium-charcoal, tweedy fabric, but the back of the chair seen against the light appears a deep, matt blue-black, while the area where the light falls across the seat is quite pale by contrast – a bluey grey. The top surfaces of the chrome base are very pale indeed – a silvery colour with touches of yellow, pink and blue picked up from the surroundings – while the areas in shadow are dark – not as dark as the chair back but considerably darker than the chair seat.

Make sure you always have a pencil and paper near you and get into the habit of drawing every day. Draw ordinary things, like the cups and plates on the breakfast table, the plant at the window, a friend watching television. Take a small sketchbook with you when you go out so that you can jot down things that interest you. Learn to draw quickly and from memory . . . and don't worry what the drawings look like. No one else need see them and years later you'll be surprised and pleased to find that a very brief sketch can stir memories of an image or an event as well as providing you with a valuable source of visual material and ideas.

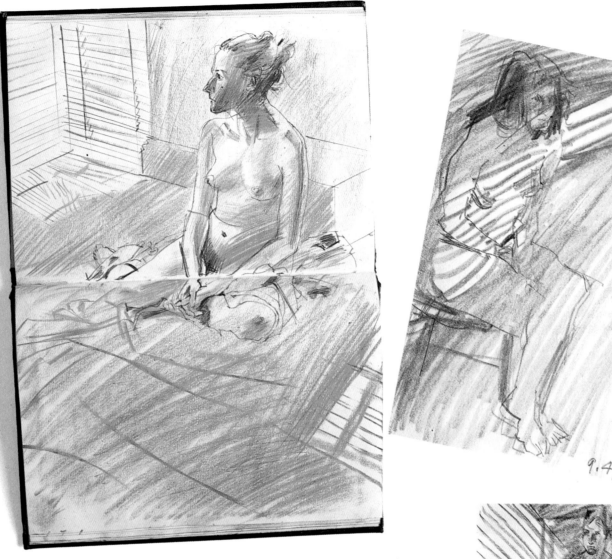

9.45x

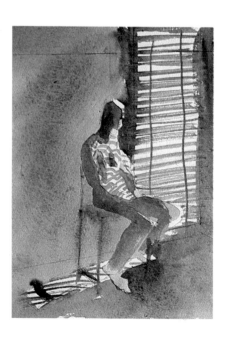

Stan Smith is fascinated by the play of light on the figure and the way it reveals and conceals forms, creating abstraction in a figurative work. Here are pages from his sketchbooks which deal with this theme. These drawings were made over a period of time using whatever medium was convenient and close to hand. Stan draws constantly and has done so all his life. In his sketchbooks he makes notes of things that catch his eye, jots down ideas and develops themes. On the next page is a painting based on the themes in these sketches.

MAKING PICTURES

Many amateur artists are wholly concerned with 'copying' from nature and judge their success or failure as artists by the accuracy with which they can replicate what they see. It is important to work from life, developing your powers of perception and your skill with paint so that you can describe the world competently and accurately. As with language, when you move on from studying grammar and vocabulary to creative composition, so in painting you can move on from exercises that merely improve your visual and manual dexterity to more ambitious and exciting projects. In this book I explore the idea of 'making pictures', how the artist edits, organizes and orchestrates the elements in the world to make an image which is entirely unique.

On this page I show a painting by Stan Smith. He has made many studies of the play of light on the figure, and on the previous pages we saw some sketchbook drawings in which he dealt with just this theme. He worked on this particular painting for over a year and in that time it changed radically. Initially, the figure sat along the bottom of the painting, with the huge window occupying the space above, but he wasn't satisfied with the way the composition was working. He left it for a while, thought about it and finally reworked it, lifting the figure up the picture area to let the light shine through underneath. This changed the geometry and emphasis, creating a strong image which sticks in the mind.

▽ *This sketch is in oil, pencil and oil pastel on paper. It is sometimes assumed that oil is only appropriate for finished paintings on canvas or board, but it can also be used for quick sketches on other supports. The paper can be prepared with a coat of size or primer, which will seal it and prevent the oil from bleeding into the paper, causing the pigment to become dry and flake off. For quick sketches which you don't intend to keep you can paint straight on to the paper.*

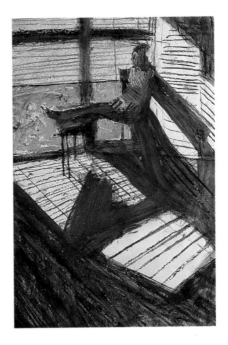

▷ *This is a large painting in which the artist explores a favourite theme. He worked on it intermittently for over a year, changing the composition radically at one stage.*

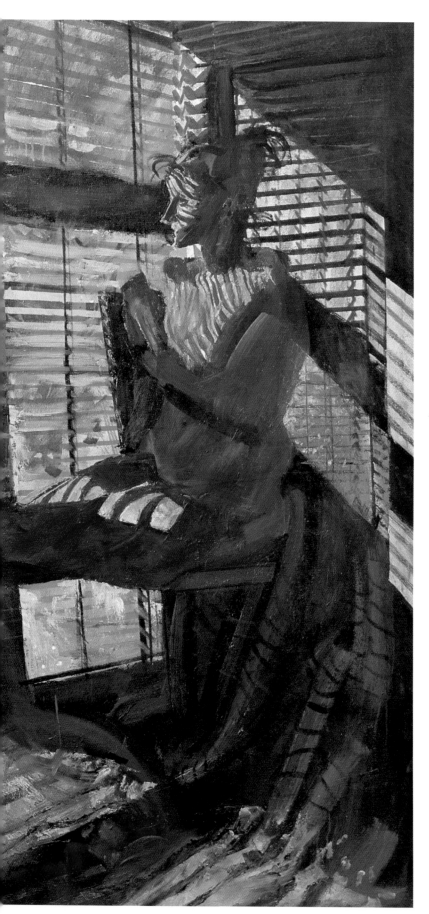

△ In this detail you can see the way the paint has been used – thinly in some areas, so that it barely stains the canvas, while other areas are heavily overlaid. The way the artist has invented colour is particularly interesting. Look, for example, at the flesh tones, where you can see every colour but pink, including ochres, light red and a very dark viridian green. If you look closely, you can see that he has also mixed his media, using dashes of oil pastel in the shadows cast by the blind.

Supports

*T*HE WORD SUPPORT describes any surface which carries or 'supports' the paint. Canvas is the most popular support for oil paint; in fact, the word is often used as a synonym for oil painting. There is something very special about the way that canvas responds to the brush, and nothing else matches its liveliness and spontaneity. Unfortunately, canvas, especially ready-stretched and primed, is impossibly expensive if you paint frequently, so it is important to get to know the wide range of cheaper supports that are available, and to find out which you like.

An artist is also a craftsman, so you will need to become familiar with your materials and learn how to prepare, handle and, above all, enjoy them. It is said that 'a poor craftsman blames his tools', implying that a superior one can produce good work no matter what materials he has to work with. This may be true, but a good craftsman will produce even better work given the best materials, and as for the rest of us, we need all the help we can get! So, don't make false economies; buy the best materials and equipment you can afford, then spend time preparing them properly and looking after them. In this way they will last longer, give better results and be more fun to use.

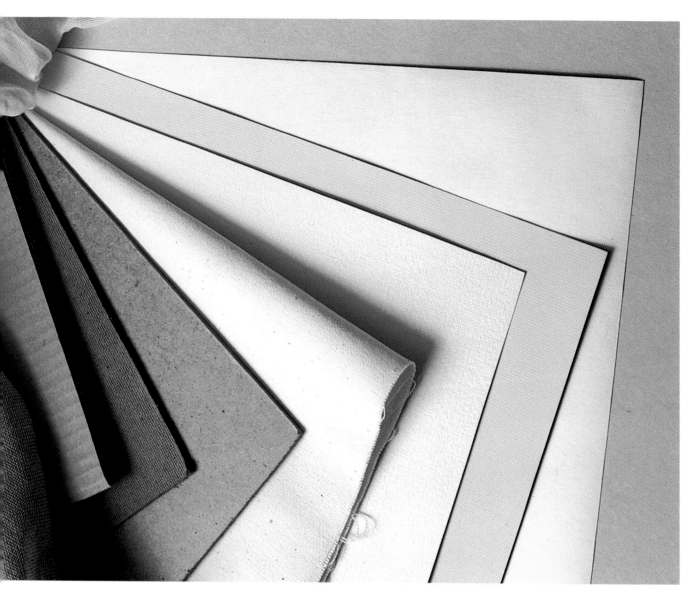

△ All sorts of materials can be used as supports for oil painting. From left to right: muslin, scrim, cardboard, hardboard (rough and smooth sides), canvas, two kinds of oil sketching paper and cartridge paper.

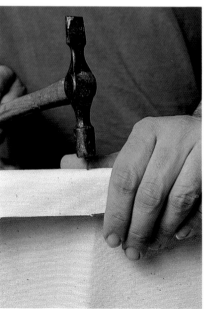

◁ Preparing your own supports is immensely satisfying. It also gives you a great deal of flexibility – you can control the size, the shape and the type of surface and save yourself a great deal of money as well. Here tacks are tapped through canvas, into a stretcher.

▽ *From left: stretched canvas, hardboard, unprimed canvas, cartridge paper, primed cotton duck, primed linen canvas, oil sketching paper, stretchers and wedges.*

CHOOSING A SUPPORT

An important requirement of any support for oil painting is that it should not absorb the oil from the paint. If the oil is leached out, the paint surface will become dry, the pigment will lose its bond and eventually the paint will crack and flake off. Another problem is that oil rots many materials. A good oil support must also have sufficient 'tooth' or texture to hold the paint. On a smooth, polished surface the paint will slip and slide and will be difficult to work.

The type of surface you choose will depend on personal taste and the way you work. If your technique is closely worked and detailed and you use thin paint and fine brushes, you will probably feel happier with a fine-grained canvas or even a gesso ground (see page 33). If, however, you work in a bolder, broader way with thick swathes of paint on a large surface, you may prefer a more textured support – a coarse-grained canvas, for example. You might even use different supports for different purposes. In time and by trial and error you'll find a particular range that suits you.

Canvas
Stretched and primed canvas is a marvellously sympathetic surface on which to paint. The flexibility of the cloth responds to the pressure of the brushstroke, while the weave gives the surface a 'bite' which holds the paint and contributes a pleasing texture to the final paint surface. Another advantage of canvas is its portability – it is light, can be stored rolled before use, and when the painting is dry it can be removed from the stretcher, rolled up again and put away. Canvas can be bought in lengths off the roll or you can invest in a whole roll and cut it to size. There is a choice of fabrics, weights, widths and weaves to suit every taste, pocket and purpose.

Linen is probably the best and certainly the most expensive. It is made from the retted (rotted) stalks of flax and retains the dark brownish-grey colour of unbleached linen. Linen canvases are incredibly strong and hard-wearing, and are ideal for larger works where dimensional stability is particularly important.

Cotton is the other material used for artists' canvases and is generally cheaper. Cotton duck is a stout, densely woven cotton with an even weave. It provides a good, reasonably priced support suitable for most purposes. The main disadvantage of cotton is its tendency to stretch or shrink depending on the amount of moisture in the air. This becomes more pronounced and more of a problem the larger the canvas is. Wedges driven into the back of the stretcher will tauten the canvas again.

Both linen and cotton are available in different weights, weaves and qualities, from very fine to quite coarse and slubby. The majority of artists' suppliers have a choice of the most popular types of canvas. Select a width that will produce the least waste when you cut it. Study the advertisements from canvas suppliers in specialist art magazines, and if there is one near you, visit it; there is no substitute for actually handling the material when choosing a support. If you are lucky, they'll have some cheap offcuts with which you can experiment. Otherwise there are many suppliers that dispatch materials by mail-order nationwide.

Canvas can also be bought on the roll ready-primed. Some will be primed with an acrylic primer suitable for both oil and acrylic paints; some is sized and primed with an oil primer for use with oil paint only.

Other materials that can be used as supports include linen and cotton mixtures, and hessian.

Stretched canvases

Ready-stretched and primed canvases are available in a range of standard sizes. They are primed with either an acrylic ground or an oil-based primer. Check the texture. Some are fine-grained and suitable for detailed work; others are coarser.

Wood supports

The earliest oil paintings were painted on wooden panels, but these were soon superseded by canvas. Wood panels are heavy, expensive and difficult to prepare. If you do have access to wood panels, make sure they are well seasoned to minimize warping. Battening the back and sizing both sides will also help to stabilize them.

Canvas boards

The great advantage of canvas boards is that they require no preparation as they are supplied primed with an oil or acrylic ground. They have a good tooth, and are available with very fine or slightly more textured surfaces, and in a good range of sizes. They are ideal for the beginner who doesn't want to spend too much money and has neither the time nor the facilities to prepare any of the other cheap supports I have described.

Oil sketching papers

The cheapest and simplest of all the ready-mades are the oil sketching papers. These are inexpensive embossed papers primed for use with oil paints or oil pastels. They have a range of surfaces from very fine to coarse, with a variety of embossed patterns which loosely replicate the texture of canvas. Light and available as large sheets or sketching pads, they are useful for making notes and experimenting. The pads are particularly convenient as they provide a firm surface for when you are out sketching.

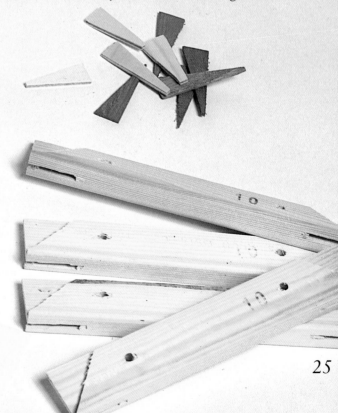

STRETCHING CANVAS

To stretch an unprimed canvas you'll need canvas, scissors, tacks, four stretcher pieces, wooden wedges or keys and a hammer. Stretchers vary in length, width and the way they are bevelled. The weight of the stretcher depends on the size of canvas you are stretching; the larger the canvas the heavier the stretcher, and for really large canvases you'll need a crossbar, possibly two. Canvas puts the wooden stretcher pieces under some strain and a large stretcher may come apart if you don't use a crossbar.

Fit the four stretcher pieces together, making sure that the bevelled edges are on the underside – these bevels prevent the stretcher from cutting into the canvas. The stretchers we used here were bevelled on both sides. Tap the corners gently with a mallet for a firm fit. Lay the frame on the canvas, making sure that the edges are parallel to the weave. You must get the canvas square; if you cut it on the cross, it will stretch unevenly and in time will become floppy. Cut the canvas with scissors or a craft knife and a metal straight-edge or steel rule, allowing a 2-in (5-cm) overlap on all four sides and making sure all the time that you are cutting parallel to the weave.

Fold the fabric over one stretcher and tack it or staple in the centre. Now do the same on the opposite side. If you are working on a large canvas, you may need canvas pliers to give you enough leverage to get the canvas really taut. Now tack the other two sides in the centre, making sure the canvas is taut without being overstretched – it should be springy to the touch but not tight as a drum. Test the surface of the ready-stretched canvases in your art suppliers to get a feel for the tension you are after. If the canvas is too tight, you can always take it off the stretchers and start again.

Continue tacking the canvas, working from the centre of the stretcher to the corners finishing with a flat, neat fold as illustrated. You shouldn't need wedges with small canvases, or even with large linen canvases, because linen is fairly stable, but if a canvas does begin to flop, you can put in wedges to

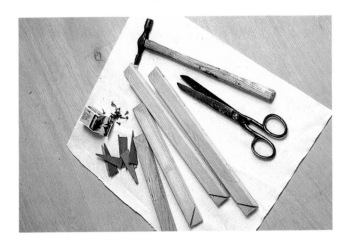

△ *You will need canvas, four stretcher pieces, scissors or a craft knife and a straight edge, eight wooden keys and a hammer. A staple gun is a quick way of fixing the canvas to the stretcher. If the canvas is large, you may also need a pair of canvas pliers.*

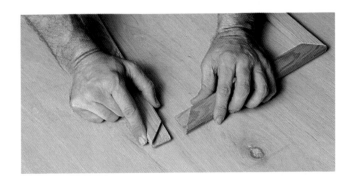

△ *Slot the stretcher pieces together, making sure they are absolutely square at the corners. You don't need to bother with a set square; just check the stretcher corners against the corner of a table, or measure the diagonals with a tape measure to make sure they are identical.*

tauten it again. Start on opposite corners and work round the canvas until it is properly stretched. Don't ram one set of wedges home or you'll exert more pressure in one direction than another. The trick is to keep the canvas square and evenly stretched in every direction. With practice you'll get a feel for what is just right.

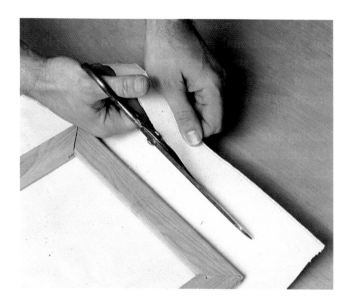

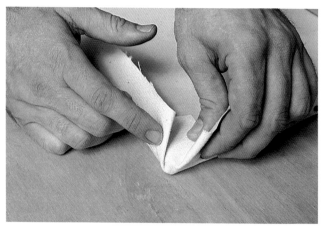

△ Fold in the flap of canvas at the corner as shown, making the fold as flat and neat as possible. Tack it.

△ Lay the canvas face down and place the assembled stretcher, bevel edge down, on top of it. The bevel prevents the canvas being marked by the length of the stretcher behind it. Cut the canvas to size, allowing a 2-in (5-cm) overlap all round.

▽ Fix the canvas with one tack inserted in the centre of one side of the frame, pull it tightly across to the other side and tack it there. Repeat this on the other two sides. Now insert tacks on either side of the central tacks, working on one side then the opposite side and so on. Repeat this, working out from the centre towards the corners.

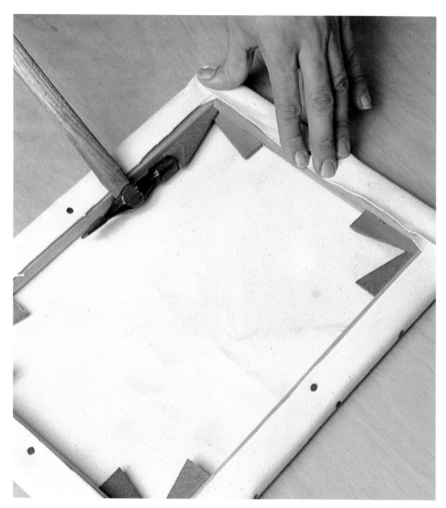

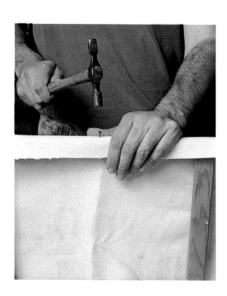

△ If there is any slack in the canvas, it can be taken up by tapping keys into the corners, but don't overdo it. With a canvas as small as this one, it shouldn't be necessary.

SIZING AND PRIMING CANVAS

Canvas is highly absorbent and must be sealed to prevent the paint seeping into the fabric. This protects the canvas from the oil and the chemicals in the pigments, and also makes the surface easier to work. Painting on raw canvas is hard work, because the canvas absorbs the oil so quickly that paint becomes difficult to apply or move around the surface. Other absorbent supports, like paper, cardboard and hardboard, also need to be sealed.

The surface applied to a support is called the ground. There are many different grounds, and you'll have to experiment to find the one that suits you. A traditional ground consists of a couple of coats of glue size, which seals the surface, then a coat of white oil primer. Acrylic primers are applied directly to the support.

Making Size

The conventional way of sealing canvas is with glue size. The best and most flexible is rabbit-skin glue, which you will find in powder, crystal, solid or ready-made liquid forms. Most suppliers include directions for the preparation of size, but generally the size is left to soak in cold water, causing it to swell. It is then heated to dissolve the crystals and applied to the canvas with a brush while still warm.

Size is an ideal growing medium for mould, so if there is any left, cover and store it in a cool place. If mould does grow, simply scrape it off. To use the size again, reheat it. If you don't have an old saucepan, use a jam jar. Reheat by standing it in hot water.

▽ *As a rough rule of thumb, use one cup of glue crystals to seven cups of water. Put the crystals in an old saucepan or glue pot, add the water and leave the crystals to swell and absorb all the water. At this stage they will look fluffy.*

△ **Preparing size** *Rabbit-skin glue is available in several forms including crystals or solid squares. You will need a container in which to heat the glue size.*

◁ *Warm the mixture over a low heat. To avoid heating over a naked flame, put the size in a pot or jar which can in turn be placed in a saucepan of warm water. Stir with a wooden spoon or stick and the crystals will dissolve, producing a clear, viscous solution.*

▽ *Apply the warm size to the right side of the canvas with a large brush. Work from side to side with broad, sweeping strokes. As the size cools, it will become gelatinous.*

△ **Priming canvas** *An excellent ground suitable for canvas, hardboard or card can be prepared by mixing an acrylic emulsion glaze with equal parts of a water-based household emulsion paint. Apply two coats to the stretched canvas.*

Priming Canvas

You can paint directly on to the sized surface, but most artists prefer to apply a white ground or primer first. This creates yet another layer between the support and the paint, and provides a pleasant and responsive surface on which to work. Also the whiteness of the ground gives the painting an added brilliance and sparkle, and will counteract any tendency for paint to darken with age.

Oil primers are particularly flexible, but they take a long time to dry and should not be used for paintings in acrylic – remember this if you are likely to do an acrylic underpainting. You can buy oil primers ready-made from artists' suppliers or a good-quality oil-based undercoat will do equally well. Apply at least two coats, allowing the primer to dry completely between coats. Apply primer liberally so the pores of the canvas are filled; otherwise you will need a great deal of paint to cover the canvas.

Acrylic primers provide a modern, one-step ground which is applied directly to the support. I have used an acrylic emulsion glaze mixed with emulsion paint.

CHEAP SUPPORTS

Canvas is the support which automatically springs to mind when we think of oil painting, but there are a great many other surfaces which can be used. Some are cheap, others are easy to prepare, and others still are suited to particular styles of painting and particular purposes.

If you are not careful, it is possible to spend a great deal of money on materials and equipment. However, if you are to improve your skills and develop your ideas, it is essential that you always have painting materials to hand. Here we look at ways of producing good, cheap supports and ways of recycling waste paper and card.

△ **Preparing cardboard** *Any cardboard can be used as a support, but the thick board used for cartons and packing is particularly good as it is firm and sturdy. Cut the cardboard using a craft knife and a straight edge.*

△ *Apply acrylic primer, working briskly with a large brush. Because cardboard is absorbent, you will need to apply at least two coats of primer.*

△ **Sizing paper** *Brush warm size on to paper and leave it to dry. If the paper is thin, it may crinkle. To prevent this, you should stretch it on a board. Take the sized paper, place it on a wooden board and tape all four sides with gummed paper. Leave to dry. Cut it from the board when it is dry. It will be perfectly flat. Paper can also be primed with acrylic primer. Apply a coat of primer with a brush and leave to dry. You can apply another coat when the first is dry.*

Paper and card
The cheapest support of all is paper. It can be used untreated for quick sketches, to work out ideas or to practise techniques. Because it is so absorbent, the paint surface will become very dry in time, but this does not matter for study pieces. A quick coat of size or acrylic primer will provide a more resistant surface. Prepare some sheets when you have a spare moment, so that you always have something to paint on. Good-quality wallpaper and cardboard are also excellent painting surfaces. Cut up cardboard boxes and save sheets of card packing. I've primed a piece of cardboard with an emulsion-glaze-emulsion-paint primer, but any acrylic primer or even a couple of coats of acrylic undercoat would also work.

Hardboard

This is an excellent support. It is relatively cheap, available in large sheets which can be cut down to the size that you want and provides two different surfaces, one with a rough, woven surface and the other smooth. It is tough and resilient, but the edges are weak and break easily. They can be protected by attaching battens, but generally only the largest sizes need to be treated in this way.

Hardboard, like canvas, needs to be sealed. Start by roughening the surface of the smooth side to give it some tooth – use coarse sandpaper or scrape the surface with an old sawblade. Then size both sides of the board; this prevents warping. When it is dry, apply an oil primer to the side you intend to use. Hardboard can also be sealed with an acrylic ground, but again apply the ground to both sides.

The rough side of hardboard is extremely absorbent and difficult to work and will wear out your brushes very quickly. Apply several coats of primer to provide a good seal and a surface which is easier to work and kinder to your brushes. It is worth experimenting with different grounds and treatments to see if you can work with hardboard; many artists use nothing else.

Applying fabric to hardboard

You can create cheap and interesting supports by covering hardboard with fine materials like muslin or scrim. Both are cheap, loosely woven cotton fabrics. Muslin is very fine and a pale cream in colour. Scrim is much coarser, has a more obvious texture and is a tawny-brown colour. Either can be applied to board with a coat of size or acrylic primer, which will act as both sealant and glue. Scrimmed or muslined boards have a good, interesting texture.

▽ *Lay the hardboard on the muslin and cut a piece of muslin, allowing about a 2-in (5-cm) overlap all round. Now lay the muslin on top of the board, which should be smooth side uppermost as this is less absorbent. Flatten the muslin out and make sure the weave runs parallel to the edge of the board. Apply primer with a decorating brush, working from the centre and brushing outwards, smoothing out creases and bubbles as you work.*

△ **Applying muslin to hardboard** *Muslin applied to hardboard provides an excellent surface with a good texture. I've used acrylic primer to seal and fix the muslin, but you could also use glue size. Start by cutting a piece of hardboard to the required size.*

▽ *Turn the board over, fold the muslin in and smooth down the flaps with a brush loaded with primer. Leave to dry. If you like a smooth finish, apply another coat of primer when the first is dry.*

▷ **Applying scrim to hardboard**
*You will need scrim, a piece of
hardboard cut to size and some
prepared glue size.*

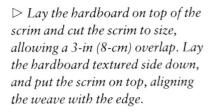

▷ *Lay the hardboard on top of the
scrim and cut the scrim to size,
allowing a 3-in (8-cm) overlap. Lay
the hardboard textured side down,
and put the scrim on top, aligning
the weave with the edge.*

▽ *Pour warm size on to the scrim
and work it over the surface using a
large brush. Work out from the
centre, smoothing out the wrinkles.*

▽ *Turn the board over, fold in the
flaps of scrim and paste them down.*

Applying gesso to hardboard

Gesso is a ground made of gypsum or chalk mixed with water or size to provide a dense, brilliantly white surface traditionally used for egg tempera (pigment mixed or tempered with egg yolk) or some types of oil painting. The gesso was applied in a series of layers which were allowed to dry, then sanded down between applications and built up to a hard, white surface. Gesso powder is available from most artists' suppliers, and gessoed boards can be bought from specialist suppliers. Because it is so absorbent, a true gessoed ground requires a special approach, but it is worth experimenting to see if you like it. It is ideal for some kinds of detailed, small-scale work such as natural history subjects.

These days an acrylic gesso primer is widely available. This has the matt-white quality of a true gesso but is less absorbent and, because it is supplied ready-mixed, it is much simpler to prepare a board. It can also be used on canvas and paper.

▽ **Applying gesso primer to hardboard** *You can make a true gesso ground by buying gesso powder and mixing it with glue size, following the manufacturer's instructions. Acrylic gesso can be purchased ready-made and is much easier to use.*

△ *Cut the hardboard to the correct size and roughen the smooth side with sandpaper to give it some tooth. Apply the gesso primer, using a loaded decorator's brush. Work from side to side, using smooth, regular brushstrokes.*

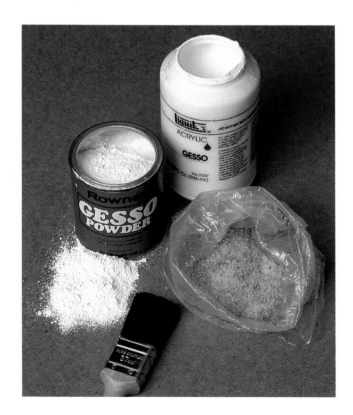

△ *Allow the primer to dry thoroughly, then sand the surface gently to get it smooth.*

△ *Apply another coat of primer, this time working at right angles to the first coat. Allow it to dry and repeat the process.*

Paints and Other Materials

THE TOOLS AND techniques of the oil painter have not changed much in the past 500 years and in that time has evolved a wonderfully arcane language, mysterious to the uninitiated but creating a bond between those within the magic circle. I love words like scumble and tonking, and the marvellously exotic oil of spike lavender, sunbleached linseed oil and Venice turpentine. Indeed, one of the many pleasures of oil painting is pottering around art shops, leafing through specialist magazines and manufacturers' catalogues, and visiting craft and artists' materials exhibitions.

A first visit to an artists' materials supplier can be daunting for the beginner and so in this chapter I introduce the basic materials and explain the most useful terms. It is a good idea to develop a relationship with a particular shop. You'll find people in the trade are helpful and knowledgeable, and because many of them are practising artists in their spare time, they are happy to talk about painting, materials and your particular requirements.

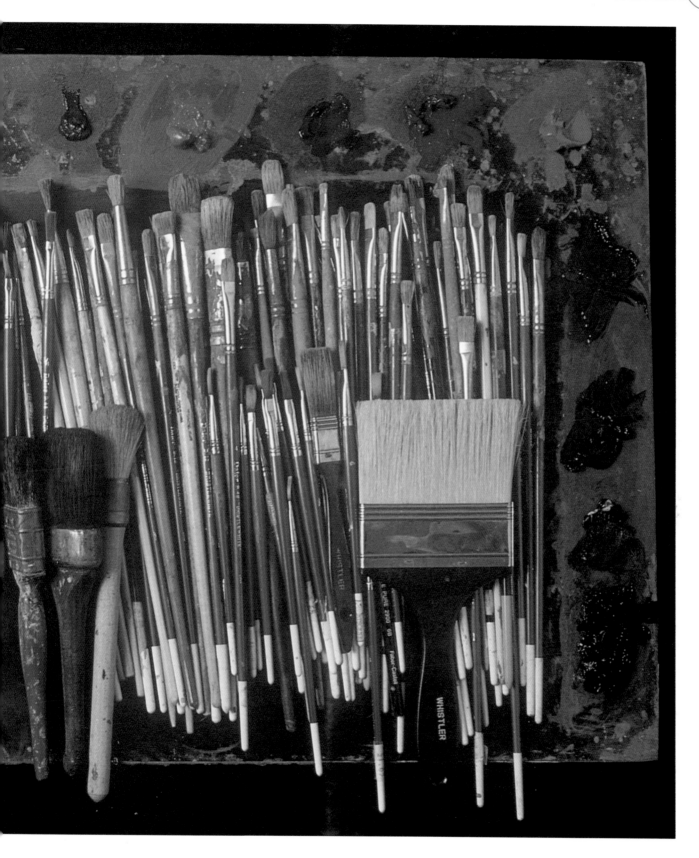

Artists' materials are enjoyable for their own sake. In time you'll find out which you like best, developing your own collection of old favourites.

PAINTS AND PIGMENTS

A pigment is a solid coloured substance which is ground to create a powder. Some pigments occur naturally; others are manufactured in a chemical process. Because pure pigment in powder form cannot be made to stick to a support, pigments are mixed with a binding medium to create a paint. Different binding media are used for different types of paint: the binding medium for oil paint is linseed oil; that for watercolour is gum arabic. You can buy pigment powder and make your own paint, but although some artists remain convinced that hand-ground pigments are superior to tube colours, stick to ready-made paints to start with. Different types of paint are referred to as media, so oil, watercolour and acrylic are all media. Drawing materials like pencil, pastel and coloured pencil are also described as media.

Earth pigments

Pigments can be divided into groups which reflect their origins and method of manufacture. The earth colours are a large group of naturally occurring pigments which include yellow ochre, raw sienna, burnt sienna, raw umber, burnt umber, light red, Venetian red and terre verte. Earth colours have been used since prehistoric times and there are surviving examples of cave paintings made with these materials at various sites in Spain and France, such as Altamira and Lascaux. These paintings, which are about 20,000 years old, show bison, running deer and boar, the animals our forebears hunted and lived by, and are rendered vigorously and confidently. The palaeolithic artists used materials which they found about them – naturally occurring earths, ochres, manganese oxides,

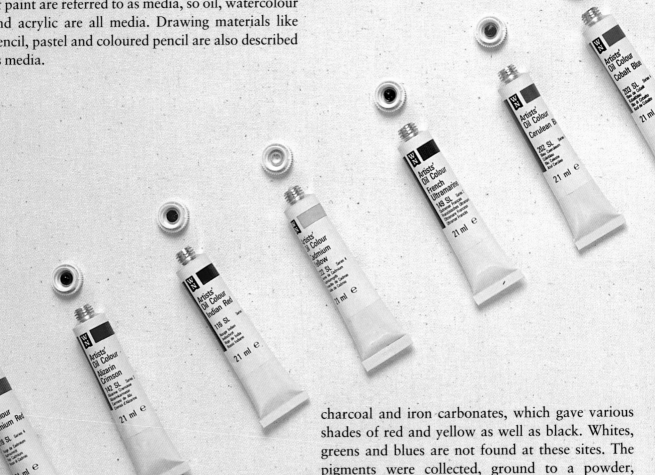

charcoal and iron carbonates, which gave various shades of red and yellow as well as black. Whites, greens and blues are not found at these sites. The pigments were collected, ground to a powder, mixed with melted fat and applied to the walls with brushes, fingers, twigs, feathers or leaves.

Organic and inorganic pigments

Inorganic pigments like viridian and cobalt blue are produced chemically. Organic pigments like rose madder and the 'lake' colours are extracted from raw materials in the form of a dye which must then be mixed with a substrate, such as alumina, so that when dry they can be ground.

A selection of Winsor & Newton's artists' colours. The range includes 108 colours, grouped by price into series. Some pigments are considerably more expensive than others and this is reflected in the price of the tube of paint. So don't be surprised to find that cobalt violet costs considerably more than Prussian blue. Generally the Winsor & Newton's series 1 paints are cheaper than the series 6 colours.

Artists' or students' quality

Oil paint is sold in tubes and most manufacturers produce two ranges: artists' and students' quality. The former contains the best pigments and has the highest proportion of pigment to extender. The latter cost less and the range of colours is more limited. For example, while Winsor & Newton have 108 colours in their artists' range, there are only forty-seven in their students' range. The price of an individual colour largely depends on the cost of the raw material used and some colours are

available only in the artists' range. Costs are kept down by replacing some of the more expensive and traditional pigments with modern alternatives. Students' colours lack some of the finer qualities of the artists' range, but you won't notice this to start with and they are good value for the beginner.

Permanence

Some colours are more permanent than others, and paint manufacturers have a coding system which indicates the degree of permanence of a particular colour. These codes are clearly printed on the tube and you will find the key to them in the manufacturers' catalogue or in leaflets. Although permanence will not concern you at this stage, it may become relevant later on. For example, if you eventually work to commission, you will want to be sure that your colours will not deteriorate or fade.

△ **Get to know colours** *Collect manufacturers' colour charts. They will help you become familiar with the names and appearance of colours and are a useful reference when reordering paints. Collect samples of canvas as well.*

Catalogues and colour charts

Manufacturers' catalogues are a mine of information so it is worth collecting and studying them. You generally have to pay for them, but not very much. Not only do they show you what is on the market but they also contain a great deal of useful technical information.

Most paint manufacturers, also known as artists' colourmen, produce printed colour charts which illustrate and name their entire range of colours, and give a product code number for reordering. These printed charts are a guide only; the limitations of the printing process prevent absolute accuracy. Many colourmen also produce charts made with washes of paint. These are handmade and therefore costly to produce, but they are a valuable tool and will prove extremely useful.

Looking after paints

Paints are costly, so look after them. Always put the cap on when you have finished. To make sure it goes on properly, wipe the neck and the inside of the lid with a cloth that has a little turpentine or

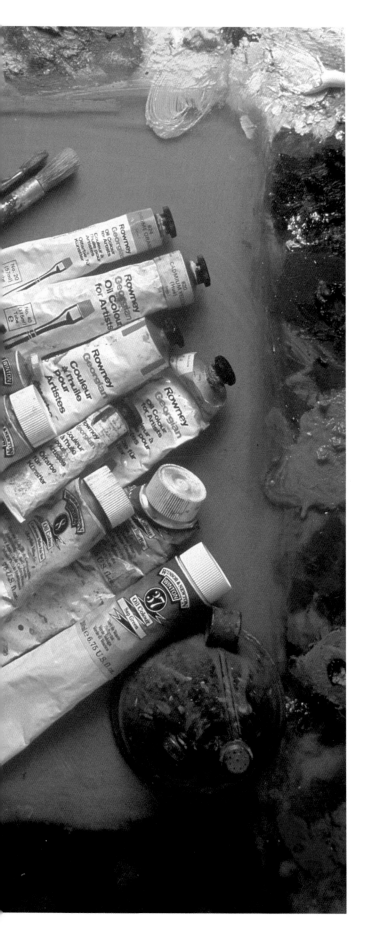

▽ **Care of paints** *Clean excess paint from the top of the tube with a rag. This will ensure that the lid screws on properly.*

◁ *Look after your materials. Clean brushes after every session and put the lids back on the tubes of paint.*

white spirit on it. This will keep the threads clean and ensure a good seal. It should also prevent the cap getting stuck, although if this does happen, try freeing it with pliers, or grip it in the door jamb. Running hot water over the lid sometimes does the trick.

Keep the outside of your tubes clean. This might sound rather prissy but there is nothing more irritating than having a tube of colour which is so grubby that the name of the colour is obliterated. You have to waste time unscrewing the lid and squeezing out colour to see it, and if you like a colour you'll need to know what it is in order to get some more.

DILUENTS AND MEDIA

There are many products which can be added to oil paint to change its consistency and texture, the way that it moves over the support, the way it holds the mark of the brush and the speed with which it dries.

Diluents

A diluent is a solvent which thins the paint so that it can be mixed and handled more easily, but it evaporates completely and has no binding effect on the pigment. Turpentine is the most useful and popular solvent for oil painting. Made from the distilled resin of pine trees, it is a clear, volatile, flammable liquid with a characteristic smell. It speeds up the drying time of the oils used to bind the pigments in the paint, and also the media you add. Turpentine should stored in the dark, in tightly sealed containers, as exposure to air and light causes it to become thick and treacly.

Shown here are a selection of painting media. Turpentine is the most common diluent used with oil paint. Winsor & Newton's Liquin is an extremely useful alkyd medium developed to increase the flow and speed the drying time of oil paint. Linseed oil increases the flow and transparency of oil paint. Wingel is a quick-drying glazing medium. Oleopasto is a translucent gel which can be used to extend the paint and to build up impasto textures.

Oil of spike lavender is a pleasantly scented substitute for turpentine, used by artists who don't like the smell of turpentine.

The other solvent used with oil paint is turpentine substitute or white spirit. This is considerably cheaper than turpentine, but it is impure and should not be used for painting. However, it is ideal for cleaning brushes and palettes, so you should always have plenty to hand.

Media

A medium is anything you add to paint to change its character and the way it handles. By adding a medium you can, for example, thin a paint to make it less opaque in order to create transparent glazes of colour. Another medium will give the paint more substance so that it holds the mark of the brush or knife, allowing you to build up a thick impasto. Media can be added to accelerate the drying time –

useful if you are working out of doors or want to lay a series of glazes. Others will slow the rate at which the paint dries; this could be useful if you work slowly and want to use a wet-into-wet technique, rather than painting wet on top of dry paint.

Drying oils

The oils which are added to oil paint to change the way it behaves are called drying oils. The most popular oil medium used with oil paint is linseed oil. That sounds simple enough, but when you go to your art supplier to buy some, you'll be faced with a whole range of different types of linseed oil.

Refined linseed oil will do to start with. It is a pale oil which thins oil colour, increases gloss and transparency, and reduces the rate at which the paint dries.

The best-quality linseed oil, called cold-pressed linseed oil, is extracted from flax seeds without heat. The process produces less oil and the product is therefore more expensive. Other forms of linseed oil have slightly different qualities and properties. For example, sun-bleached linseed oil dries slightly faster than refined linseed oil, while standard linseed oil slows drying but gives the paint surface a tough, elastic finish, and drying linseed oil increases the rate at which the paint dries.

The other common oil medium is poppy oil. Like linseed oil, it is used to bind dry pigments into a paint in the manufacturing process. Because poppy oils are pale, they are often used with whites and pale colours in situations when it is important not to darken the paint.

Most manufacturers produce a range of traditional oil media made from the various mixtures of oils and solvents. Each has specific qualities. Look around each time you visit your artists' materials supplier, pick up leaflets and look at catalogues. In time you'll become familiar with the ranges.

The alkyd media

In the last twenty years manufacturers have developed a range of alkyd-resin-based media. These are generally characterized by their fast drying times but, like the oil media, each has different qualities.

In time you will get around to experimenting with all these different media, but for the time being keep things simple and stick to refined linseed oil and possibly one of the alkyd media to allow you to work quickly.

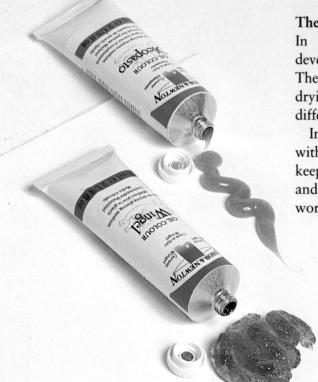

▷ *Hog-hair brushes, from left to right: round, flat, filbert, bright, fan.*

▽ *Synthetic/hair-blend brushes, from top to bottom: flat, four round brushes, rigger.*

BRUSHES AND KNIVES

Brights, filberts, flats and fans, hog, sable and ox – and you only wanted a brush! Even the smallest art shop will have a large selection of brushes in different sizes, shapes and materials, and at wildly different prices.

Brushes are important. They are the artist's principal tool for applying paints to a support, and over the centuries the very best shape and quality for every task has been evolved. The kind of brush you use will make a great difference to the kind of picture you produce, so you should select carefully rather than trying to force a brush to create effects it is not suited for. Once again, experience and experiment will tell you what you prefer, and what you can work with. A brush is as personal as a fountain pen, and only you can decide what you like.

Brushes for oil painting have long handles, because generally you will be working at an easel, at a distance from the support. A long handle is good for large-scale work because it encourages you to work more broadly and freely from the elbow and the shoulder, rather than from the wrist. Watercolour brushes have shorter handles, but if you do small-scale oils you might prefer to use short-handled brushes.

Types of Brush

Three types of brush are used by the oil painter: natural bristle, natural hair or synthetic fibre, which simulates the characteristics of the first two.

The most popular oil-painting brushes are hog hair, which are made from pigs' bristle. Each strand of bristle has split ends, or flags, which allow the brush to hold a large quantity of paint. Bristle brushes are stiff and hard-wearing, qualities which make them ideally suited to the stiff texture and coarser grounds used for oil paint.

There are four main shapes for oil painting: round, flat, bright and filbert. Round brushes are useful for applying thinned paint to large areas and for painting lines. Flats have long bristles and can be used for laying on bold, broad areas of colour; the sides can be used to make lines and short marks.

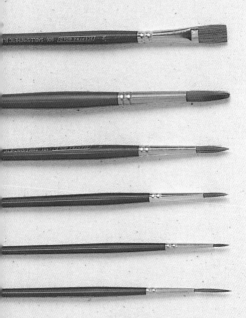

Brights are like flats but have shorter bristles; they are useful for more controlled work. Filberts are similar to flats but curve inwards at the ends; they are very useful and can be used for tapering strokes and dabs of colour. Then there are fan brushes, designed for detailed work such as rendering hair, and riggers, which are long, very thin brushes with a fine point designed for line work and lettering.

The best hog brushes are handmade, with the bundles of bristles bound together in such a way that the natural curves of each filament points inward to give the brush a neat profile.

Sable brushes are ideal for glazes and fine work. Those with long handles are designed for oil painting. The very finest sable is made from the tail hair of the wild mink, a weasel from the cold regions of Siberia and Korea. This is a costly and fairly rare material, so if you do invest in a good sable brush, treat it with care.

▽ *Hog-hair brushes, from left to right: filbert, bright, flat, round.*

Other soft-hair brushes are made from mixed fibres including ox hair, sable and synthetic materials. The synthetic materials have improved considerably in recent years and these make ideal and moderately priced alternatives to sable.

Brush sizes
Brushes are generally sold in a range of sizes marked from 00, the smallest, to 14. However, a 14 in one range will be different from a 14 in another. You'll find a larger brush useful for tinting canvases and laying in broad underpaintings. Start with a 2-in (5-cm) decorator's brush.

Choosing a brush
When selecting a brush, get the best you can afford, and buy a few good brushes rather than lots of cheap ones. Choose brushes that look neat and don't have stray hairs sticking out at odd angles. Test the springiness of the brush by pressing it gently, tip down, in the palm of your hand. Soft hair brushes should spring back into shape when wet. Test this by dipping them in water to see that they hold their shape. Good art shops provide a pot of water for this purpose.

Knives
There are two types of knives used for oil painting. Palette knives have flat, broad, flexible steel blades and wooden handles. They are used for mixing paint and cleaning palettes. Painting knives, on the other hand, are designed for applying paint and have flexible steel blades in a range of shapes,

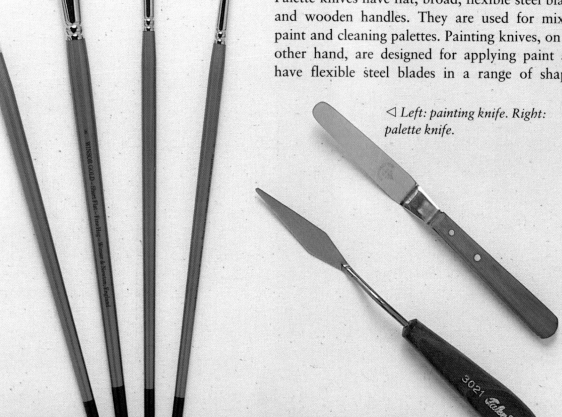

◁ *Left: painting knife. Right: palette knife.*

generally triangular with a pointed end. Between the blade and the wooden handle there is a cranked shaft which allows you to work on the canvas. To confuse the issue, 'painting' knives are used for a technique which is called 'palette knife' painting. Painting knives allow you to build up a thick impasto, which looks quite different from that achieved with the brush.

Care of brushes

Brushes are costly and essential tools, so they must be looked after. Always clean brushes immediately after use. Don't leave them standing bristle-end down in a jar of white spirit as the pressure will distort the hair. It is a good idea to use two jars of white spirit, one for getting the worst of the paint off, the other for a final rinse in clean fluid. Next hold the brush under cold water and rub it gently on a cake of soap. Then work the bristles in the palm of your hand so that you work up a lather. Clean the bristles right up to the ferrule. Rinse the brush in water, squeeze out excess water between

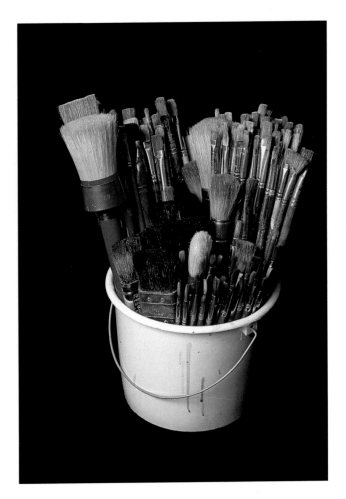

Cleaning brushes

▽ **1** *Start by wiping the brush on a piece of rag or kitchen towel. This will remove a lot of the paint.*

△ **4** *Moisten the brush in cold or warm (not hot) water.*

your fingers and gently pull the bristles back into shape. Soft-hair brushes can be brought back into shape with a vigorous flick of the wrist. Store brushes bristle-end up.

If you do allow paint to dry on your brush, you can clean it with a commercial brush cleaner, then wash it with water and soap to remove the solvent. These cleaners are fairly drastic, so avoid letting your brushes get into this state.

▽ **2** *Dip the brush in a jar of white spirit and move it about vigorously. If there is a lot of paint near the ferrule, press the brush against the base of the jar.*

▽ **3** *Wipe the brush on a rag. You should have removed most of the paint, but if the brush is large or heavily loaded you may have to dip it in white spirit again.*

△ **5** *Rub the bristles gently on a bar of soap, then work them around the palm of your hand.*

△ **7** *Rinse the brush under running water, making sure you remove all the soap.*

△ **6** *Work up a lather: you need to loosen all the paint, especially around the ferrule.*

EASELS

An easel will be one of your most expensive outlays, but a good one will last a lifetime and it is difficult to paint in oil without one. There are many different kinds of easel and the type you choose will depend on where you paint, what scale you work on and what you can afford.

Portable easels

If you intend to work out of doors regularly, you will need a portable easel. Even though with a bit of ingenuity you can probably find some way of propping up your work, painting is difficult enough without having to contend with a canvas which keeps slipping about, or gets blown away by the wind. The cheapest type of easel is a folding wooden sketching easel. These are light, take canvases or boards up to about 50 in (127 cm) square and can be fixed either upright, or horizontal for watercolour sketching. Because the easels are compact when folded, they are easy to carry and store. A good sketching easel is a sensible investment if you don't want to spend a lot of money, and don't have a great deal of space for work or storage.

Another version of the sketching easel is made in aluminium. Like the wooden easel, it is compact when folded and can also take a canvas of up to about 50 in (127 cm) square. Aluminium easels are slightly more stable and easier to erect than wooden ones, but are also rather more expensive. However, they are ideal for sketching and a useful compromise for working at home.

Easel boxes

The easel sketch box is one of those wonderfully well-designed products that have evolved over a period of time to meet a particular need. They are tripod easels with a drawer for paints, palette and brushes. They fold down to a box, with a carrying handle and clips which can hold one small, wet canvas. Do have look at them. They are intriguing and, though expensive, ideal if you paint away from home a great deal. After dropping a lot of hints, I was given one as a present and love it.

Big easels

Next we step up to bigger easels, definitely not portable but very stable and designed to take large canvases. Radial easels have short tripod legs, can be tilted backwards and forwards and take canvases up to about 76 in (193 cm) square. They can be folded for storage.

Studio easels have firm H-shaped bases and a ledge for brushes. They can be tilted backwards and forwards, and the canvas can be raised or lowered by means of a catch or ratchet. Some studio easels fold flat, but they still take up more space than a radial easel.

Artists' donkey

This traditional design combines a drawing-board support and a bench on which the artist can sit astride. Some donkeys have a bench with storage space. Both are popular in schools and art colleges.

How to choose

The price of these various styles of easel depends on the material from which they are made, their size, and the quality of the craftsmanship. Good hardwoods such as mahogany are the most expensive, but excellent and much cheaper easels are made in softwoods. Treat the easel with linseed oil before you use it. This will feed the wood and give it a protective seal. The easel will become spattered with paint in time. This doesn't matter, but do make sure that the hinges and bolts remain free by keeping them clean and treating them with a lubricating oil from time to time. Wipe an oily rag over the wood every so often too.

An easel is an important purchase so take your time, talk to other painters and have a look around before you buy.

▷ *Left to right: a standard radial easel; a bench easel, with storage; a jointed radial easel, which can be used horizontal for watercolour, vertical for oils.*

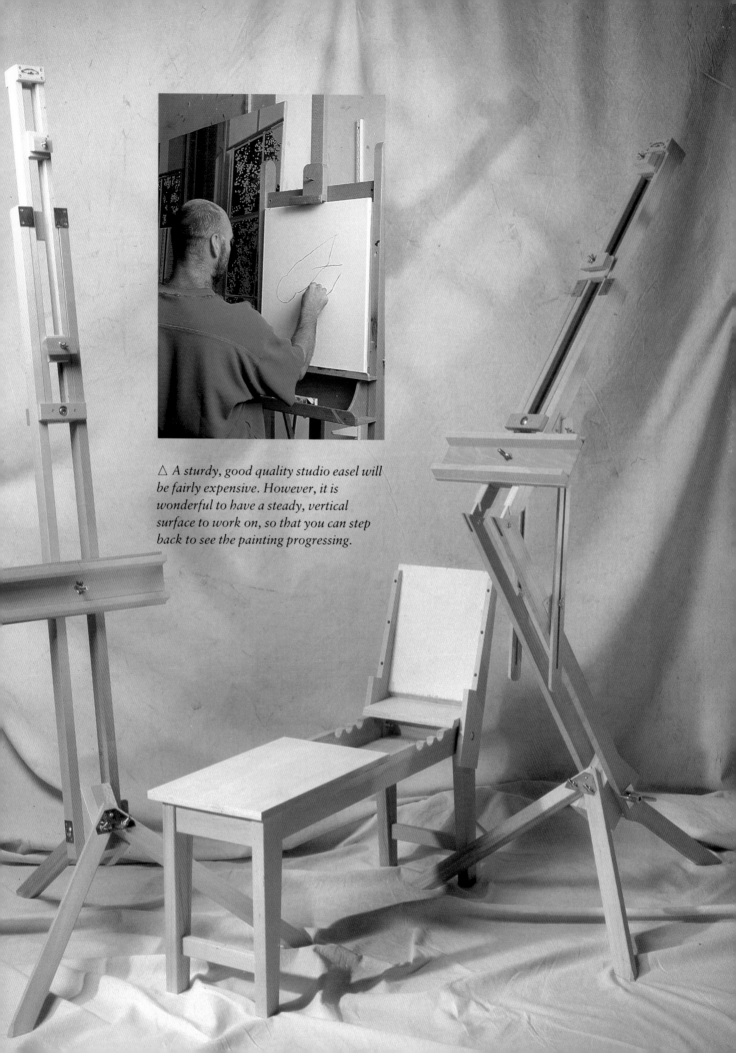

△ A sturdy, good quality studio easel will be fairly expensive. However, it is wonderful to have a steady, vertical surface to work on, so that you can step back to see the painting progressing.

OTHER EQUIPMENT

Palettes

Palettes are the surface on which an artist mixes colours. Traditionally, palettes for oil painting are oval, rectangular or kidney-shaped boards made of lightweight hardwood, such as mahogany. They have a thumbhole so that they can be supported on one arm, allowing you to carry your colours as you move backwards and forwards in front of the easel. A good palette should be well balanced and comfortable to hold. To clean your palette, which you will need to do from time to time, scrape off surplus paint with a palette knife, wipe the board with turpentine, then oil it with linseed oil. In time the board will build up a rich, protective patina.

You can make a palette from plywood or any other cheap wood. Sand the wood to get a smooth finish, then seal it by painting it with a layer of linseed oil. Wipe off the excess with paper towels or a rag, and leave it to dry for several days. Apply another coat of linseed oil, allow that to dry and repeat the process until you have a good hard seal.

Some artists prefer not to carry their palette but walk to it. Many convert a trolley by fixing a wood, glass or melamine surface on to it, thus giving themselves a much larger mixing surface which can be wheeled about the studio, with storage space for various media, paints and rags below.

Choose a palette larger than you think you will need. This will give you plenty of space for mixing colour and experimenting. If your palette is too small, you will quickly run out of space and this will artificially limit your opportunities for exploration and investigation. To begin with you will inevitably spend a great deal of time looking for the right colours.

Peel-off palettes are available on paper pads. They are handy if you are working outside as they can be thrown away once you're finished, but they are too expensive for everyday use and too small to be really serviceable.

Dippers, pots and jars

You will need containers for the diluents and media you mix with your paint. Dippers are metal containers that clip to the palette, so that the media are near the paints for mixing. They are available in different sizes, singly and in pairs, with lids and without. Those with tops prevent the medium drying out, so that you can keep them for quite a long time – useful if you work slowly and need only small amounts. If you paint larger pictures and use lots of media, you'll probably end up with a collection of jars, saucers and dishes in which to put ready-mixed media, and for mixing your own.

Artists are inveterate collectors of glass jars. You'll need at least two for brush-cleaning and another for storing brushes. Nor can you have

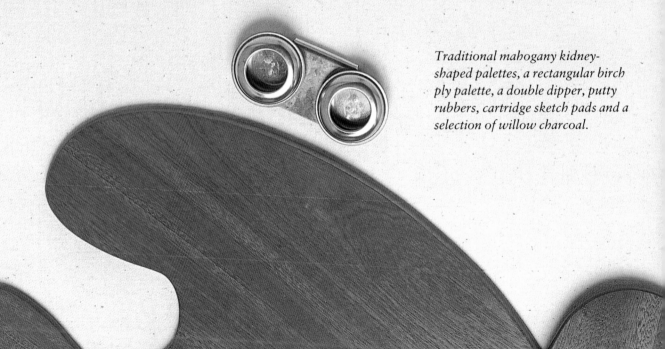

Traditional mahogany kidney-shaped palettes, a rectangular birch ply palette, a double dipper, putty rubbers, cartridge sketch pads and a selection of willow charcoal.

enough rags. You'll need them for cleaning your hands, your brushes and your palette, for tinting canvases and even for laying in a quick under-painting, as we demonstrate on page 77. Non-fluffy cotton materials like old T-shirts and sheets are best, as they are absorbent and don't leave bits on the painting or palette.

Oil paint is a messy medium, no matter how careful you are. It is sticky and takes ages to dry, so a wet canvas is a hazard for days, if not weeks. In an ideal world you would have a room just for painting and then you could leave your palette of colours and wet paintings between sessions. How-ever, if, like most people, you have to pack your things away when you finish painting, make sure they are stored well out of the way. If not, you'll find that oil paint gets everywhere.

Other essentials for the oil painter are kitchen roll, an overall and lots of newspaper for mopping up spills, protecting surfaces and tonking – I explain tonking later (see page 57).

Drawing materials
You will need a sketchbook to make preparatory drawing in pencil or charcoal. Charcoal is particu-larly useful for quick tonal studies and also for underdrawing, as it can be dusted off leaving only a faint outline. Willow charcoal is the nicest to use. It is soft, offers a narrow tip for linear work and the long edge can be used for blocking in areas of solid tone. Willow charcoal is available in thin, medium or thick sticks, and sometimes in assorted widths. Charcoal pencils are cleaner, but the charcoal is harder and they lack willow's sweet, fluid quality.

A putty rubber can be moulded to a fine point so that you can erase small areas and pick out highlights without smearing – particularly useful when you are working with charcoal.

Colour

COLOUR CONCERNS all painters no matter what medium they work in. It is one of the primary means by which they describe the world and express their responses to it. No artist ever claims to have mastered colour; it is something they continue to learn about and experiment with throughout their working lives.

Colour is a vast and confusing subject, the study of which covers many disciplines. Physicists study the phenomenon of light, chemists look at the properties of dyes and pigments, physiologists study the way the eye and brain allow us to perceive and interpret colour, while psychologists seek to understand its symbolism and the way we respond to it.

Artists can use the findings of all these disciplines, but more importantly they must learn to 'see' colour. Having trained themselves to see it, they must then learn to handle their medium so that with solid and relatively crude materials in a finite range of colours they can re-create subtle and infinitely varied light effects. It's quite a challenge. But above all colour is a pleasure, something to be played with and enjoyed.

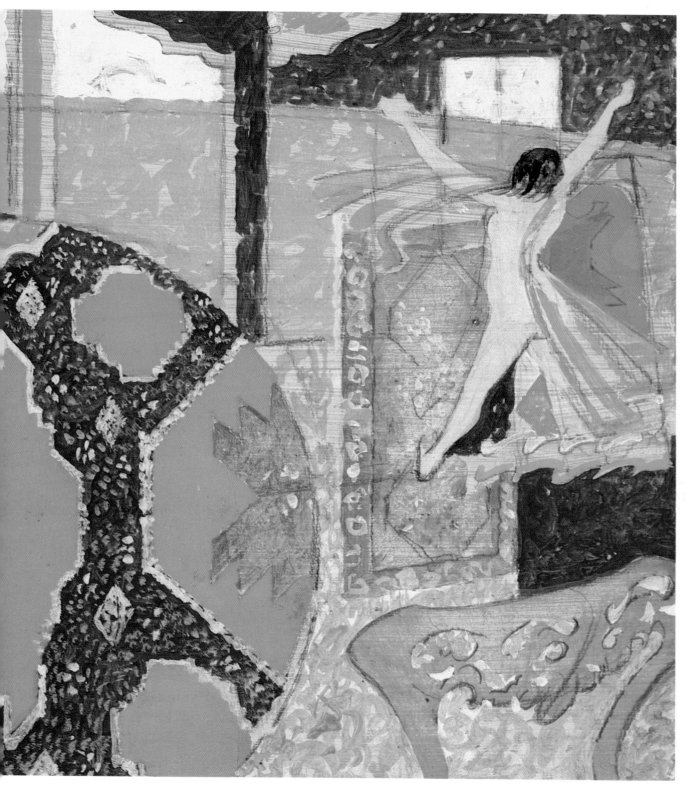

In this painting the artist, Lionel Bulmer, takes an everyday subject – an oval table with a patterned cloth – and by flattening form and editing and exaggerating colour creates an image which is unique and exciting.

51

Using colour

There are two principal ways in which artists use colour. The constructive use of colour renders three-dimensional space and form on a two-dimensional surface. Artists use colour to construct an illusion. In aerial perspective, for example, they make use of the way that cool colours appear to recede while warm colours advance. Colour can also be used to express emotions, mood and atmosphere, and generate an emotional response in the viewer.

Seeing colour

You can't paint colour until you learn to see it. But when you start to look with the eye of an artist you'll realize that the world we live in is more colourful than you had previously thought. Take shadows, for example. Children and naïve painters paint shadows as though they were black or dark grey, but if you look hard you will see that they are full of subtle colour and tone. If light really did travel only in straight lines from its source, the areas of an object which are cut off from the direct rays of the sun would indeed be pure black. But in fact the sun's rays are scattered and reflected back from the surface they strike, creating a shimmering, complex and constantly changing background light. Even in a brightly lit landscape, shadows are not pure black but are softly modulated, tinged with colour from surrounding objects and the sky above.

The colour wheel

One of the devices by which artists try to understand colour is the colour wheel. This is a circular diagram used to show how colours can be mixed from the three primaries, and it explains certain colour relationships.

Let's look at the primaries: red, yellow and blue. These are important because they cannot be mixed on the palette from other colours, and in theory every other colour can be mixed from them.

Orange, green and violet are called the secondaries because they are derived from the primaries: red and yellow produce orange; yellow and blue produce green; and red and blue produce violet.

The tertiaries are produced by adding a primary to a secondary. They produce useful colours like bluish green and yellowy green, reddish orange and reddish violet.

Definitions

Colour has its own vocabulary and it will be helpful to understand some of the terms. Every colour has four qualities: hue, tone (or value), intensity (or saturation) and temperature.

▷ This colour wheel shows primary and secondary colours, with warms on one side, cools on the other and complementaries opposite each other.

A hue is a specific colour, defined in terms of its redness or blueness, but not its lightness or darkness.

Tone is the lightness or darkness of a colour. White and black represent the two extremes of the tonal scale and any colour can be placed somewhere in between.

The effect of adding black, white or grey to a hue is to reduce its intensity. The colours around the outside of the colour wheel are at their maximum intensity because they cannot be made any stronger. They can, however, be broken down into weaker forms, by adding white, black or grey, while still retaining their hue.

Temperature refers to the degree of warmth or coldness of a colour. This is a subjective and aesthetic distinction which has no physical basis, but it is invaluable to the artist. In the projects later in the book I constantly refer to warm and cool colours.

Warm and cool colours

The colour circle can be divided into two halves. In one we find the warm colours: yellows, reds and oranges. In the other are the cool colours: blues, violets and greens. But there are degrees of warmth and coolness, so some blues are relatively warm and some reds are relatively cool. Ultramarine, for example, is a warm blue that can be mixed with red to make a good violet. Prussian blue, on the other hand, is a cool blue and can be mixed with a 'cool' yellow like lemon yellow to give a brilliant green. Study a colour chart and you will see that reds like carmine and alizarin crimson are cooler than hot reds like cadmium red and scarlet.

Generally, warm and cool colours are carefully orchestrated to create a picture that appears neither too cold nor too hot. However, in painting rules are often broken for creative effect, and a painter may deliberately pitch a painting in a warm or cool key.

Aerial perspective

While warm colours appear to advance towards the spectator, cool colours seem to recede. Aerial or colour perspective is a device by which the artist creates an illusion of space using cool colours in the background and warm colours in the foreground. If you look at objects in the distance, you will see that the further away they are the less distinct they become — edges become blurred and colours and tones move closer together. By blurring forms, using cool and muted colours in the background, and contrasting this with crisp edges, bright and warm colours in the foreground, you can enhance the sense of space in your work.

Complementary colours

These are pairs of colours that are opposite each other on the colour wheel. Take the primaries, for example. Every primary colour has a complementary which is a mixture of the other two primaries. Study the colour wheel and you will see that orange (red plus yellow) is the complementary of blue; green (yellow plus blue) the complementary of red; and violet (blue plus red) the complementary of yellow. Complementary colours have a special relationship. When placed side by side they intensify each other, so red looks redder when it is juxtaposed with green. For a practical application, study the work of the Impressionist painters. You will find that almost invariably areas of green like grass and trees have traces of their complementary reds, giving the greens a special zest and vividness. If you mix two complementaries, you will create a neutral brown or grey – useful, subtle shades that are more interesting than the greys produced by mixing white and black.

Looking for tones

We have already defined the term tone (or value) as the lightness or darkness of a colour. Just as we learn to see colour, so we also learn to see tone. It is the distribution of lights and darks over the surface of an object that allows us to understand its form. Look at any subject while ignoring the local colour – the actual colour of an object or an area – and try to see it purely in terms of lights and darks. Half closing your eyes will help by emphasizing the

contrasts. A black-and-white photograph is a good example of a tonal study.

Get into the habit of making a tonal study of a subject before you paint it. Charcoal is an ideal medium for this because it is capable of rendering subtle tonal gradations. A tonal study will do two things. It will both help you to understand the forms and also let you see very clearly an important aspect of the composition, the distribution of lights and darks across the picture area. In a successful painting these will be arranged in a balanced and harmonious way.

A useful way of learning about composition is to make tonal studies of the works of great artists. Take your sketchbook to an art gallery and look at your favourite pictures, or find reproductions in books. Study the paintings through half-closed eyes so that you can identify the dark masses and the light areas. Make quick, scribbled drawings of these lights and darks. The results will be sketchy, almost abstract images. By studying these, you will learn a great deal about the way these artists used the picture area.

▽ **Mixing colours for landscape**
Learning to mix colours is an essential part of the artist's training. Here I show some greens and greeny-browns that would be useful for a landscape painting. From left to right: raw sienna and viridian; viridian and cadmium yellow pale; cadmium yellow pale and black; yellow ochre and French ultramarine; French ultramarine and raw sienna.

The colours here are, above, left to right: yellow ochre, burnt sienna, alizarin crimson, raw sienna, burnt umber, chrome orange, chrome yellow, ivory black and cadmium yellow. Below, left to right: Payne's Grey, cobalt blue, viridian, Prussian blue, cerulean blue, chrome green, French ultramarine, sap green.

Starting to Paint

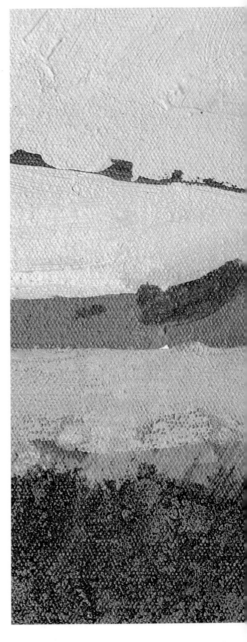

OIL IS A wonderfully sensuous and responsive medium. To get the most out of it you should first learn to enjoy and feel comfortable with the materials and the paint. The basic oil techniques which I will describe in this chapter are actually very simple to follow. However, before you work through them I suggest you play with the paint for a while. Take two or three tubes of colour, a few sheets of primed paper or board, and a couple of brushes and just have a go.

Squeeze a blob of paint on to a palette, load a brush with paint and see how it moves on the support. Now see what happens when you use a smaller brush, a knife, a rag or your finger. Vary the amount of paint on your brush. See what effects you get with a heavily loaded brush, and then with a fairly dry brush. Thin the paint with a little turpentine and experiment with that. Notice whether it covers the board or whether the ground shows through. Does the paint retain the mark of the brush? Try mixing the paint with linseed oil and see what difference that makes. Get to know the paint: play with it and enjoy it. When you've finished, you can scrape the paint off with a palette knife, wipe the support with rag and turpentine and start again. Or you can allow your experiments to dry and paint over them with primer.

△ *Paint is used to create descriptive effects, but it can also give a picture surface character and energy. In this detail the paint surface is flat and unmodulated in some areas, but on the left layers of broken greens create a sense of flickering, moving colour, while on the right the artist has scratched back into the paint surface to suggest grasses.*

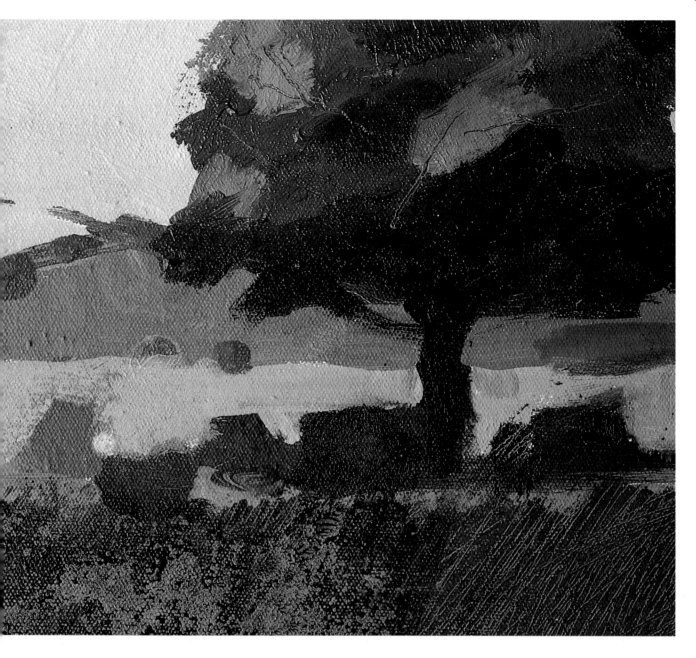

◁ *Tonking is a method of removing excess paint from the support. Lay a piece of absorbent paper over the area – newspaper will do – and rub it gently. Peel the paper off and you'll find that some of the paint comes too. Tonking is useful when the paint surface gets so wet and slippery that it is difficult to continue painting. The technique was devised by Henry Tonks.*

A BASIC KIT

▽ **Flesh tones**
*Start with this limited palette – later
you will evolve your own.*

If you are starting from scratch, you may find this shopping list of basic items useful. There are so many materials available that the novice sometimes doesn't know where to start. Once you've mastered the basic techniques described in this book, and worked through the projects, you will know your likes and dislikes and whether the medium suits you. This list is intended to get you started.

Buy some turpentine to thin the paint and lots of white spirit to clean your brushes. It might also be worth buying one of the alkyd mediums as these allow you to work quickly. I found Winsor & Newton's Wingel very useful for the projects in this book.

Make sure you have plenty of painting surfaces. A pad of oil sketching paper plus three or four canvas boards would be good to start with. The supports should be a reasonable size, otherwise you'll fiddle, and you should start by painting boldly and broadly to get the feel of the medium. The 24 in × 20 in (61 cm × 51 cm) or 30 in × 20 in (76 cm × 51 cm) sizes are good. Or you can buy hardboard. Cut it to these sizes and prime it with an acrylic primer.

You will need four or five brushes. Choose hog brushes and, as with the supports, pick ones that are slightly larger than you think you need. Sizes vary from manufacturer to manufacturer so I'll be specific and recommend the Winsor & Newton set which includes a number 4 flat, a number 6 filbert, a number 1 round and a number 8 bright. You'll also need a soft brush for underdrawing and putting in details – a number 3 synthetic or mixed fibre brush is good here.

A palette or mixing surface is essential. This can be bought or home-made, but make sure it is big enough. A sheet of glass or melamine board makes an excellent fixed palette.

Make sure you have lots of rags, kitchen towel and newspaper for protecting surfaces, cleaning and mopping up spills.

Paints

All colours are available in 21 ml and 37 ml tubes; whites can also be bought in 60 ml and 120 ml

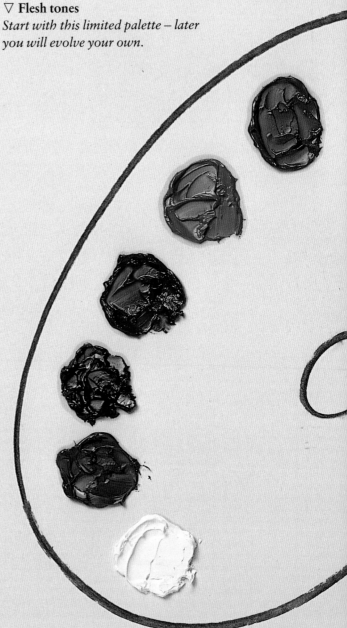

tubes. Choose the 37 ml size for most colours, but you'll need a 60 ml tube of white. Start with a few colours and add others as you become more knowledgeable and confident.

A limited palette

The beginner is easily tempted into buying lots of colours, but this is both unnecessary and expensive. It is better to start with a limited range of colours. If you have only a few colours you will be forced to make the ones you need by mixing them and this means you will have to look hard and analyse just what it is you are seeing. In this way you will sharpen your perception of colour.

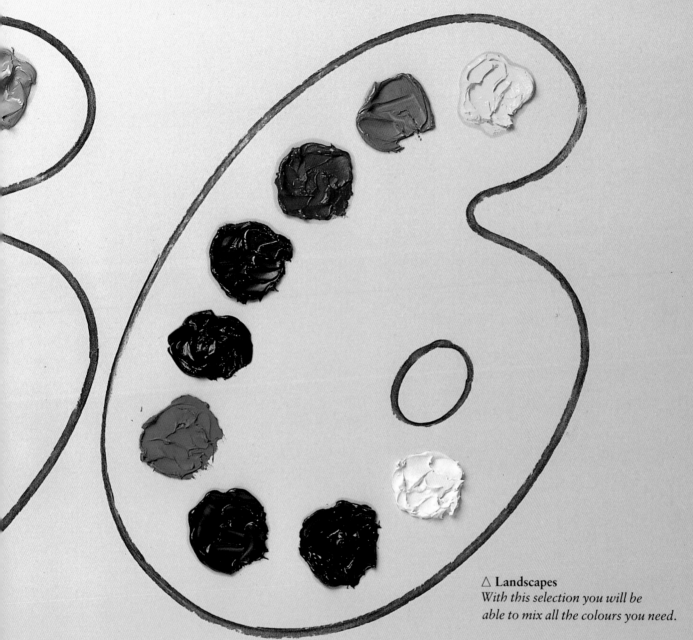

△ **Landscapes**
*With this selection you will be
able to mix all the colours you need.*

A basic palette for flesh tones
For figures or portraits a palette that includes a good selection of earth colours is useful. The following colours will allow you to mix lovely subtle flesh tones:
yellow ochre, raw umber, light red, alizarin crimson, terre verte, cobalt blue, titanium white.

 With this selection you will be able to mix a range of delicate colours – light violets, chalky mauves, warm fawns, peachy pinks, drab greens and pale creams. Every artist evolves their own particular palette of colours and in time you'll devise your own, but this will give you a good start.

A basic palette for landscapes
To paint a landscape you will need a surprisingly large range of greens, and the best way of finding these is to mix them for yourself. My recommended palette includes Prussian blue, a cool colour which gives a good range of sharp greens, and ultramarine, which is a warm blue producing muddier greens. This is a good working palette for landscape:
cadmium yellow light, raw sienna, burnt sienna, burnt umber, Prussian blue, cerulean blue, ultramarine blue, black, titanium white.

 Viridian is a useful addition. It is rather strong and transparent on its own, but can be mixed with other colours to produce a range of greens.

59

USING PAINT

Before you start, make sure you have all the equipment you need: tubes of paint, a palette or something to mix paint on, a brush, some turpentine in a pot and one, or two, pots of white spirit for cleaning your brush. You will also need some rags.

Squeeze a little of each colour on to your palette. Lay the colours out around the edge, leaving the centre of the palette free for mixing. Most painters develop a consistent method of laying out colours so that a particular colour is easy to find. There are many systems. A popular method is to lay out the warm colours first, starting with the palest, such as yellow, and working through oranges and reds to the greens and blues on the cool side of the spectrum. White and black can be placed together at one end, or they can be placed at opposite ends. Earth colours are sometimes grouped together, either on one side or with the reds and yellows.

Putting out all your colours before you start has advantages, especially if you intend to work quickly and finish the painting in one sitting – a method known as painting *alla prima*. If all your colours are on the palette, you can concentrate on painting, and not waste time searching for tubes of paint. Another system is to start with a limited palette of two or three colours plus white and see what colours the subject and the painting suggest to you, that is, to let the painting evolve its own colour key.

Start by dipping your brush in the turpentine, then pull some colour from the blob of paint on the palette and blend the paint and turpentine together in the centre of the palette. To mix a new colour, pick up a bit of the second colour and mix that with the first. Add more of each until you get the colour you want. Load your brush with the colour and apply it to the support.

If you will need a lot of a mixed colour, use a painting knife to pick up paint from the edge of the palette, then use the flat of the knife to mix the paints together. When the paint is mixed, you can use a brush dipped in turpentine to dilute it to the right consistency.

Because oil is such an exciting and seductive medium, the beginner often gets carried away and uses too many colours, mixing them in an uncontrolled way. The palette gets messy and the colours on the canvas become muddy; the painter is disappointed with the result and, what is worse, doesn't learn from the process. Even if you are naturally flamboyant, try to curb your enthusiasm to start with. Keep your palette clean and orderly and don't mix more than two colours together in addition to white. Wipe your brush on a rag and wash it in white spirit before you change to a new colour. In this way your colours will stay fresh, and because you know how a particular colour was achieved, you will increase your understanding of paint and colour mixing. As your knowledge and confidence increase, you will evolve a more flexible and personal approach.

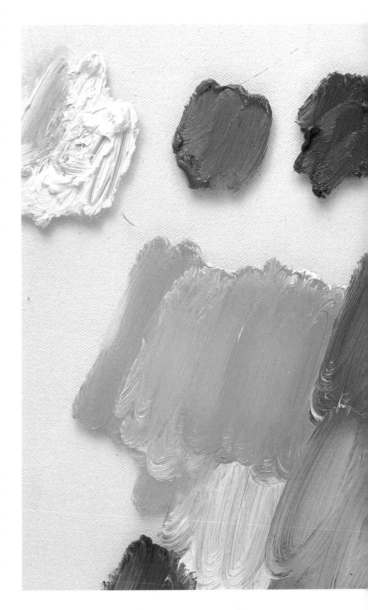

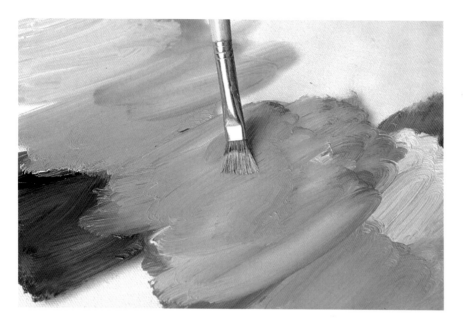

◁ *Use the middle of the palette to mix colours. Continue adding colour to the mixture until you get the shade you want. As you can see, you can get a lovely range of subtle colours from this very limited palette.*

◁ *The flesh-tint palette laid out with the warm colours on one side and the cools on the other. From left to right: titanium white, yellow ochre, light red, alizarin crimson, raw umber, terre verte, cobalt blue.*

TECHNIQUES

PAINTING WET-INTO-WET

One of the characteristics of oil paint is that it dries slowly unless you add media which accelerate the drying time. A wet paint surface is alive. It allows you to blend new paint with the existing layer of paint in such a way that it will be impossible for a viewer to tell at what stage a particular colour was added. This means that you can work slowly, leaving your painting for a time, then coming back to it and resuming from where you left off. This has several advantages. It allows you to get to know a subject intimately, to look at it carefully, change your mind, leave it, think about it and then continue working on it at a later date. It is especially useful for people who have only a limited amount of time for painting, as it means you can do a little each day and continue to work into a wet surface. The rate at which oil paint dries depends on the type of ground you use. Gesso (a traditional chalk and size ground), for example, is absorbent and the paint will dry more quickly here than on an acrylic primer. Drying time is also affected by the amount of diluent you have added to the paint and the thickness of the paint layer. Paint thinned with turpentine will dry more quickly than paint used direct from the tube.

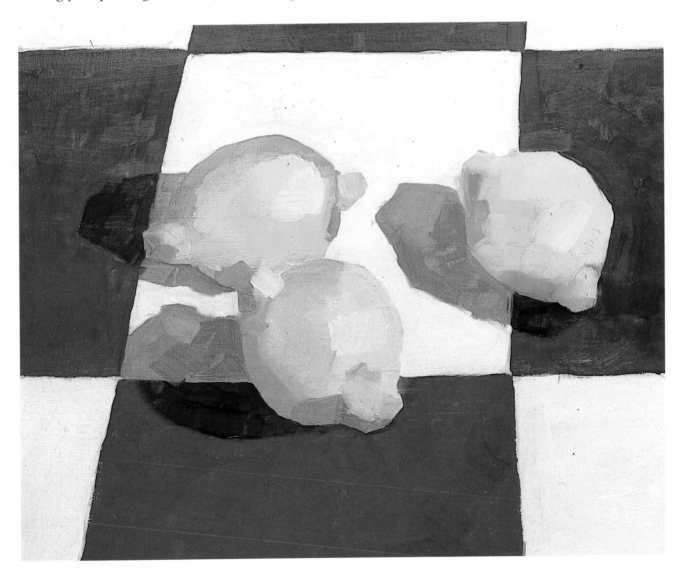

Blending colours

Another quality of oil paint is the way that it holds the brush or the knife, and many techniques exploit this to create textural effects. Working wet-into-wet, it is also possible to blend colours so as to achieve smooth, unmodulated surfaces in which the mark of the brush is almost entirely obliterated. Some painters use this approach over the entire surface of a painting; others use it in parts, contrasting areas of rich texture with smoothly blended passages.

Fat over lean

'Fat' describes paint rich in oil. Some colours are naturally fatty, but paint can be made fat by adding an oil such as linseed oil. 'Lean' paint contains little oil or is thinned with a diluent such as turpentine. Because lean paint dries more quickly than fat paint, and contracts less, you should always paint 'fat over lean' to ensure that the paint layer remains stable as it dries. Start by mixing your paint with a little turpentine, but as the layers build up, add more oil and less turpentine.

Oiling out

If parts of a painting become dull as it dries, you can give it a sheen by rubbing a little linseed oil into the dull area. Oiling out a painting by moistening the entire surface is also useful if you decide to rework a painting after it has dried. A slightly oily surface takes the paint better and is pleasanter to work on than a dry surface.

Blending *By working into wet paint it is possible to achieve very gradual transitions between one colour and another, or one tone and another. Practise doing this on a piece of scrap paper.*

◁ **Wet-into-wet** *This painting was done with a brush. The artist continued to work into the wet surface until it was complete. In some areas the paint is fairly flat and unmodulated (the checked cloth, for example) and in others you can still see the mark of the brush, but texture is not a particularly important element of the painting. Compare this with the pictures on pages 68 and 70, in which the artist has deliberately built up a thick paint layer.*

TECHNIQUES

WAYS OF MIXING COLOURS

There are several ways of mixing colour in oil paint. The most obvious is by combining two or more pigments on the palette, or sometimes on the canvas. Learning to mix colours is a demanding but exciting business. You can read books on the subject but only by patient experiment will you learn which colour mixtures produce the colours you want. So spend time getting to know the colours you use and what you can do with them. Mix colours in different proportions and put dabs of the mixed colour on a scrap of paper to see if they are exactly what you want. In time you will hold these colour 'recipes' in your head, but you will never exhaust the possibilities of your palette.

Because oil stays wet for so long you can change colours on the canvas by mixing another colour into the wet paint. Be careful, though, not to overwork the paint – if you mix too many colours the paint becomes dull. Oil paint looks best when it is fresh. With experience you will be able to judge just how far you can go.

Optical colour mixing
This is the term used to describe the blending of colours which occurs in the eye rather than on the canvas or palette. The system, sometimes known as Pointillism or Divisionism, was devised in the late nineteenth century by the French painters Signac and Seurat after a careful study of optics and colour theory. These artists used the system in a very formal way, as you can see if you study their paintings in galleries or books. If you put dashes and dots of different colours on a canvas, you will find that the separate colours do indeed begin to merge as you move away from the canvas, creating

new colours. So an area painted with dabs of yellow and red appears orange, while blue and yellow dabs placed side by side will appear green. Colours mixed in this way are often more intense than those mixed on the palette because the paints are in their purest form, and are not affected by the interaction of pigments and the media used in the paint.

A less rigid system of optical colour mixing is called broken colour. This effect is achieved in several ways: by laying touches of different un-

△ *Red and yellow being mixed on the palette.*

blended colours side by side, or by applying one layer of colour over another so that the underlying colour shows through. By dipping the tip of your brush into first one colour and then another and by applying the loaded brush to the canvas, you can create a striated brushstroke which contains mixed, partially mixed and unmixed colour, making for a lively paint surface. This partial mixing of colour sometimes happens by mistake and in time you will learn how to exploit these 'accidental' colour effects.

△ *An orange mixed from the red and yellow.*

△ *The partially mixed, broken colour effect achieved when the same red and yellow paint are picked up on the brush and worked on to the canvas.*

△ *Dots of red and yellow paint placed side by side. Seen from a distance these merge in the eye to create a vibrant orange.*

Scumbling

In this technique a thin layer of opaque or semi-opaque paint is loosely brushed over a ground or a previously applied colour in such a way that the first colour shows through in places and modifies the scumbled colour. The paint may be scrubbed on with a stiff brush, or rubbed on with fingertips or a cloth. This technique is a useful way of laying in an underpainting which is not too dominant or of 'knocking back' an area of colour that has become too dominant. You could, for example, scumble dark green over a green which was too garish. It can also be used to create special effects like clouds or mists on the horizon.

Drybrushing

In drybrushing the brush has very little paint on it, so that when it is dragged across a surface, especially a coarse-grained canvas, it leaves a trail of mottled colour. To achieve a drybrush effect load

a stiff-bristled brush with colour and then blot it on cloth or paper so that it is almost dry. The effect is enhanced if you spread the bristles of the brush so that they are separate, then drag the brush across the surface at a shallow angle so that the flat of the brush rather than the tip touches the support. This technique is useful for creating special effects like grass, fur or feathers.

▷ *Red scumbled loosely over green. In places the underlying green shows through and modifies the red; in other bits of pure green remain, creating complex and shimmering colour.*

65

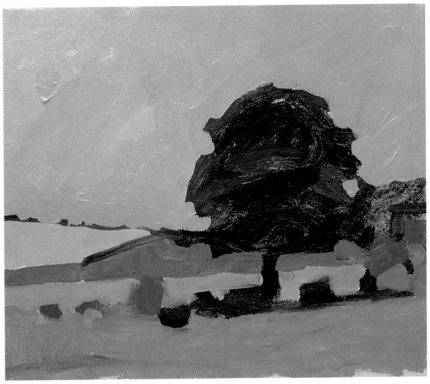

▽ *Creamy paint is then scumbled on to create an uneven covering which suggests clouds.*

△ *This image has been created using flat, untextured colour.*

▽ *Similarly, the dense foliage of the tree is broken up by scumbling on a lighter green.*

TECHNIQUES

GLAZING

In oil painting a glaze describes a transparent film of colour which allows you to modify an area of colour without obliterating it. A glaze can be applied over a tinted ground, an underpainting, an area of impasto or even another glaze. Traditional oil paintings were developed in two stages: a monochrome underpainting, followed by carefully controlled layers of colour applied as glazes and scumbles (opaque and semi-opaque layers of colour). The resulting paintings had a special luminosity and depth, often described as an 'inner light'. This can be seen in the works of masters such as Jan van Eyck (*c.* 1395–1441) and Rembrandt (1606–69).

It is possible to produce an entire painting by building up layers of glazes, but these days it is more usual to combine glazing with direct painting. The best way of understanding the possibilities of glazing is to make a small painting using a glazing technique. Start with a monochrome underpainting and allow that to dry completely before you start to glaze. If you do the underpainting in oil, the drying time could be several days, but you can speed things up by using acrylic paint, which will dry in hours.

To make a glaze, mix the paint with linseed oil and a little turpentine. Or use one of the alkyd-based oil media, which are excellent for glazing and dry more quickly than traditional oil media. You can glaze the whole painting with a single colour, or use different colours in adjacent areas. Allow one layer of colour to dry before you apply the next and, remembering the fat-over-lean rule, add more medium to each layer of glaze.

Glazes can be used to create shadow areas of great luminosity and depth, and they can be brushed over highlights to give them added brilliance. Glazing is particularly useful in areas such as figure painting or portraiture in which you need to achieve subtle modifications and transitions of colour and tone in order to render the delicate tones of flesh. You can use a glaze to give unity to a painting or parts of a painting. For example, if the modelling of a portrait looks too crude, a glaze may pull the tones together.

△ *Ultramarine is mixed with Wingel, an alkyd medium, to create a transparent glaze. You could also use linseed oil with turpentine.*

▷ *A glaze of ultramarine is laid over cadmium yellow pale. Notice the way the yellow shines through the transparent blue layer.*

IMPASTO TECHNIQUES

Applied thickly, oil paint can be used to build up a luscious and richly textured surface in which the marks of brush, knife or even fingers play an important part. The term impasto is used to describe this low-relief surface and the technique of applying paint in this way. With impasto the way the paint is applied, and the tool with which it is applied, become yet another means of artistic expression. The viewer can enjoy the almost three-dimensional quality of the paint surface and get a sense of the excitement with which the artist handled the paint.

Until the end of the nineteenth century, impasto techniques were generally combined with layered and blended paint effects. Rembrandt, for example, combined overlapping layers of semi-transparent scumbles and transparent glazes with passages of richly textured paint. Sometimes swathes of paint were applied wet-into-wet, the fluid brushstrokes modelling forms such as hands or the folds of drapery. At other times encrustations of paint were used to capture the texture of crisply pleated collars, lace or intricately worked jewellery. Impasto was often used for highlights, the opaque colour contrasting with the transparent layers of colour used to give depth to shadows. Often his impastos were also glazed.

For the artist Vincent Van Gogh (1853–1890), impasto was a principal means of expression, used over the entire picture surface rather than confined to specific areas. He worked directly with a brush or knife loaded with paint, sometimes using his fingers to move the paint about, mixing colour on the canvas rather than on the palette, and even applying it directly from the tube. His brushstrokes emphasize form and imply energy. There are swirling lines, short stabbing strokes, staccato lines and lines which undulate across the picture surface.

△ **Impasto with a brush** *In this painting the mark of the brush gives the painting a lively surface. Notice the way the direction of the brushstrokes follows and describes the form of the lemon. Compare this with the treatments of the same subject on pages 62 and 70.*

▽ **Glazing over impasto** *Glazes can be applied over heavily textured passages. Here the separate areas of textured colour are clearly visible.*

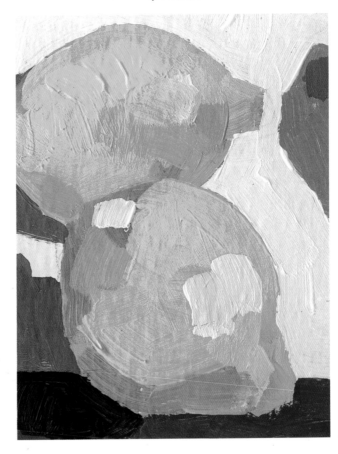

Creating texture with the brush

To exploit the textural qualities of oil paint to the full you will need to work boldly and broadly. This can be difficult when you are unfamiliar with the medium and therefore inclined to be tentative. Start by making a painting of a simple still-life subject. Use a small support 12 in × 16 in (30 cm × 40 cm) and a brush which is slightly larger than you would normally choose (a number 8 bristle, say). Mix only a little turps with the paint.

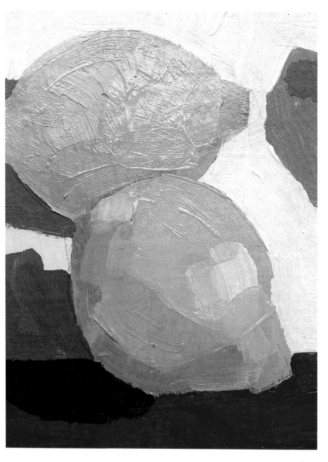

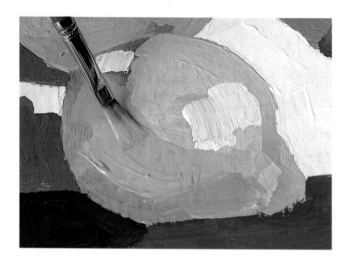

△ *A glaze of transparent colour is washed over the lemon.*

△ *The glaze modifies the underlying colour without obliterating it.*

▷ **The marks of the brush** *Every brush can be used to create a range of different marks, depending on whether you use the tip or the side, how much pressure you apply and the sort of gesture you use. Here we show a range of marks made with a round and a flat bristle brush. On a piece of paper experiment to see how many different marks you can get from a single brush. Explore the possibilities of different kinds of brushes.*

Painting with a knife

Although a brush is the normal implement used for applying paint to a support, you can use anything you like. What you use will depend on the effect you are trying to achieve, the area you have to cover, the speed at which you want to work, the tools you have to hand – in fact, what you feel like using. In the first project on page 77, for example, the artist uses a rag to apply the underpainting. He did this in order to get the canvas covered as quickly as possible and to simplify the image. Although the brush has undoubtedly proved itself the most popular and versatile painting tool over hundreds of years, you should, nevertheless, explore different ways of applying paint from time to time. It will keep your work fresh.

The painting knife is a convenient and flexible painting tool. It can be used to add texture to parts of a painting – to scratch back into the paint surface or to create areas of crisp impasto. It is also possible to do an entire painting with the knife. This is a particularly useful technique for paintings done *alla prima* (in one sitting) as the knife allows you to trowel on the paint so that the colour builds up fast. Painting knives are available in a variety of shapes and sizes and can be used to make a range of marks. The paint should be rich and thick if it is to hold the mark of the knife. You can dab on separate patches of pure colour, or use the tip to flick in shapes and the flat of the knife to slur colours together to create a relatively smooth paint surface.

△ *The crisp surface of this painting has been achieved using a knife. Compare the detail above with the detail of the picture on page 77 which was painted with a brush.*

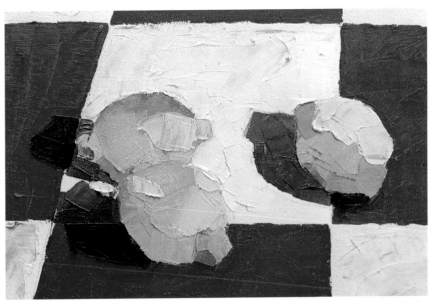

These marks are made with a palette knife. Experiment for yourself!

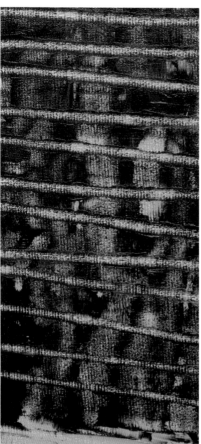

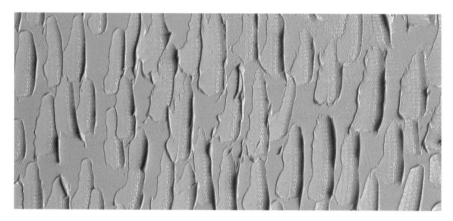

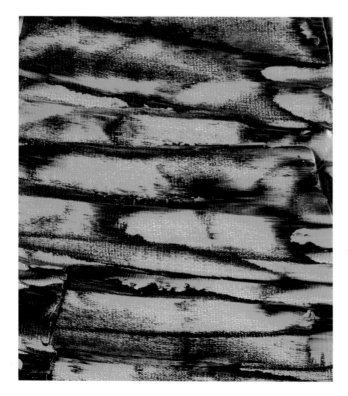

TECHNIQUES

STARTING A PAINTING

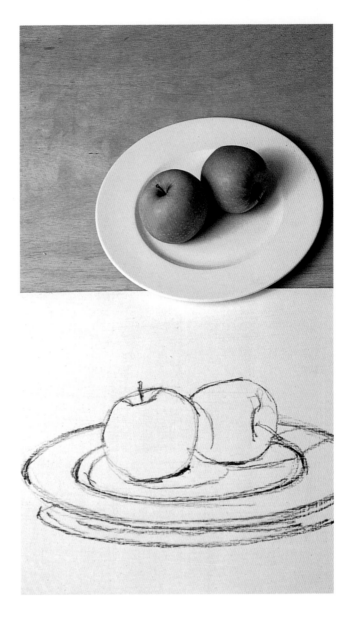

Making the first mark on that brilliant white canvas is probably the most difficult thing the artist, especially the beginner, has to do. Here are several different ways of starting a painting.

Underdrawing in charcoal

An underdrawing may be made directly on to a white ground, or on to a ground that has been tinted with a colour. It can be made in almost any medium, including charcoal, pencil and even paint. Charcoal is often used for underdrawing because it has a pleasingly fluid line, can be used on almost any surface, is easily amended or erased and is unlikely to damage the support. It is especially useful if you have to make a lot of changes, perhaps because you lack confidence about your drawing skills, or are unsure about how to organize the composition. The underdrawing is not a detailed study of the subject – that sort of exploratory drawing should be made in a sketchbook as a separate exercise. The underdrawing merely allows

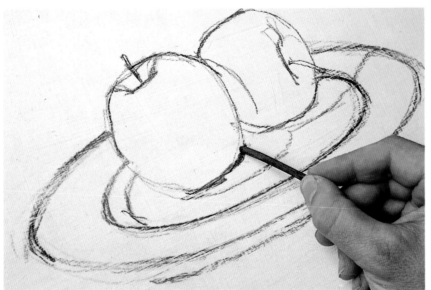

Underdrawing in charcoal

◁ 1 *Using a thin stick of willow charcoal, draw in the main outlines of the subject. Concentrate on the broad shapes and the way they fill the rectangle. Work quickly and directly and don't worry if you have to redraw lines several times; it doesn't matter what the drawing looks like.*

△ 2 *The underdrawing helps you organize the image on the picture area. It is not a detailed study of the subject.*

you to establish the broad areas of the painting and to indicate where they will fall in relation to the edges of the support and to each other.

Using a thin or medium stick of willow charcoal, make an outline drawing of the subject. Use a soft, clean cloth to erase incorrect lines or to remove the whole drawing so that you can start again if necessary.

Because charcoal dust would discolour the paint, you must either fix the finished underdrawing with a spray fixative or 'knock it back' by flicking it with a cloth. Knocking back removes loose particles of charcoal while retaining a faint outline of the drawing which is an adequate guide for the first stages of the painting. Some artists reinforce the charcoal outline by going over it in thinned paint.

Tinting a ground

A white ground is very stark and even a bit frightening, so many artists start by applying a layer of transparent colour to the ground. This was a usual method of working from the seventeenth century until the late nineteenth century, when the Impressionists started to paint on white grounds. You will probably find a tinted ground easier to work on at the beginning. Choose a middle tone, because it will give you a base on which to apply lighter tones and highlights, as well as mid- to dark tones. You will be able to work up to the lights and down to the darks. You will find that the tinted

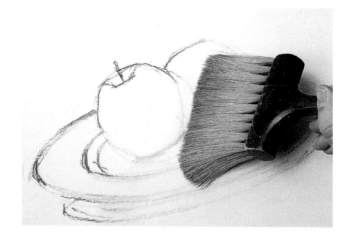

△ **3** *When you are satisfied with the composition, remove the charcoal by flicking it with a duster, or by brushing it lightly with a soft brush. The remaining pale outline will be sufficient to guide you when you start to paint.*

ground provides a key against which to judge the other tones and also holds the whole painting together. A painting done in this way begins really to look like something very early on. You can either tint a ground before you do the underdrawing or wash a tint on over it. Allow the tint to dry completely before beginning to paint over it. Acrylic paint is an especially useful medium for tinting because it dries so quickly.

▷ **1** *Choose a mid-tone which is neutral or relates to the subject you are painting. For example, a muted green would be helpful for a landscape painting, while blue would be an obvious choice for a seascape. Here the artist has used raw umber. Mix the colour with plenty of turpentine and apply it to the surface with a large brush. Cover the entire surface working briskly. If you want a very pale tint, leave it for a few minutes and then wipe it off with a clean cloth. If you are tinting a large area, use a cloth, sponge or paper to apply the colour; it will be quicker.*

Underpainting

You can start a painting with a brush drawing in thinned paint. This is a very direct method of working and allows you to lay in a drawing quickly. It is particularly useful if you work on a large scale, as you can suit the size of the brush to the scale of the painting. On a large painting charcoal lines would look frail and tentative, whereas a big brush will allow you to work fast with bold, vigorous lines.

A brush painting is ideal if you are working *alla prima*, out of doors. First, it is simple and means you have one less piece of equipment to take. Second, because you are using paint and brush rather than charcoal, the drawing feels more immediate and this means you can start the painting with the directness and energy appropriate to *alla prima* work.

If you are new to painting and drawing, rather than merely to oil painting, it is worth reiterating that you should choose a brush slightly larger than you think you will need. Beginners often draw hesitantly and are distracted by unimportant details. A big brush will counteract that tendency and encourage you to be bold and direct, to concentrate on the broad aspects of the composition rather than fiddly details.

A brush drawing can also be used to reinforce the faint trace of a charcoal drawing, so that you can see the drawing during the early stages of the painting.

Use a neutral colour such as grey or brown, or a colour which is suggested by the subject – green for a landscape or blue for a seascape, for example. Blue is used for underpainting because it is a clean colour and recedes. Paul Cézanne (1839–1906) often used a blue underdrawing, and because he frequently worked very thinly and didn't cover the entire canvas with paint, the blue lines of the underdrawing are evident in the final painting.

Monochrome underpainting

A traditional method of starting a painting is to do an underpainting in tones of a single colour on a white ground. This allows you to establish the broad forms of the subject and the tonal values without taking any decisions about colour. Choose a neutral colour or a colour appropriate to the subject and thin the paint with turpentine. You can either do an outline drawing and then block in the mid- and dark tones, leaving the white of the canvas to stand for highlights, or you can block in areas of tone without drawing first. The approach you adopt will depend on your skill, confidence and personality. Some people like things sorted out in an orderly fashion – drawing first, then tones, then colour – while others like to avoid committing themselves too early. To 'see' the tones in a subject, half close your eyes and look for the middle tones. Then look for the darkest and the lightest areas. It helps if you let your eye travel over the subject, comparing one area with another. In that way you can decide which parts are equivalent in tone, and where the maximum contrasts are.

Brush drawing

▷ **1** *Choose a neutral colour or a colour which relates to the subject. Here the artist has used black. Thin the paint with turpentine and, using a small bristle or hair brush, start to draw in the outlines of the subject. Study the subject and think about the way it will fit the picture area. Do not be afraid to redraw lines several times; if the drawing gets too messy, you can wipe them off with a cloth. The most common mistake is making the subject of the painting too small in relation to the picture area, so be bold.*

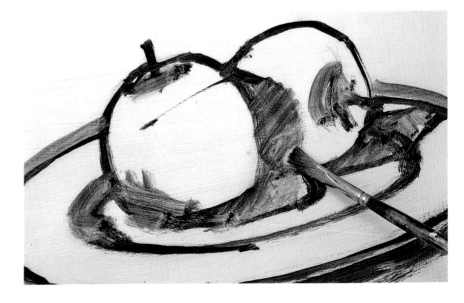

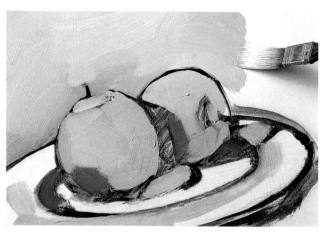

△ **2** *The finished drawing should be a simple outline with perhaps an indication of the darkest tones. The intention is to sort out the composition, not to make a detailed drawing.*

Monochrome underpainting

△ **1** *Using thinned paint in a mid-tone, block in all the parts of the painting that appear to you to be neither light nor dark. Leave the white of the canvas to stand for the lightest areas.*

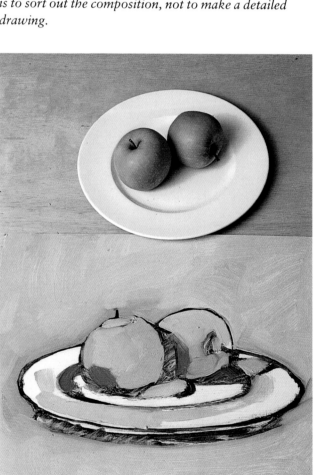

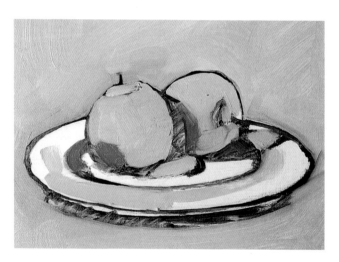

△ **3** *Once the broad forms have been established and the distribution of lights and darks has been roughly established, you can assess the composition and make adjustments as necessary.*

△ **2** *The rim and part of the middle of the plate were lighter than any other area. The darkest areas were under the plate and between the apples.*

PROJECTS

STILL LIFE WITH ARTICHOKE FLOWER

In this project I have done everything I can to make it easy for you to begin your first oil painting. A stark white canvas can be daunting, so the artist has toned the ground. The still-life group has been assembled from everyday household objects and the artist, Stan Smith, has used a rag to block in the underpainting, a specially direct method of painting intended to overcome any hesitancy on your part and to get you started.

Setting up the still-life group

Still life is a marvellous subject for the painter: the possibilities are limitless and the materials are always near to hand – you can select them, move them about and light them as you wish. Any group of objects, no matter how apparently random, will trigger ideas if you study it carefully.

In this still-life group the most obvious themes are colour, texture and shape. It is not a 'colourful' arrangement, but it is nevertheless full of wonderfully subtle warm ochres and muted greys, which contrast with the cool whites and blues of the table-cloth. The natural textures of the stoneware pot and wooden spoons, the basket and the oyster mushrooms, and the dried head of the artichoke are set off by the crispness of the table-cloth. The tall spoons give the arrangement a strong vertical emphasis, but the dominant shapes are the ellipses of the pot and the basket and the repeated ovals of the spoons, which contrast with the angularity of the blue border and the folds of the fabric. Notice also the way the objects can be seen as a single shape against the background.

Make a selection of objects that interest you and see if you can find any linking shapes and colours.

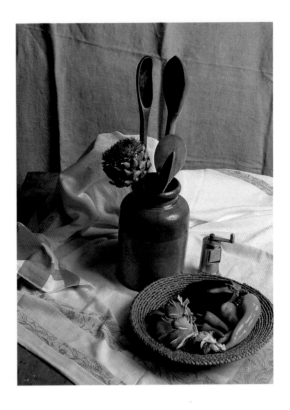

△ *In this still-life group simple shapes, warm, neutral colours and natural textures are set against the cool white tones and crisp texture of the tablecloth. A length of linen canvas was used as a backdrop, the oatmeal colour picking up the predominant colour theme and pulling the group together.*

Ideally something – an unusual shape or colour – will grab your interest and provide a focus for the composition. Put the still life together quickly, then spend time studying it, looking for the compositional possibilities, the 'hooks' for the painting. The idea is to 'make a painting', not merely to 'copy' what is in front of you. Your painting should communicate your response to the subject and express the excitement you felt painting it.

Toning the ground

When choosing a support, you are looking for a size you will feel comfortable with and a shape which suits the subject. Here the artist has used a portrait (vertical) canvas, 30 in × 20 in (76 cm × 51 cm), because the subject is vertical. He has toned the ground with thinned paint in a middle tone. This simplifies the painting process, providing a key for you to work against.

▽ *A stark white canvas can be intimidating. A toned ground makes it easier to start and also simplifies the painting process by providing a middle tone. As you add the lights and darks, the broad forms of the painting emerge very quickly. Here the artist uses raw umber thinned with turpentine. He applies the colour freely, creating a loosely textured surface which will become part of the painting. Allow the canvas to dry before you progress to the next stage. The toning can be done with acrylic paint, which dries quickly.*

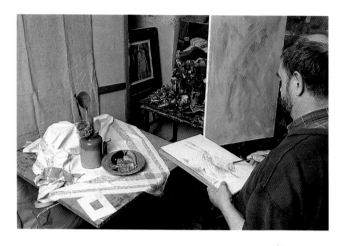

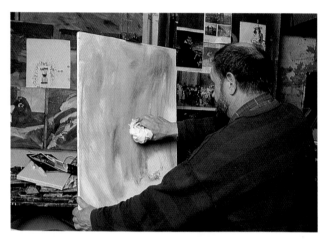

△ *Start by making quick sketches of the subject. Move around, looking for the most interesting viewpoint. Try looking down on the group from above, then crouch down and see what it looks like when seen from eye-level. Use a viewfinder – a window cut from card or paper – to help you frame the subject. Work in a sketchbook, using pencil or charcoal.*

◁ △ *The artist made two sketches in which he experimented with different compositions. By placing the main elements slightly to the right of centre he created interesting background shapes. Always look for these 'negative shapes', the background spaces between the objects, and between the objects and the four sides of the canvas. It is best to avoid placing the main elements of the picture right in the middle – asymmetry generally works better than symmetry.*

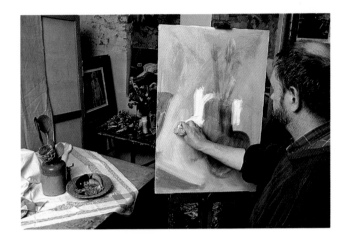

△ *The artist mixes a dark tone and, working very quickly, blocks in the broad shapes of the pot, the basket and the spoons. Now, with white paint thinned with a little turps, he starts to lay in the pale tones of the background. Remember the fat-over-lean rule and mix a little turps with the paint; don't add oil at this stage.*

Preliminary drawings

Make several exploratory sketches at this stage. These will help you decide how much of the subject to include and how to arrange it within the picture frame. Use these drawings to look for rhythms and repeated forms, for angles and directions. The more drawings you do, the more you will see in the subject, and the more possibilities you will find. These drawings should be jotted down quickly, the sketchier the better. It is the looking and the analysing of what you see that are important, not the finished drawing.

Working with a limited palette

It is a good idea to start with a limited range of colours, eight at the most. Here the artist has used titanium white, cobalt blue, viridian, raw umber, alizarin crimson, cadmium red, cadmium yellow and some black. Using a limited selection like this, you can achieve an almost infinite range of colours and tones. A good way of mixing colours is to work with ones from different sides of the colour wheel. For example, if you mix the complementaries red and green, you should in theory produce a pure neutral grey. In fact, because of the impurity of pigments you don't, but you do get the most marvellous warm and cool neutrals. You can make

△ *This system of painting has several advantages. The extreme tonal contrasts of the underpainting provide an excellent basis for subsequent layers in which the tones can be refined. It also allows you to 'see' the main structures of the composition, because the positive shapes of the objects and the negative shapes of the background are quickly established. If the artist had been working with a brush out of a white background, the process would have been much more complicated and the simple yet dynamic arrangements would not have been so obvious.*

them veer towards the cool side by adding more of the cool colour and more to the warm side by adding more of the warm colour. This is a lovely way to mix colours and particularly suited to a picture with a subtle and limited range of tones.

Painting with a rag

At first it is difficult to work broadly and simply, the temptation being to focus on the details of a particular area rather than to deal with the whole painting. Even experienced painters find that their

work becomes tight and from time to time experiment with a different approach or a change of medium to free themselves up. A rag is a splendid means of applying paint because it forces you to generalize and to work fast, which means that you really 'get into' the painting quickly.

Using gesture

Choose a long-handled brush and move away from the canvas. This will force you to use bold, fluid elbow and shoulder movements. The more restricted movements, using the wrist as pivot, are best suited to detailed, close work. Gesture is an important and expressive aspect of painting. Study the work of Van Gogh and you will find swirling, sweeping swathes of paint, and tiny, agitated brushmarks, each creating a different kind of energy and texture.

Reviewing progress

The painting was allowed to dry for a day because a wet surface is slippery and difficult to work. Leaving the painting for a while also means that when you return, you can assess it with a fresh eye.

▽ Though simply rendered and generalized, the painting is already convincingly established. The areas of colour relate to each other because of the underlying tonal painting and there is a sense of dimension and structure even though there are no linear elements. The paint surface has a pleasing tactile quality, which is one of the pleasures of oil paint.

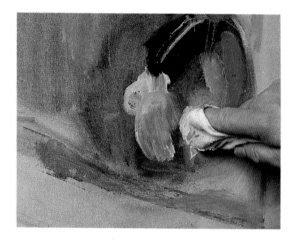

△ *The artist starts to block in local colour (the actual colour of the object) and accidental colour (colour reflected from surrounding objects). These are the colours that he actually sees rather than the colours he knows to be there. For the aubergine he uses a blackish-purply mix, with a bit of blue and lighter purple, and a touch of pink on top. This will provide a guide for the next stage. The peppers are put in with a bright mixed green, while a warm mixed grey is used for the mushrooms.*

79

Study it from a distance, considering it as a whole, then looking at colour, tone and composition in turn. Half closing your eyes will help you concentrate and will exaggerate the tonal contrasts – which is why artists are so often seen squinting at their paintings.

Having established the broad outlines of the painting and put in the local colour in a positive way, the next stage is to cover the ground and develop subtle contrasts from the rather abrupt ones created so far. Imagine the painting as a series of pictures, each more sharply focused than the ones before. At every stage the painting becomes more accurate and more subtle.

Enjoying paint

Oil is an infinitely flexible medium, capable of capturing the qualities of any surface or texture. It can be used thickly, thinly, blended or as dabs of pure impasto, in layers or applied directly to the canvas. It is also a marvellously sensuous medium, and you should not be afraid to enjoy its tactile qualities – thick, creamy impastos of pure pigment that can be sculpted with the knife or brush; clear, brilliant glazes that stain the ground; or delicate scumbles of thin colour which trickle down the canvas. Young children have this delight in paint, but most of us lose it as we grow older. We become rather prim and favour a smooth, carefully modelled,

rather impersonal surface. Try and recapture that childlike delight in paint for its own sake. It will make you sensitive to the quality of the paint surface and will enrich and enliven your work.

Mixing colour

Mixing colour is difficult, especially when you are working within quite a limited range – as on the basket, for example. Study an area carefully, analyse the colour you see and mix an equivalent on the palette. Put that on to the canvas but be

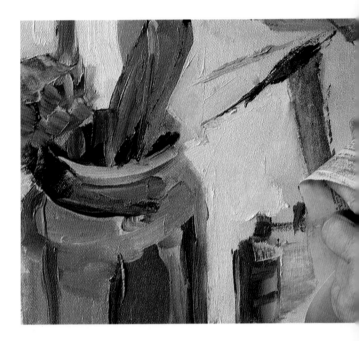

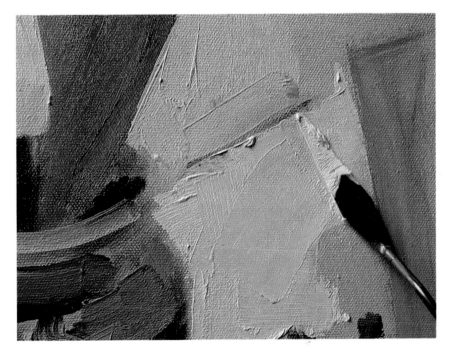

◁ *At this stage the artist changes to brush and knife in order to develop the detail within the painting. The knife was used to give the drapery a crisp, angular feel. Be sensitive to the quality of materials. A thin cotton fabric should look crisp and thin, not heavy like a blanket. Look for ways of expressing the hardness of the glazed surface of the pot, the flaccidity of the mushrooms, and the brittleness of the artichoke.*

prepared to make adjustments. Because colour is affected by adjacent colour, what looks right on the palette may look very different on the canvas.

A useful way of identifying colour and tone is to allow your eye to travel over the subject, making comparisons and finding equivalents – for example, the highlight on the jar is the brightest part of the jar, but it is not as bright as the brightest part of the tablecloth. And although the pot is predominantly warm in tone, it picks up cool reflections from the white cloth.

◁ *The artist has put down a band of colour with a knife and now tonks, or blots, it with paper. This leaves a positive shape on the canvas, but because there is very little paint on the surface he can paint over it immediately.*

▷ *With a number 5 bristle brush and creamy paint the artist develops the whole picture surface, putting down paint and then standing back to judge the effect. His eye travels backwards and forwards between subject and canvas, and across the subject and the canvas, comparing and contrasting tones and colours.*

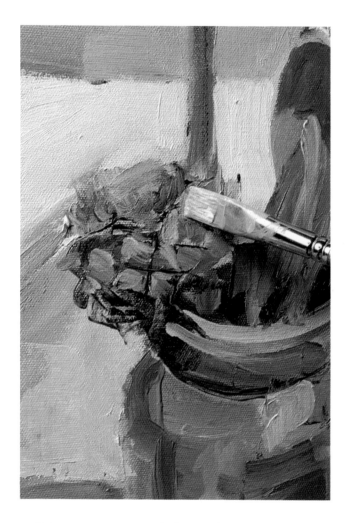

◁ *A light middle tone was used as the base for the basket. Into this the artist puts dark touches with a soft brush, to indicate the texture of the rings of raffia.*

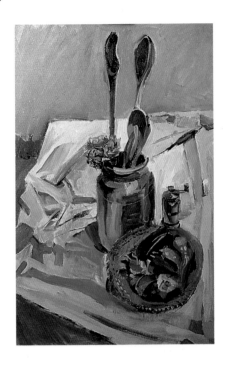

Adding texture

Oil paint can be built up in layers and thick impastos to create a textured surface which holds the mark of the brush, knife or even fingers. You can also scratch back into the wet paint with a knife, the end of the brush or a pencil – this technique is called sgrafitto. You can even mix media. Here, for example, the artist used a variety of techniques to create a visually exciting and descriptive paint surface. On this page you can see him using waxy pencil on the dry paint to create crisp edges, to suggest the woven surface of the basket and to add interest to the picture surface. He uses blue pastel to define the patterned border of the white cloth.

△ *If you look at the basket again, you'll see that it has been rendered in several different ways. There is dark on a middle tone, light on a middle tone and in the foreground, where it catches the light, there is light on dark. Look carefully and paint what you see.*

 As the painting progresses the forms emerge more convincingly, and the objects settle into their place in space. Underlying layers of paint, even the ground, show through in parts, informing and modifying subsequent layers. The muted background, for example, is warmed by the raw umber which was used to tone the ground.

△ *A pencil is used to scratch a criss-cross texture on the edge of the basket. Elsewhere it is used to draw into the wet paint.*

◁ *Texture is sgraffitoed into the surface of the pot with a pencil.*

▽ *Oil pastel is used to add texture and detail to the decorative border.*

▷ *The artist continues to work into the painting, never concentrating on one area but always seeing the painting as a whole. He scumbles a cool green over the background, which gives this area more solidity while at the same time pushing it back in space, so that it definitely sits behind the still-life group. The finished painting works on several levels. It is a realistic representation of the collection of objects. However, the artist has not copied slavishly but has made the subject his own by a process of selection and editing, and by his choice of colour and the lively treatment of the paint surface. I hope you too will produce something which is uniquely your own.*

Finishing a painting

When is a painting finished? That's a difficult question to answer. It's finished when you think it's finished – although, having decided that a painting is finished, six months later you might take it out and work on it again. Some artists keep paintings around them in the studio, glancing at them as they work on other canvases. One day they suddenly realize that a single touch will pull the whole thing together. Others work on a single canvas spasmodically for years. Beginners sometimes overwork a painting, so that the paint surface becomes muddy and loses its freshness and spontaneity. Try living with your painting for a few days before you add the final flourishes.

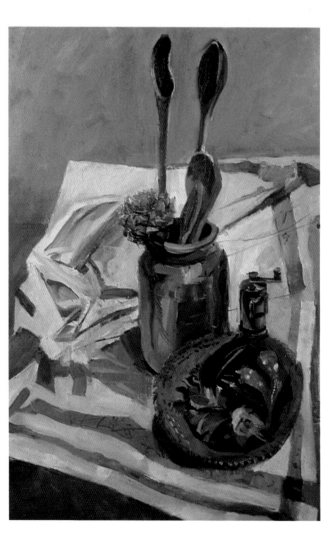

PROJECTS

PAINTING OUT OF DOORS

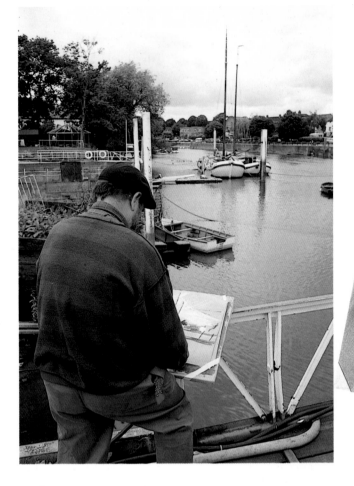

Painting out of doors in front of the subject is very different from painting in the studio. There can be a variety of problems: the weather is unpredictable, and the light inevitably changes as the day progresses or as clouds come and go. Nevertheless, there is no substitute for recording your experiences immediately and, if you are interested in landscape as a subject, you will find this is something you will have to do from time to time. Painting from nature is wonderfully enjoyable and stimulating, and will provide you with an unlimited fund of material which can be developed further in the studio.

The English landscape painter John Constable (1776–1837) painted one or two pictures entirely in the open air, but generally oils weren't used out of doors because the whole process was so cumbersome. Until the beginning of the nineteenth century artists ground their own pigments or bought them from artists' colourmen in skin bladders. When the artist wanted to use the paint, he punctured the bladder and plugged the hole with a tack or bone afterwards. Bladders were cumbersome and inclined to burst – which is why women favoured watercolour, which didn't explode all over their clothes.

Mr Rand and the collapsible tube
The first collapsible tube was devised (*c.* 1841) by an American portrait painter called John G. Rand. The soft metal tube prevented the paint drying out, but best of all it was portable – a great boon to artists, who could now pack their oil equipment and paint out of doors with no difficulty.

The Impressionists and painting *plein air*
At the end of the nineteenth century the French Impressionists were consumed with a desire for naturalism. They sought to achieve this by analysing tone and colour and recording the effects of light on surfaces very precisely. They subscribed to various theories of light and colour, but most of all they painted *'plein air'* to record their 'impressions' of the natural landscape as accurately as possible.

Painting *alla prima*
The Impressionists rejected the traditional style of painting with carefully controlled layers over a monochrome underpainting, blended brushstrokes and a highly finished paint surface. Instead they applied patches of bright, high-key colour which blended in the eye.

Alla prima describes a technique in which the painting is completed in one session with opaque paint which does not allow an underpainting or drawing to show through or modify the top layer. It is a direct method, and each patch of colour is laid down more less as it will appear in the final painting. The paint is applied wet-into-wet (see page 62); some of the colours are mixed on the palette, but they are also blended or partly blended on the canvas.

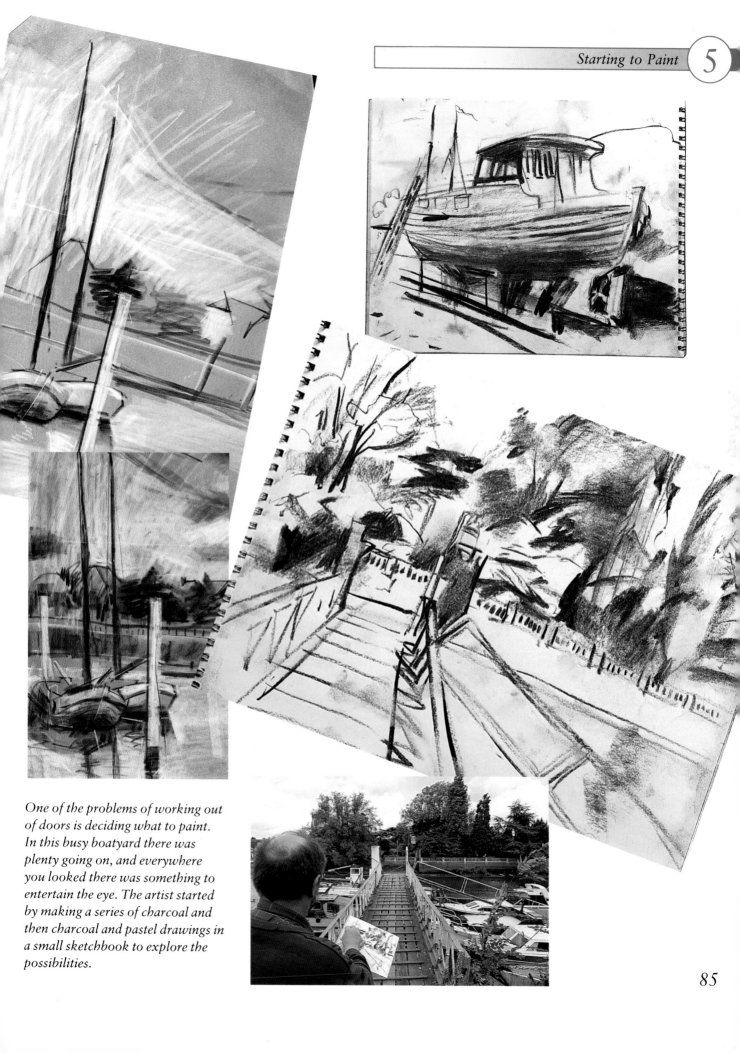

One of the problems of working out of doors is deciding what to paint. In this busy boatyard there was plenty going on, and everywhere you looked there was something to entertain the eye. The artist started by making a series of charcoal and then charcoal and pastel drawings in a small sketchbook to explore the possibilities.

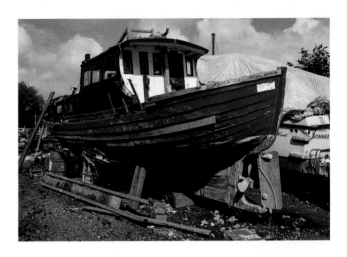

> ▷ *The strong compositional lines and good tonal contrasts of this subject attracted the artist's attention. The boat loomed above us in a rather dramatic way, its delapidated condition lending it a certain romantic appeal.*

The technique is fast, which means it is well suited to working out of doors. This is why it appealed to the Impressionists, anxious to capture fleeting changes of light and colour. They also delighted in the spontaneity of the process, and the way this was reflected in the freshness and energy of the paint surface.

The problems of working outside

There are many practical problems to overcome when you are working out of doors – the wind, the rain, the damp, the heat – and these should not be underestimated. You need to be comfortable if you are going to work outside for some time; you can't sit and do a two-hour painting in the freezing cold with your hands going numb, nor can you paint with gloves on. In those conditions you will have to paint in short bursts, allowing yourself regular breaks to warm up.

If you frequently paint out of doors, you will gradually collect all the equipment that is necessary: a lightweight easel, a folding stool and a bag containing all the things you need for your work. Don't forget to take something to eat and drink, because an empty stomach can be very distracting. In winter you'll need a flask containing a hot drink; in summer lots of fluids and a sun hat at least.

A car is useful, especially in uncertain weather. Not only does it allow you do carry much more kit; it also provides a haven from wind and rain – a sort of mobile studio.

Having found a location, you need to make the most of your time. Start by doing a brief analysis in your sketchbook. Look around to find the most interesting view, and remember, it may not be the prettiest. A spectacular view may not make a good picture – possibly because everything is too far away or there is no interest in the foreground. Don't forget that you can select and exclude; you

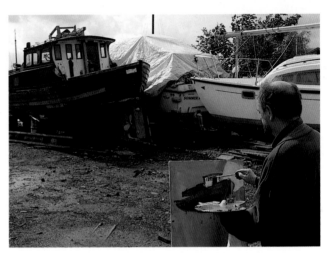

△ *We didn't have a prepared canvas of the right size, so the artist used the top half of a 30 in × 20 in (72 cm × 51 cm) canvas, giving us a painting which is 20 in × 15 in (51 cm × 38 cm). If you are short of time, it is sensible to work on a smaller scale, and if you are working away from home, small canvases are easier to carry. He started by putting in the hull of the boat in reds mixed on the palette, the brushstrokes following the direction of the planking.*

don't have to put in all those pylons unless they add something to the picture! What you leave out is as important to your painting as what you include.

It can be very difficult to isolate the subject of your picture in a panoramic landscape. Where do you start? A viewfinder is a useful tool. By looking at the landscape through a frame, you can see which sections are potentially interesting. If you haven't got a viewfinder, make a frame of the thumb and forefinger of both hands and peer through that.

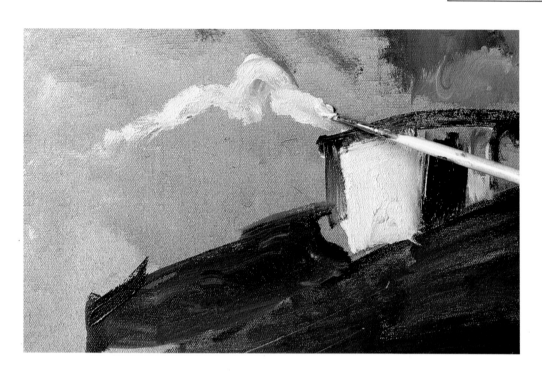

△ *The sky was constantly changing. For a few seconds the sunlight on the clouds created this strange effect which caught the artist's attention. He recorded it, and would decide at a later stage whether to retain it or not.*

▽ *The broad forms are established very quickly with fresh, juicy paint. The artist wants to get as much as possible down quickly and to cover the canvas.*

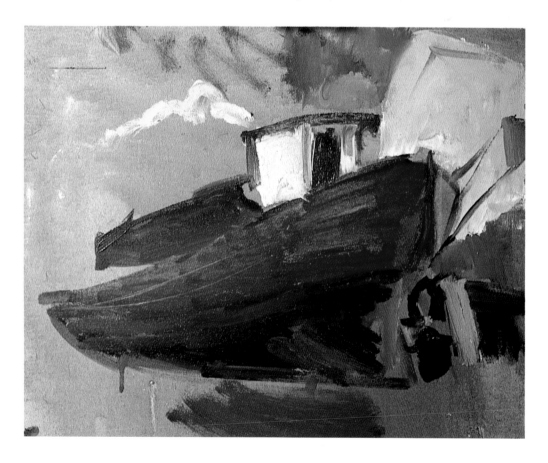

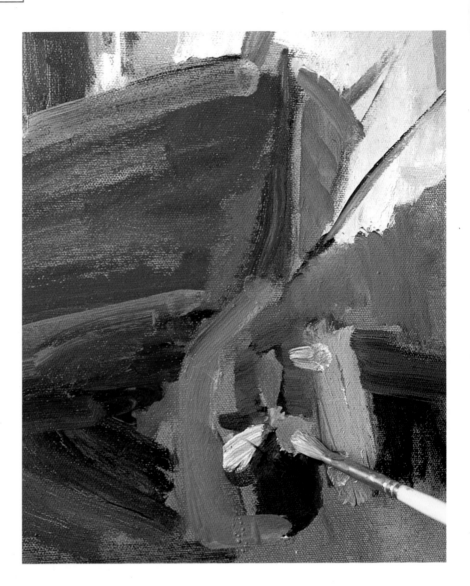

▷ *In this detail you can see just how descriptive the brushstrokes can be. They follow the forms of the hull and the propeller, and capture a sense of the speed with which the artist is working.*

Starting to paint

The idea of this exercise is to get a painting down as quickly as possible to make an accurate record of the scene and your response to it. Start with a toned canvas, using a neutral mid-grey tone or raw sienna. This should be prepared at home and allowed to dry. Acrylic paint is ideal as it dries within an hour.

An *alla prima* painting is painted working wet-into-wet and is completed in one go. Get as much as you can down as quickly as possibly, and don't concentrate on one part of the painting, but let your eye dance about the entire picture surface and out to the edges – work to all four corners of the painting and keep the whole thing going. You'll find that bits of colour from one part of the painting are picked up on the brush and travel over to another part of the painting. Don't worry about these accidental bits of colour; they will hold the painting together and actually imitate the way light bounces about in nature, reflecting colours from one surface to another.

Simplify and generalize as much as you can. Let a mass of green stand for a clump of trees and a band of another green for fields. By using a richer, lusher *mélange* of texture and colour in the foreground, you create the visual illusion that it is nearer to the viewer and thus imply a sense of space in the painting. Once you have completed this simple painting, you may decide to elaborate it, but quite often you will find that what you have down already is quite sufficient.

You don't always have to travel far from home to find a landscape subject for an on-the-spot *alla prima* painting. Your garden, a local park or even the view from a window will provide you with

plenty of material. And don't paint it once and think, 'Well, I've done that, what next?' Paint it again and again. It will change with the weather, the season, the time of day, the way you feel, even the size of canvas or brush you use. You can often learn more by painting the same subject over again than by painting different subjects all the time.

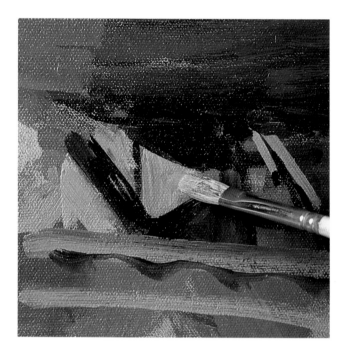

Preparatory sketches

I asked Stan Smith to do a painting of the boatyard in which his studio is located. The weather was inclement and time was limited, so he had to work directly. He started by making a series of quick charcoal sketches to investigate the possibilities, and decided to make a rather dramatic painting by cropping in to a single boat.

△ *Artists are often thought of as rather otherworldly people, but in fact most of them are immensely practical. Without a sketching easel to hand, Stan propped his canvas on a discarded shopping trolley.*

△ *These touches of local colour add zest to the painting. Again you can see the way the strokes of colour are used to build up the forms in a very concrete way. The paint is wet and slippery and some of the brushmarks skid across the surface.*

▷ *The artist continued to develop the entire picture surface, laying in the sky in mixed greys, some warm, some cool. The paint is applied loosely in patches, the brush changing direction, following the forms of the clouds.*

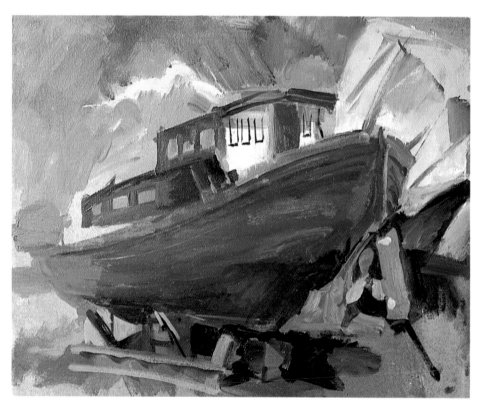

The boatyard

The weather on the chosen June day was unseasonal to say the least – bright, sunny spells interspersed by slashing rain and hailstones which thundered on the studio roof. Stan was phlegmatic about these adverse conditions, dashing out to paint when the sun was shining and working on something else in the studio when driven indoors.

In the limited time available a direct approach was the best, in fact the only, solution, so he worked on to a toned canvas with no underpainting. Using a brush and creamy paint mixed with only a little turpentine, he established the broad forms of the boat, the sky and the background. He worked quickly, progressing the whole painting at the same time. It is very important to keep the whole painting moving. If you pay too much attention to one part of the picture, it will become too detailed, and this will distract the viewer's attention and unbalance the composition. It will also waste time.

The secret of good *alla prima* painting is to keep the paint as fresh as possible. Study the subject carefully, mix the colour on your palette and put it down. You can adjust colours, scrape them off or add more on top, but try not to move the colour around too much on the canvas or it will look tired and overworked and the colours will become sludgy. Look at the details of this picture carefully and you will see that though the overall colour is

△ *With a fine brush – a rigger – the artist draws in linear details. The paint surface is still wet, so he applies the paint very lightly, drawing the brush across the surface.*

subtle, each dab of colour is clean and fresh and has been put down crisply and with conviction.

Stan used a limited palette: light red, raw umber, oxide of chromium, cobalt blue, Prussian blue, alizarin crimson, cadmium red, yellow ochre, black and white. He found his colours by making careful judgements, comparing and contrasting one area of colour with another. Take the hull of the boat, for example. It is red. You might be tempted to put down a slab of red paint and work white and black into it to make some areas darker and others lighter. The result would be a dull paint surface and a very unconvincing image. Study the photograph of the boat. The prow is a very rich, warm red, the side is slightly paler and cooler, and the shadow underneath is bluey purple. Concentrate hard and put down exactly what you see, no matter how odd it seems. Squinting helps, especially in bright light. When you stand back to view the painting after a period of work, you will be pleasantly surprised. All those separate patches of colour which look meaningless when viewed from up close really do look like the hull of a boat.

▽ *Below the hull there are planks, barrels, stones and bits of discarded plastic. The artist develops this area of the picture, adding bright tones of cadmium yellow and cobalt blue, and raw umber and burnt umber for the darker tones.*

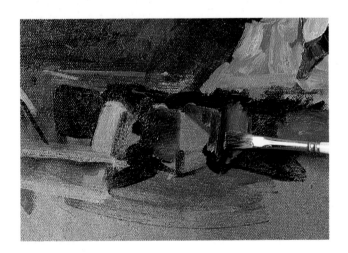

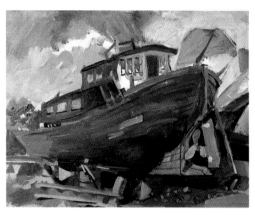

▽ *Again a section-by-section comparison of this picture with the previous stage will reveal the way the artist has continued to develop the whole painting. Some of the tonal contrasts in the sky have been softened, details of the boat have been made crisper and the brightly coloured canvases around the boat have been resolved, adding an important touch of accent colour. By adding details to the foreground around the propeller, the artist brings this area to the front of the picture plane, creating a sense of recession. The painting is wonderfully atmospheric, capturing the lowering sky, clear light and colour effects created by the peculiar weather conditions.*

△ *Compare this with the earlier picture and you'll see that the whole painting has been developed. The trees on the left are more detailed, the polythene-covered boat behind has been redrawn, the sky reworked, and the foreground and the area under the boat have been worked into.*

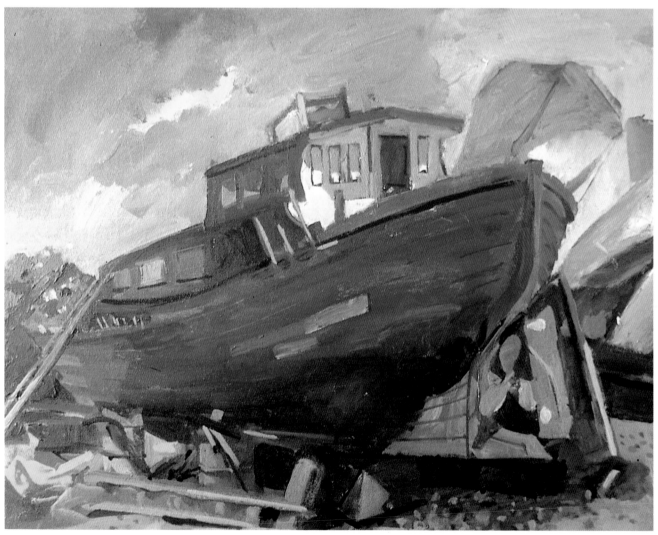

Painting
Still Life in Oils

Jenny Rodwell

CHAPTER 1 CHAPTER

Introducing still life

●

STILL LIFE developed almost unnoticed in the quiet corners of great paintings. Early pictures often depicted figures from history or religion, sometimes caught up in dramatic events. But placed on the tables and shelves, or maybe strewn on the floor, you will notice pockets of tranquillity – clusters of objects which give a sense of place and identity, just as a silent collection of possessions can vividly recall an absent person.

Long before the term existed, therefore, artists had been unwittingly painting still lifes. As religious themes ceased to be a central feature of most paintings, the artists began to focus on details in their own right – not only the landscapes, flowers and buildings, but also the vast range of objects which became the subjects of still-life painting.

Still life is now so generally accepted that many people, when they first think of 'art', see in their imagination some of the famous clichés of the genre – the fruit, the fish, the game birds and so on – that grace so many art galleries. Such old favourites can still be painted, with a fresh approach, but you need not be restricted: as contemporary paintings show, the range is infinite.

94

●

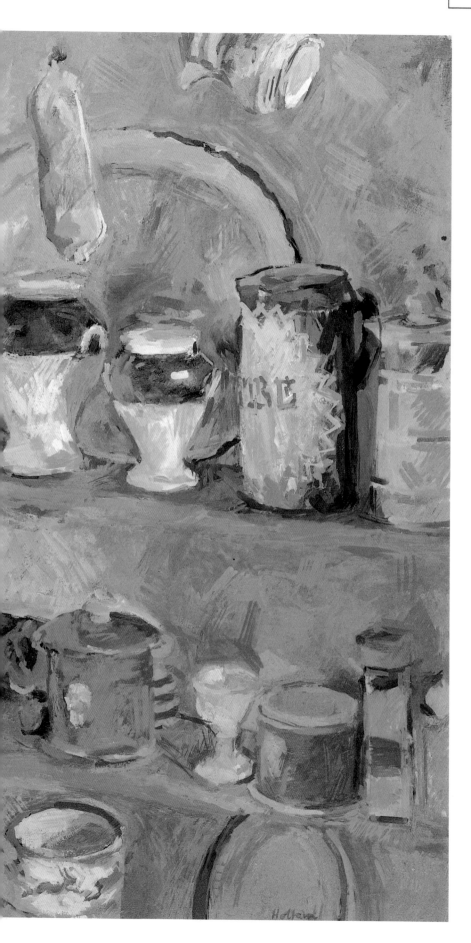

Early still lifes featured as details in religious and figure compositions. Often they were domestic objects – books laid out on a desk, or other items chosen to provide a clue as to the identity and occupation of the subject. In this informal arrangement, artist Brenda Holtam takes a detail and turns it into a painting in its own right. The dresser was painted exactly as it was, with the mugs, plates, jars and food randomly placed on the shelves. Nothing was moved or rearranged in order to manipulate or alter the composition.

THE VERSATILE GENRE

Still life suffers from much the same problem as Shakespeare. It is regularly 'done' – perhaps overdone – in school, so children grow up assuming it is boring. Later, however, if you are lucky, you discover its variety and worth. But because of its common classroom use, still life is regarded as academic and so takes on all the negative feelings associated with school. Familiarity, it seems, has bred contempt.

Why has still life been such a popular subject in the classroom? The main answer lies in its convenience and versatility. You do not have to wait for the weather; you do not have to trek into the countryside to seek landscapes; you do not have to pay for models to remain static for hours. Still life is chosen for art students in the classroom because it seems to be a simple matter of collecting interesting objects, spreading them on a table and letting the students get on with it. Some art teachers do operate this way; however, luckily many realize that still life has much more to offer.

In fact, still life is a very creative and personal field. It enables you to take objects and artefacts you like, and with which you have associations, and extend these into painting. You are not obliged to paint something with which you are uncomfortable. This does not necessarily mean that the objects should suit your personality, but rather that you are free to choose bright, cheerful subjects if you like them, or to pick atmospheric subjects or simple, formal shapes if these are more to your taste.

Still life and oils

Historically, still life and oil paints go together. Still life only really became a genre in its own right during the sixteenth century; it was almost always carried out in oils. It is mainly a northern European genre, coming into its own after the Reformation, when religious paintings almost disappeared.

Even then the subject matter was not painted for its own sake but was mainly symbolic. Many of these early still lifes were concerned with the transience of life, hence the commonly depicted objects like skulls, candle snuffers, butterflies, mirrors and so on.

Early masters

Wandering round any of the major art galleries, you can see not only how many still-life paintings there are but also how very different they can be.

During the sixteenth, seventeenth and eighteenth centuries, still-life paintings made considerable strides. They moved on from grim reminders about the shortness of the human lifespan to statements about how good that short life could be. Piles of fruit, food, silver tableware and other emblems of an opulent lifestyle are common features, particu-

▽ **Pattern and texture** *A varied subject gives the artist plenty of scope to concentrate on those elements which interest him most – in this case the colours, textures and pattern of a still-life arrangement.*

▽ **Colour and shape** *Celeste Radloff finds in her subject a series of flat, geometric shapes which are painted in pure, vivid colours. The perspective in this painting is flattened, so there is no illusion of three-dimensional space in the composition.*

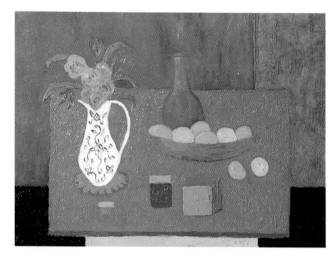

larly in paintings from France and Italy. Musical instruments, furniture and even the dogs and servants are included in many of these grand pieces.

More recently, still life has cropped up in all the major art movements. Notable exponents were the leading Cubists, Picasso (1881–1973) and Braque (1882–1963), whose major works were almost always based on arrangements of objects. In their search for colour and light, the Impressionists too brought still life into the centre of their world. Post-Impressionist giants such as Cézanne (1839–1906) and Van Gogh (1853–90) have made still-life paintings universally known and admired. They invited us to see apples, sunflowers, wooden chairs – everyday objects – in a new and magical way.

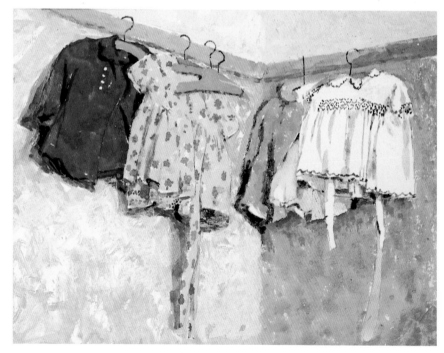

△ **Individual viewpoint** *A charming still life by Margaret Green. A child's dresses hang from a picture rail in the corner of a room. They are higher than the artist's eye level and she looks up at the subject in order to paint.*

97

THE PERFECT SUBJECT

For the newcomer to oil painting, still life is the best possible subject. Not only can you choose exactly what you want to paint, but you can arrange the subject as you like and can leave it alone for as long as it takes you to paint it. You are in absolute control.

Still life is especially suited to oils, which can be a slow painting process. With oils, it is usual to do a painting in several sittings, leaving the paint to partially dry overnight and then continuing next day – or whenever you can. With still-life painting, the subject will be there when you are ready to continue. The only unstable factor is the change in light during the day. There are suggestions later in the book on how best to cope with this.

Be selective

When painting a landscape, figure or portrait, you are stuck with whatever is in front of you. And because these subjects are rarely straightforward, it is up to you to select and simplify in the painting. The selection must take place as you work.

But with still life, if the subject is wrong, it can usually be changed. Objects can be removed, added and changed round.

Still life plus other genres

Still life embraces all other genres – as you can see from the pictures here. Often, other factors are added, so that a painting might not just be still life. It might incorporate a landscape, interior or human portrait. We frequently see still lifes, for instance, with a window or door in the background. The still life is thus placed in a broader context and we can see past the objects into the world beyond.

When still life encroaches on figure painting and people enter the picture, we find that the objects become more personal. They remain central to the picture, yet they are seen as belongings, or as part of a home.

Whole or part

Some still-life subjects take in a whole section of a room. Rather like a wide-angled lens, they might

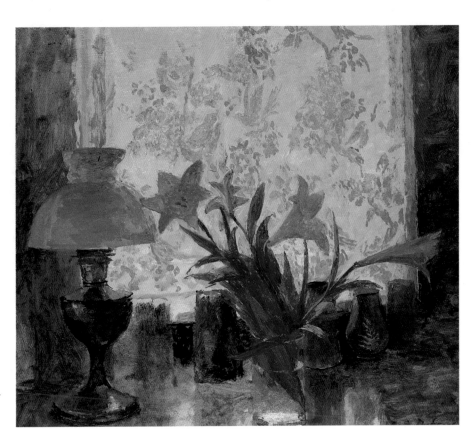

◁ **Subtle whites** *The choice and composition of these objects plays an important part in the finished painting. Fred Dubery chose objects for their light tones and subdued, warm colours. The arrangement includes a variety of different whites, including the lilies and floral curtains.*

▷ **The impact of colour** *When Lionel Bulmer collected these objects together, colour was uppermost in his mind. Each item in the painting – including an exotic bird with vivid plumage, a patterned wall hanging and an eye-catching cloth – was chosen for the vivid contribution it made to the overall composition.*

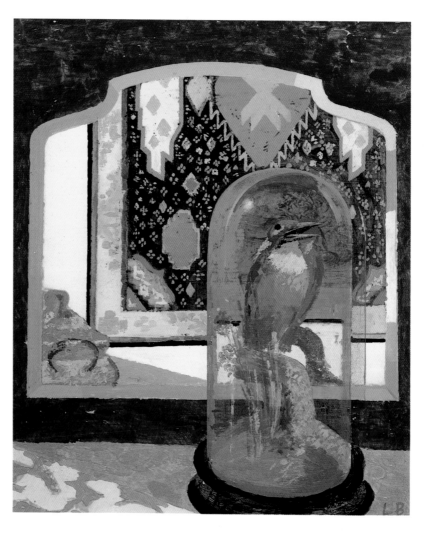

include furniture, doors, windows, etc. In this way, a whole interior becomes a kind of still life, the study of a mass of objects relating to each other – a frozen moment in a room, perhaps. Even though the emphasis is on the objects themselves, the artist in this case would be concerned with the relationship of those objects not only to each other but also to their environment.

Conversely, a still life can be a microscopic part of a whole – the equivalent of viewing the subject through a magnifying glass. It might be a single flower or any other small object, enlarged so that every detail is visible.

Fruit, flowers and gearboxes

Jugs, jars, flowers and fruit are often associated with still-life painting, but an infinite range of objects can be gathered in. Natural forms such as shells and driftwood are fascinating subjects – and do not forget the mechanical world. Car parts and pieces of machinery are as exciting to one artist as a vase of flowers is to another.

Often the best still-life subjects are things that are so much part of our daily lives we have almost ceased to 'see' them. The still life gives them new meaning. Thus many of the objects we choose to paint are close to hand.

One of the most fruitful places to explore is the kitchen, as it is filled with an amazing array of shapes – probably why cooking utensils are among the most frequently painted subjects. Because they are so versatile, we turn to them again and again, and still find something fresh and interesting to paint. Some artists repeatedly paint the same item. It is not just a particular white jug or red ladle you are painting for the umpteenth time; it is an object that has a certain shape and colour, and that looks good in many arrangements.

PRACTICAL TIPS

Start simple and let this govern the choice of subject as well as your approach to painting. And be aware of the practical points that could cause hitches with even the simplest of choices: for instance, still-life objects do not always stay still – they can rot, droop and wilt.

The examples in this book range from very simple – a single piece of fruit – to quite complex arrangements. You too should begin with simple paintings and build up to more involved subjects as your skill develops, in a progression similar to the structure of this book.

In the pages that follow, a particular technique or aspect of still-life painting is demonstrated and then linked to a selected, appropriate subject. The subject for neutral colours, for instance, is a collection of shells. Complementary colours are then demonstrated, with oranges against a blue background.

You should adopt a similarly structured attitude, and make the subject matter work for you. In this way, you can decide on a theme before setting up the arrangement. If you want to use complementary colour, then choose your objects with this in mind. If you want to paint an arrangement of textures, then collect textured objects and nothing else. Work starts not with the first brushstroke but as you look around for something suitable to paint.

Despite the accessibility of objects for still-life painting, there are certain practical limitations which can be all too easily forgotten. Be aware of these from the outset and you will not waste time once you have started painting.

Food and flowers

If food, flowers or other perishable things are part of your still life, then you have to plan your work a little more carefully. Cut flowers can last several days, but they tend to open up in heat and light, and close as the light goes. They also droop and change position remarkably rapidly. These changes are not normally noticeable, but it is irritating when

painting – you start with a closed tulip, for instance, only to find it has opened up and bent over a few hours later.

Painters sometimes replace wilting blooms with fresh ones. Others have been known to support the stems of the flowers with wire, but this is a fiddly business. Probably the most practical solution is to stick to potted flowers and plants, where change occurs much more slowly.

Food can also be tricky. Fish often starts as a favourite with still-life painters. Unfortunately, it is a particularly difficult subject, because it goes off

Continuity

If you have to remove part or all of your arrangement before you have finished work but intend to reassemble it at a later date, it is a good idea to mark the positions of the objects. Small pieces of masking tape adhere to cloth as well as to hard surfaces, and do not leave a mark.

If you do forget to mark the subject, your arrangement can be reassembled by referring to the painting. This takes patience. You will find it necessary to keep moving the objects, sometimes by a fraction of an inch. Do this, then keep walking back to the painting to check.

◁ **Still life with figure and landscape** *A truly 'combined' subject, the table scattered with bottles and jars dominates the foreground of this painting by Ken Howard. The viewer's eye is drawn back into the picture, first to the bed and reclining figure, then to the landscape – the view through the window.*

▽ **Composition and colour** *Jack Millar contrasts the strong, warm colours of this still-life arrangement with the cool lemons and greens of the view through the window. The window frame and the dark shape formed by the plate, vase and flower pot are important structural elements in the composition. Paint is applied as small dabs of pure colour.*

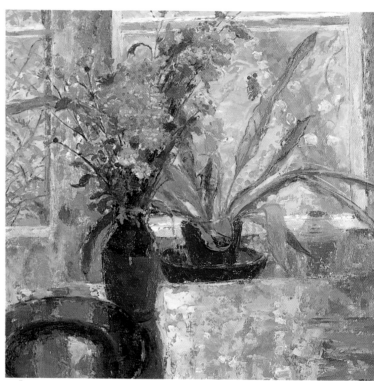

and starts to smell – very noticeably if you are closeted in the same room. You can stretch its painting-life by a day or two by putting it in the refrigerator between sessions, but this is obviously a temporary expedient. Fresh fish are very shiny, but their glossy surface and colours go dull after a short while. This can be remedied by frequent spraying with water or rubbing with oil.

Not all foods are so problematic. Bread and other baked items have to be fresh only if you want to eat them! For a painting, they can go rock-hard without changing appearance.

CHAPTER ② CHAPTER

Before you paint

WHEN YOU PAINT or photograph a landscape, you automatically 'select' an area which will be portrayed. This is known as the composition and is a vital part of landscape art. You cannot change the landscape in front of you, although you can simplify it and change it in the painting. Still life, however, grants you enormous freedom. The composition is actually created by the artist before painting starts. Even pictures which depict an apparently accidental array of objects have often been carefully arranged.

This arrangement of objects is inseparable from the painting process. You are constantly thinking about how you will translate the composition into paint. Other important things need consideration before you apply the paint. This chapter tells you how to arrange your objects. It analyses the importance of composition, using photographs of objects set up in different ways and with different emphases, taking care not to lay down rigid rules but pointing out possibilities. The chapter also discusses lighting. It covers the preliminary process of sketching and how to enlarge sketches into full-sized compositions ready for painting. Perspective – an aspect which many do not expect to associate with still life – is considered as well.

Lionel Bulmer interprets the subject here in a creative and personal way, with emphasis on both the colour and pattern. The subject is handled in a stylized rather than a literal manner, with deliberately flattened perspective and heightened colours.

ARRANGING YOUR SUBJECT

Composition is a vital part of a picture, and the arrangement of objects in a still life is a vital part of the composition. If you give no attention to this, the picture could end up dull no matter how well it is painted. In still life more than in any other sort of painting you are in control of what you are painting, and it is a pity to waste this opportunity.

Beware, however, of overdoing this aspect. Your subject may be quite simple – a few kitchen utensils or some pieces of fruit, perhaps. Even so, the possibilities are limitless, and you could end up taking more time to arrange the objects than to paint the actual picture. You need to be decisive as well as creative.

One good idea: tip all the pieces haphazardly on to a surface and take it from there. Move the objects around until you have an arrangement of shapes, colour, tone and texture you like the look of. Then start work before you lose confidence in the result.

There are no rules about still-life arrangements. You can see simply by looking at a subject whether or not it appears crowded, clumsy or contrived. However, as a general guide, objects look better if they are displayed in a natural manner, and for this reason geometric or symmetrical arrangements are usually best avoided – unless that is the particular effect you are seeking to create in the picture.

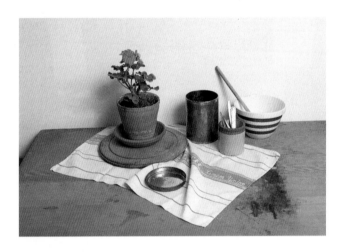

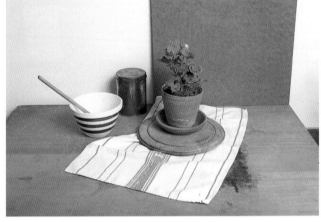

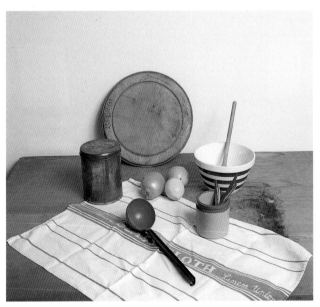

△ ◁ *All the objects are arranged in a central cluster, with the white shape of the tea towel containing most of the darker shapes. There is no discordant element to take the viewer's attention away from the main group. The blue stripe leads the eye into the centre of the arrangement.*

△ *Again, the objects are arranged in a central cluster, but the artist has divided the background into two contrasting shapes – dark and light. This device breaks up the horizontal symmetry of the arrangement and provides a choice of background for the different objects.*

◁ *Here the white cloth is taken off the bottom edge of the arrangement, with the stripe and ladle handle positioned to lead the eye inwards towards the centre of the arrangement. The circular shape of the breadboard cuts into the white background, so transforming a blank wall into a positive shape in its own right.*

The illustrations on this page show a selection of objects arranged in different ways, any one of which would be suitable for painting. The artist started off with a collection of kitchen items and laid them out in various ways. In some arrangements, everything is clustered in the centre; in others, one or more of the objects is only partially visible, with the rest being taken deliberately outside the picture area. Sometimes the artist uses all the objects; at other times certain things are discarded in order to simplify the subject.

Contrast and colour

As a general rule, the more variety you can include, the more interesting the subject will be. A mixture of light and dark objects, for instance, gives a greater tonal contrast to the painting than a selection of things which are all either light, dark or medium-toned. This is why the tea towel here is so important. The artist uses it as a stark white shape to break up areas of darker tones, either in the wooden table top or in the background.

The colours of the objects themselves are also important. If they are all warm reds and browns, for instance, the painting could be boring. As soon as you introduce a touch of blue or another cool colour – as the artist has done here with the stripes in the tea towel and the blue on the pudding basin – the whole arrangement comes to life.

Shape and texture

Inevitably, any subject is made up of lots of different shapes – including the shape of the table top and the shape, or shapes, of the background. You can control and change all these by moving objects around, placing one in front of another, altering the distance between each one and so on.

You can change the background by dividing this into two or more shapes, as you can see from the photograph, or by breaking up a bland expanse of background with a strong shape, such as the round breadboard illustrated.

A variety of shapes and textures usually makes for a more interesting still life and certainly gives you greater scope when you are putting the subject together. These kitchen utensils include angular, cylindrical and elliptical shapes, surface textures are reflective metal and porcelain, matt wood, soft fabric and the irregular natural surfaces of the fruit and foliage.

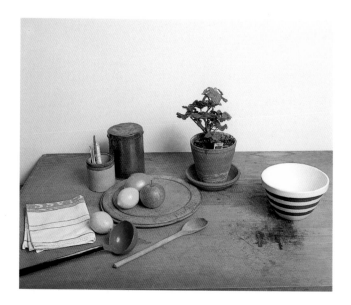

△ *The objects are spaced further apart. A scattered arrangement can sometimes isolate the objects and produce a bitty composition, but here the arrangement is held together visually by the strong diagonal movement of shapes from the bottom left-hand corner which leads the eye firmly into the centre of the composition.*

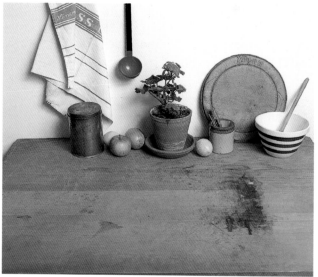

△ *Here the artist has created an unusual horizontal arrangement which obliterates the straight dividing line between the white background and the table top. Because there is very little sense of space in a single row of objects, the artist has created space by including a lot of empty foreground in the composition.*

SCALE AND PROPORTION

You have arranged the pieces and the background, but there is another important factor to consider when planning your composition, and that is the canvas itself.

Choosing a shape

The shape of your canvas is part of the composition. A rectangle is the most popular, because it is versatile and easy on the eye. You can also choose whether you want to use the rectangle vertically or horizontally, and this choice depends on the subject and how you want to depict it.

Bought canvases generally come in standard rectangular sizes, but if you stretch your own and buy your own stretcher pieces (see pages 26–7), the scope is wider. It allows you to make square or exaggeratedly long rectangles to suit your exact requirements.

The painting on this page was done on a bought, standard, rectangular canvas which suits the subject very well as the artist has painted it. But you can see from the illustration that the same subject could be treated in many equally interesting ways, simply by working on a different shape.

Big or small?

Most artists develop a preference for painting on a particular scale, and this need not necessarily be dictated by the size of the subject itself. One painter will feel comfortable working on a tiny canvas, even when painting comparatively large objects, such as giant plants or pieces of furniture. Another will take a small single item, such as a shell, and choose to paint it on a gigantic scale with large brushes in order to explore and emphasize the particular forms and patterns within the subject. It is very much a matter of personal taste.

The newcomer to still life, however, will probably find it easier to avoid extremes, at least initially. Most of the demonstrations for this book were painted on canvases measuring from 16 × 12 inches (40 × 30 cm) to 36 × 24 inches (90 × 60 cm), and certainly anything between these sizes is manageable and quite portable. Later you may want to experiment with larger or smaller paintings. Your work can only benefit from trying out new dimensions.

Infinite alternatives *As you can see from these thumbnail sketches, there is no single 'correct' way to compose a picture. These sketches show just a few of an almost infinite number of possibilities. Your painting may be rectangular or square, upright or horizontal; the subject can be painted in its entirety, or you may decide on a close-up, using just one part of the subject.*

LIGHT SOURCES

A still-life subject can be totally transformed by a changing source of light or type of lighting. Those who have already tried to paint by natural light alone will have found to their irritation that sunlight is inconsistent. Daylight changes constantly – disappearing altogether just when you are in the middle of a particularly important piece of work.

One of the great advantages of still-life subjects is that they are stationary and unchanging. Flowers and food do gradually deteriorate, but even so they remain paintable for a reasonable length of time. This stability allows you to paint at odd times of the day or night if that is the only time available. But this advantage is lost if you are totally dependent on the vagaries of natural light.

With still life more than any other subject, therefore, it is well worth paying some attention to lighting, both for your own convenience and for getting the best from the subject.

Lighting the subject
No electric lamp is exactly the same as daylight, but 'daylight' bulbs produce a reasonably similar effect which at least has the advantage of consistency.

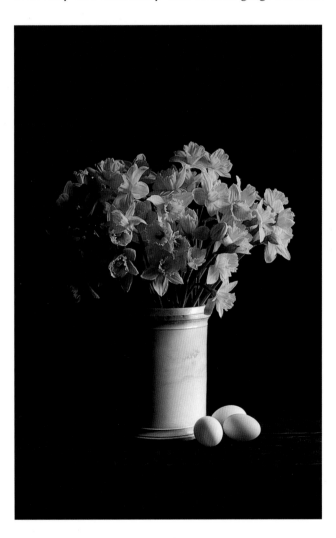

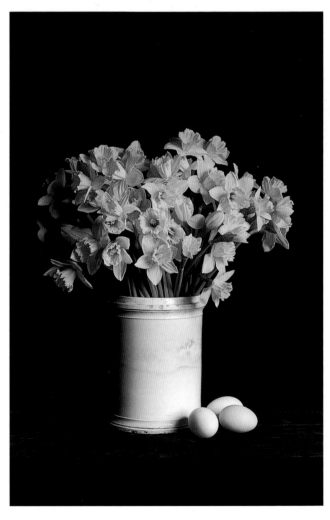

Transparent or translucent objects are less affected by the direction of light than opaque objects. These four illustrations show a still-life arrangement illuminated from different directions.

◁△ *Side-lit*
△ *Two-thirds side-lit*

These are available at art shops and most electrical shops, and can be used to replace natural light totally or partially. If you like to paint through the day and into the evening, a daylight bulb near the window can take over when the sun goes down without changing the light source and without affecting the shadows and highlights on the subject.

Many artists are happy to use electric lighting to illuminate their subject, preferring the warm tones of an indoor lamp to the cooler ones of natural light. Use an ordinary household lamp, spotlights or any other type of available lighting, arranging these and directing the light to suit the subject.

With spotlights and other direct lighting it is possible to change the colour emphasis and atmos-phere of a subject by placing a tinted filter over the bulb. The filter colour should not be too dramatic, but a pale pink or amber, for instance, can saturate your still life with a warm glow which will affect the overall painting.

Light to work in

Apart from lighting the subject, you also need a good source of light in which to work. Colours look completely different when seen in different lights, so if you start work in daylight you cannot easily change to electric lighting without affecting the colours in the painting. Again, a daylight lamp is a useful stand-by and will ensure colour continuity throughout the picture.

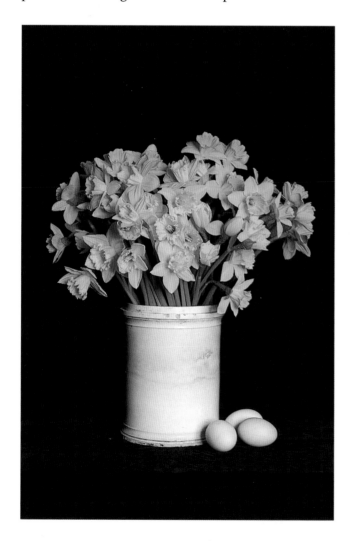

△ *Front-lit*

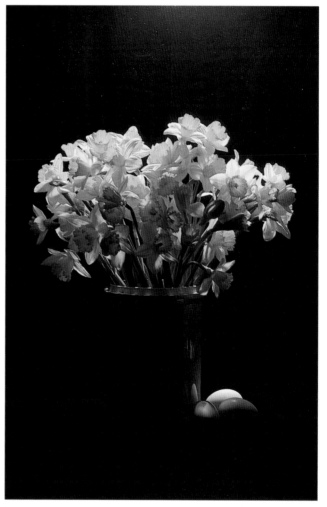

△ *Back-lit*

SKETCHES

There is more than one way of looking at a still life, and the best way to explore the variety of possibilities is to make sketches of the arrangement before starting to paint. This forces you to look for new things in the subject and to consider it from a number of different aspects and angles.

Ways of seeing

Walk around your still-life subject. You may find it is more interesting from the side than from the front. The composition might also look better from above or below, so experiment with your elevation. Keep an open mind at this stage, and do not be afraid to try out new ideas.

Our artist made three sketches of the still-life arrangement shown here, looking at the subject from various angles and exploring different elements and even materials. Each sketch shows the subject in a new or unusual light. Each one also tends to emphasize a different aspect of the subject, which may or may not be included in the final painting. They have served to broaden the artist's choice.

Sketching materials

Pen and wash proved the ideal method for capturing the tonal contrasts in the composition. A pencil sketch concentrates on the arrangement of both the various shapes within the subject and the incidental shapes these create in the background. Another sketch, done with graphite, shows the subject from above, with the artist looking down at the objects on the table top.

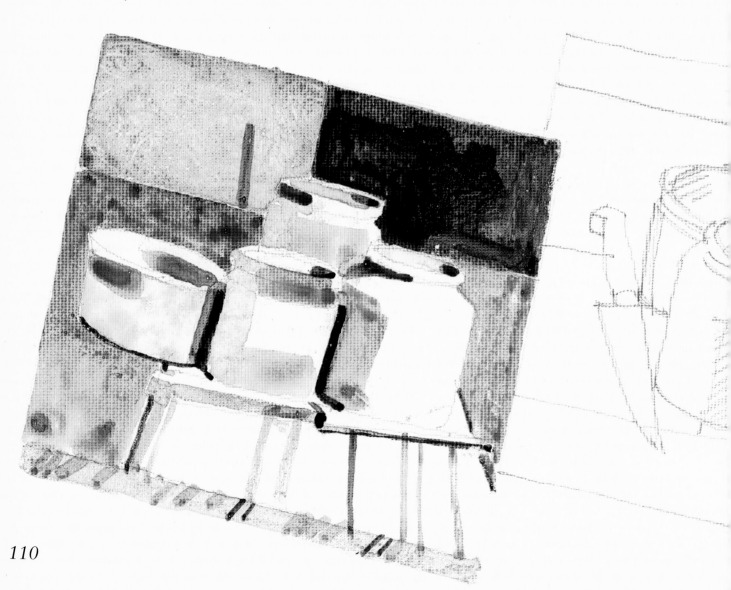

Almost any drawing or writing tool can be used for sketching – anything, in fact, that will make a mark. Pencils, ballpoints and fountain pens are all useful, and the sorts of thing we can lay our hands on at a moment's notice. Felt-tips, typewriter correction fluid and highlighter pens are among the more unlikely materials that have found their way into sketchbooks.

Lively sketches

You will probably be surprised at how good your rough sketches look. After all, they were done so quickly, and without any real thought or planning! Actually, it is this very lack of planning that makes sketches look so fresh and lively. The next step is to make sure you retain this spontaneity when you start to paint.

Left to right *Pen and wash, drawing pencil, graphite stick.*

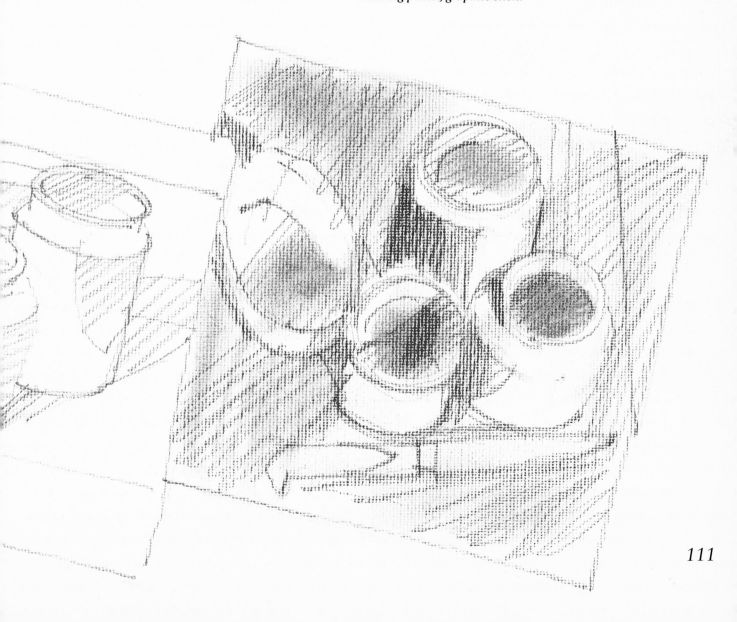

FROM SKETCH TO CANVAS

If we are going to keep our painting as fresh as a sketch, let us consider for a moment how we worked when sketching, so that we can capture the vitality that finished paintings sometimes lack. If the sketches did look lively, ask yourself why they were so unselfconscious. Perhaps it was because the sketches were a means to an end rather than the end itself. In other words, it did not matter whether they looked good, as long as they did the job. The lines, therefore, were confident and the drawing flowing and strong.

When confronted with a pristinely white canvas, however, the situation changes completely. Because this is the 'real' thing, it seems somehow important to be extra careful and to avoid making a mistake. Sadly, this caution often proves to be the biggest mistake of all, because the initial stage is that of transferring and enlarging a small sketch on to a bigger canvas. If the result is a timid drawing, the painting can look stilted from the outset.

Freehand drawing

Experienced artists often draw directly on to the canvas, referring to the sketch as they draw. Often they deliberately use paint or a thick stick of charcoal to avoid making the drawing too tight. They seek to work in the same free manner on the larger drawing as they did on the original sketch.

For the beginner, an over-cautious approach can lead to the enlarged drawing being too small in relation to the canvas, resulting in too much empty space around the subject. The remedy is to treat these background areas as actual shapes, paying as much attention to them as you do to the rest of the subject. These important background areas are often referred to as 'negative shapes', and there is more about them on pages 136–7.

It takes confidence and practice to make a freehand drawing directly on to the canvas in this way. But if you choose chunky charcoal or oil pastel, and refer frequently to your sketch as you draw, it is quite possible to copy and enlarge the

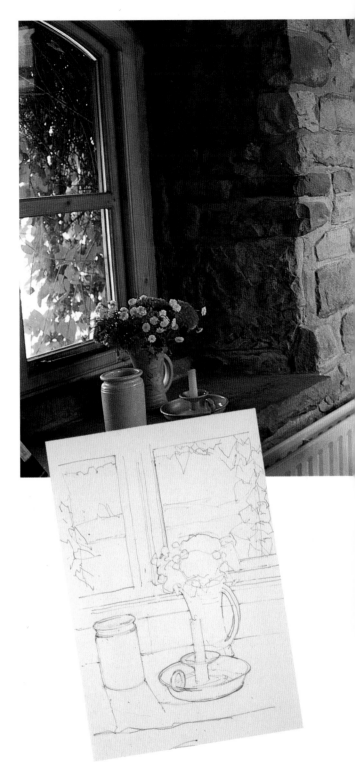

△△ **1**　*Instead of painting directly on to the canvas, the artist starts by sketching the subject. In this case, several sketches were made before a satisfactory composition was decided on for the eventual painting.*

△ **2**　*The selected sketch may need strengthening so that the lines are clear enough to be transferred by copying on to the canvas painting support.*

image without losing any of the freshness of the original sketch.

Using a grid

A more accurate method of transferring the sketched image on to a canvas is to use a grid. The grid should divide the canvas into a number of equal squares or rectangles. A similar, smaller grid is drawn on to the area of the sketch to be enlarged. The image can then be copied section by section on to the canvas. It is important that the two grids are proportionately equal, otherwise the enlarged drawing will be distorted.

As with freehand drawing, it is easy to be over-cautious when transferring marks on to a larger canvas. It is still important to draw with decisive, confident strokes. And these are easier to achieve if you work with a chunky medium that encourages you to draw boldly.

△ 3 *Using a ruler and pencil, the artist divides the larger canvas into a grid of equal sections. These may be square or rectangular, depending on the proportion of the canvas (in this case the canvas divides conveniently into twenty squares). A similar, proportionately smaller grid is also drawn on to the sketch.*

△ 4 *Using the sketch as a reference, the artist then copies and enlarges the sketched image on to the canvas. The image is thus transferred section by section, with each section being accurately and proportionately reproduced on to the larger-scale support.*

113

THE IMPORTANT DRAWING

As with any subject, the still life must usually be drawn on to the canvas accurately before you can start to paint. True, some artists paint without making an initial outline drawing; they begin by blocking in areas of tone and colour without bothering about a line drawing. In these cases, the first stage of blocked-in colour is itself a sort of 'drawing', with the paint being applied thinly so that overpainting, changes and corrections are easy.

Generally, however, the first marks on the canvas will be a line drawing. It is important to remember that this drawing should be as minimal as possible – merely a guide to establish the subject on the canvas. The rest you can do with colour and a brush. There is absolutely no point in putting a lot of detail into the drawing, because this will be completely lost when you come to start painting.

The basic forms

If you look carefully, you will notice that most still-life subjects are composed mainly of simple geometric forms. Your drawing need do no more than establish these fundamentals on the canvas.

As you can see here, the first stage is to simplify each object as a very basic structure. The plate is basically an ellipse; the jug, a cylinder with an elliptical top; the book, a cube; and so on.

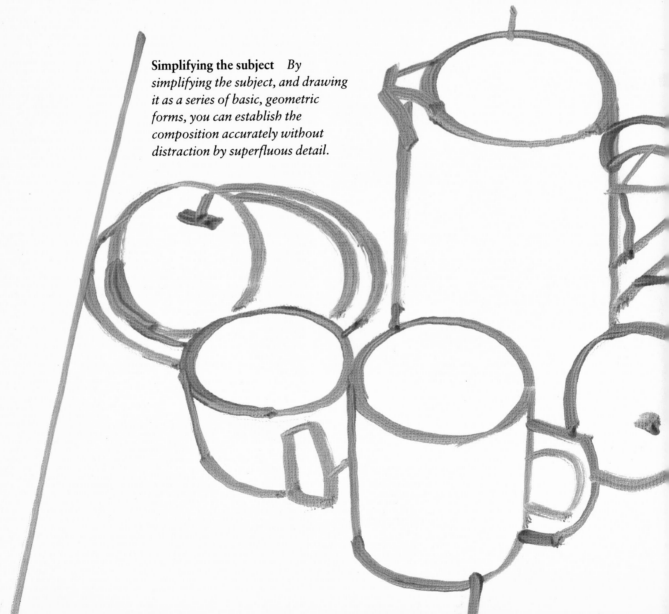

Simplifying the subject *By simplifying the subject, and drawing it as a series of basic, geometric forms, you can establish the composition accurately without distraction by superfluous detail.*

All these are particularly easy to simplify; but quite complicated structures, such as plants and other irregular natural forms, can also be broken down into a single, simple form or – occasionally – a series of simple forms. In fact, every item you will ever paint in a still life (or any other type of picture) can be treated in exactly the same way: it can be simplified.

Drawing ellipses

When looking at a flat, round object from the side, what you see is an elongated, oval shape, or an ellipse. In still-life subjects, ellipses occur time and time again – in bowls, jugs, plates, circular table-tops, mats and many other objects. They are not especially difficult to draw, but when drawn badly they are immediately noticeable and can spoil an otherwise successful painting.

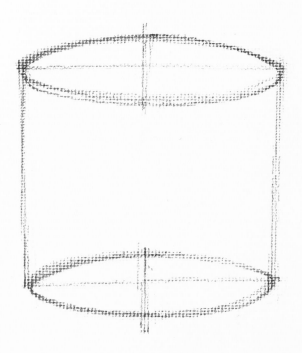

An ellipse can be drawn with the help of two construction lines, dividing the shape vertically and horizontally.

Therefore, it is well worth coming to terms with the ellipse.

The first thing to remember is that a true ellipse is symmetrical if it is divided vertically. If you draw a vertical line through its centre, the two halves become identical mirror-images.

If you draw a horizontal line through an ellipse, however, the two halves are not quite the same. You will notice that the top section is rather smaller than the bottom section, as well as being a slightly different shape. This is because the top section represents the part of the circle that is furthest away from the viewer's eye, and it therefore looks smaller as it recedes into the distance.

All this may sound rather complicated, but if you tackle the problem as the artist has done in the drawing here, using construction lines to help you with the rounded shapes, then an ellipse is actually quite straightforward. With practice, you will draw ellipses easily and automatically, without needing the structure lines at all.

PERSPECTIVE

When you paint three-dimensional objects on a flat canvas, you are actually creating the illusion of space and distance on a two-dimensional surface. Anything that contradicts this illusion will destroy the effect you are trying to create.

The crucial element in creating a special painting is accurate linear perspective: the idea that lines on the same plane will eventually meet at an imaginary point on the horizon – the 'vanishing point'. If they do not do so, the space in the painting will be distorted and look wrong.

Most of us are familiar with perspective diagrams showing streets or railway tracks disappearing as they converge. Consequently, we tend to associate perspective with landscape painting and forget that it is equally present in all other subjects.

Incidentally, we should also bear in mind the fact that the term 'horizon', as used by many artists, can be slightly misleading, because it actually refers to the eye level of the viewer rather than to any natural line. Thus the 'horizon' of a still-life painting is an imaginary line running at the same level as your eyes when you are in your working position.

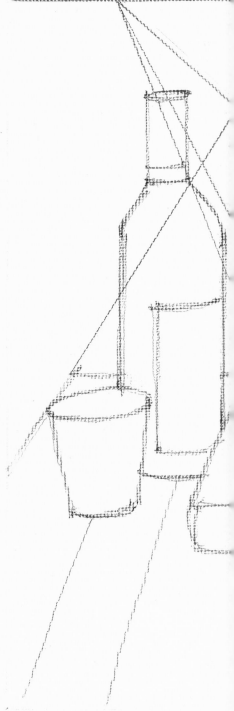

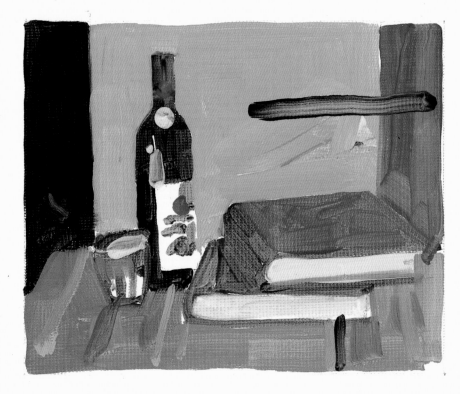

Linear perspective *The parallel sides of the table recede away from the viewer to meet at an imaginary point on the 'horizon line' – the viewer's eye level. This point of convergence is known as the 'vanishing point'. The parallel sides of a book or other object placed randomly on the table meet at a different vanishing point on the same horizon line.*

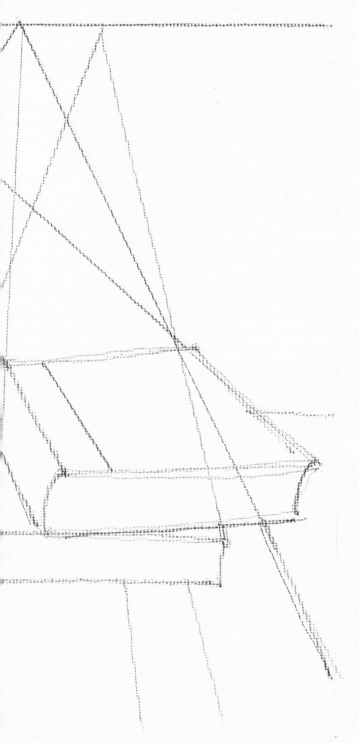

Table tops and surfaces

For the painter of still-life subjects, the most dominant example of perspective will probably be the table top or surface on which the subject is placed. If this is rectangular or square in shape, and the edges are visible in your composition, then the rules of perspective apply. You must make sure the edges of the surface are at the correct angle to each other, and that they converge at the same point on the imaginary horizon line which is your eye level.

If, as in the drawing here, a book or some other rectangular object lies on the table, then this too will have a vanishing point somewhere on the same horizon line.

Find the angles

There is a very simple way of drawing the edges of a table top or any other rectangular object at the correct angle. First, make sure you are facing the subject squarely. Now, take a pencil or brush and hold this up in front of you, tilting it sideways along the line you wish to draw. The brush or pencil must be held upright, at right angles to the floor. While tilting it sideways, do not move your brush or pencil either towards or away from the subject, but keep it upright, as if you were holding it against an imaginary windowpane.

Without altering the angle in any way, carefully lay the brush or pencil on the canvas along the line to be drawn. This should give you the correct angle and enable you to draw your table-edge in the right position, but you can always check the line by repeating the process.

CHAPTER **3** CHAPTER

Basic techniques

W<small>E HAVE</small> divided our analysis of techniques into two, this chapter covering the basic stages and Chapter 4 covering the more complex ones. Yet a textbook start has been avoided. This chapter launches you straight into the possibilities of texture, deliberately taking it to the extreme, with impasto – thick strokes of paint – applied with a knife. The objective is to explore immediately the furthest limits of texture-making. Even if you never again apply paint with a knife, you will be acquainted with the process, which is after all a classic oil-painting technique used by many professionals.

We then move into the decorative, again taking the subject away from the academic and showing where the limits exist and how broad they are. This allows you to go directly for bright colours, patterns and jazzy outlines, rather in the way that Matisse (1869–1954) and some of the Fauves did. It reinforces the important idea that there are lots of different approaches with still life. Starting with some very different ones will help you escape from preconceived rules of thumb.

The basic drawing techniques are not ignored, and the chapter demonstrates 'negative shapes', a useful way of learning to draw.

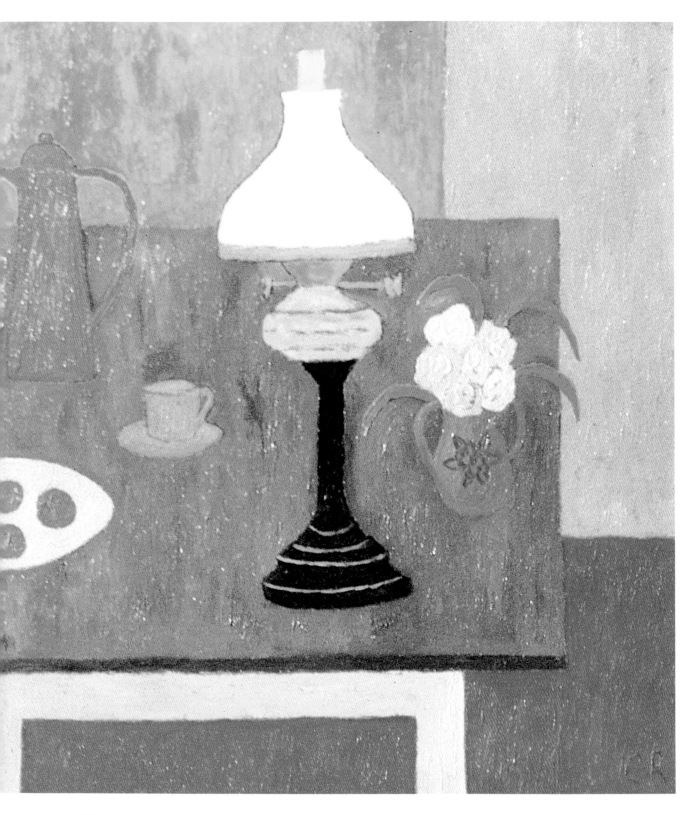

In this still life by Celeste Radloff, the blue table, white lamp, pink floor and green background are painted as an arrangement of bold, flat shapes. The emphasis here is on colour, and on how each colour reacts with its neighbours. Other pictorial elements – texture, tone and form – play a comparatively minor role in the painting.

119

TECHNIQUES

KNIFE PAINTING

Typically, a painting done with a knife has thick, built-up colours, often applied in chunky ledges or wedge shapes. The knife strokes are usually visible in the finished picture.

Impasto

Thickly applied colour is often referred to as 'impasto'. Paint thickness varies, depending on how you work, but knife marks tend to start with a squidge of thick colour which tapers off to a thin scrape, revealing the canvas texture underneath. These contrasting effects can be exploited to introduce different textures into your subject.

Thick paint gives lots of opportunity for scratching back to make patterns and textures in the painted surface. You can do this using the tip or side of the knife blade, or any other suitable implement.

There is an immediacy and directness about knife painting. The paint can be quickly mixed on the palette, and just as quickly and robustly applied to the picture, often using the same knife. This tends to make for fresh colour and a lively, interesting paint surface. The bolder you are, the more pronounced these qualities will be. In fact, the greater your confidence, the easier it is to paint with a knife. If you are fussy and pernickity about detail, if you try to get a neat finish on the paint marks, then not only does knife painting become unnecessarily difficult but you can also lose the rugged qualities inherent in the technique.

Size and shape

Because knives are available in different shapes and sizes, you can vary the scale of the paint marks to suit the size of your painting. A large area can be quickly blocked in using a long, broad knife, and the knife marks will be appropriately chunky to suit the scale of the painting.

For smaller pictures, painting knives are also available in quite tiny sizes. These enable you to work on a small scale without jeopardizing the

Laying colour
◁ **1** *The rounded edges of this oval painting knife give the wedges of paint a slightly concave shape, causing the edges of colour to stand up in pronounced ridges.*

◁ **2** *The same oval knife is used to lay long, overlapping blocks of colour. Again, the rounded blade creates a concave mark with ridged edges.*

Mixing paint
▷ *A flat palette knife is used for rapid and thorough mixing. The flexible blade enables the artist to scrape and press the red and white paints together until the two colours are completely blended.*

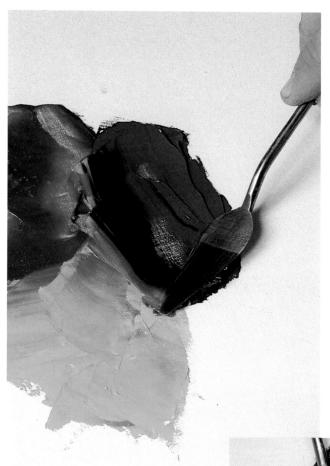

texture or spontaneity of the painting.

The shape of the knife you choose depends very much on the effect you want. As you can see from the illustrations here, an oval blade can be used to lay slightly convex ledges, while a blade with a straight edge creates a flatter effect.

Which type of knife?

Artists often 'break the rules' and use palette knives for painting. Remember, you can be flexible.

But although they come in different shapes and sizes, the painting knife and palette knife are the two basic knives used. Both have flat, flexible blades. The painting knife has a cranked handle, making it easy to apply flat colour. Palette knives are rather like the metal spatulas used in cooking, and usually have long, straight-edged blades.

Palette knives are designed for mixing colour on the palette, and for scraping off unused paint at the end of a day's work. The blades are easy to wipe, and the knives make the mixing and scraping less messy than they are when done with a brush.

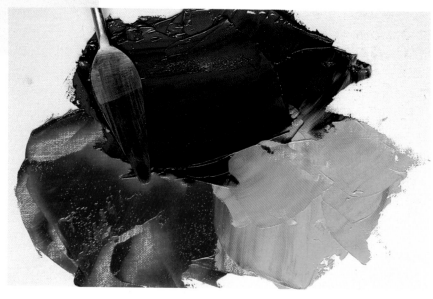

Overlaying

△△ **1** *Two or more wet colours can be used on top of each other, provided the applied paint is thick enough to cover the colour underneath. This layer of blue is too sparse to cover the colours underneath and goes muddy as it mixed with the underlying red and yellow.*

△ **2** *A subsequent, thicker layer of blue completely covers everything underneath, and the resulting colour is bright and pure.*

121

PROJECTS

GREEN APPLE

Chunky knife marks on coarse hessian might at first seem an unlikely way of painting this smooth, shiny cooking apple. In fact, no approach could be better. The solid wedges of colour are effectively used to simplify and describe the light and shade on the rounded fruit. And the open weave of the hessian background provides an attractive textural contrast in a painting that is otherwise built up entirely with knife strokes. The result is almost more 'apple-like' than the apple itself.

Light and planes

On a rounded object such as this apple, light and shaded areas merge into each other. There is no visible edge or outline to separate the shadows from the highlights. They have no actual shape.

When painting such objects, there are two basic approaches.

▽ **1** *Starting with the light tones, the artist begins by blocking in planes of pale green with a small, straight-edged painting knife. The pale green is mixed from viridian green, lemon and white, and the initial line drawing is painted in mid-green on a hessian-covered board primed with acrylic medium. The board measures 10 × 12 inches (25 × 30 cm).*

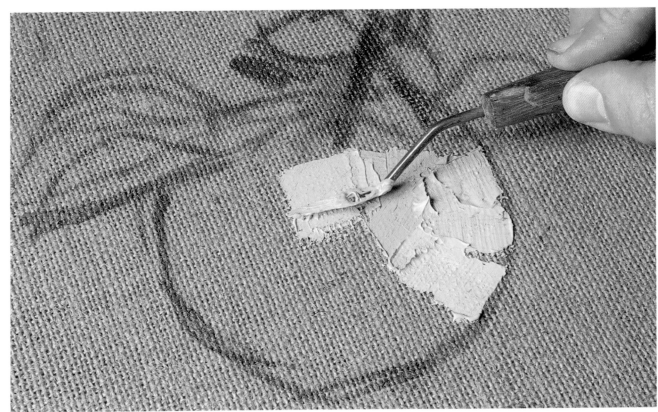

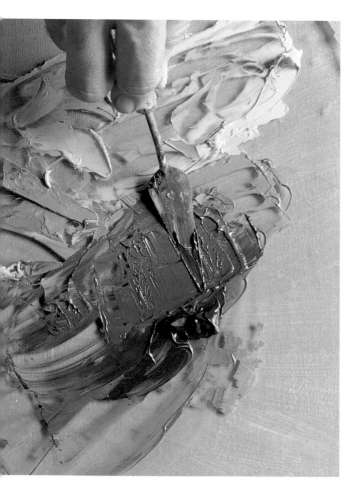

◁ **2** *All the apple tones are mixed from varying quanitites of viridian green, cadmium yellow, lemon, raw umber and white. Colours are mixed with a plastic palette knife, and applied with small and medium painting knives.*

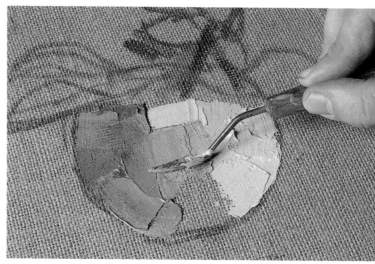

△ **3** *The medium and darker tones are laid in mid-green mixed from raw umber, viridian green, white and cadmium yellow. Paint is applied thickly, with each block overlaying the adjoining colour as the artist looks at the subject and simplifies the colours into the three main tones.*

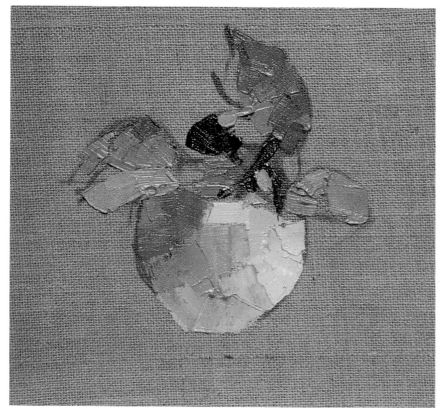

◁ **4** *Leaves are painted in a similarly simplified manner in greens mixed from raw umber, cadmium yellow, white and a little ultramarine blue.*

123

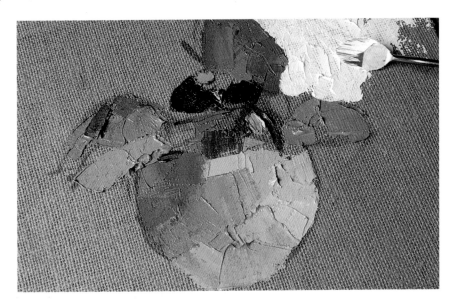

△ 5 *The background is laid in pure white, using an oval painting knife. The ridges produced by the oval blade create a roughly textured paint surface which the artist emphasizes by using very thick paint.*

The most obvious is to blend the colours to give an imitation of the smooth surface of the actual fruit – to make the painting as superficially realistic as a photograph.

For the newcomer to the subject, this approach is not always the best one to take. Successful blending, rubbing tones and colours together to make them look smooth, works only if the tones are right in the first place. The best way to establish the tones correctly is to simplify these into approximate visible patches of light and dark, or planes.

Analysing planes

To understand the concept of planes, imagine your apple is made of folded paper – an origami apple. This apple is not a smooth, round object but a structure made of many paper planes. Each of these planes catches the light from a different angle, and its colour shows up as a light, dark or medium tone, depending on how much light it receives.

On a real, rounded apple, light also falls in different ways, with the patches blended and merging into the rounded form.

Light with a painting knife

When painting with a knife, it becomes easy and quick to block in areas of flat colour. The technique is therefore particularly good for depicting broad planes of light and shade. In this apple painting, the artist has simplified the subject and depicted each plane as a discernible patch of pale, medium or dark green, according to the source of light.

▽ 6　*A small painting knife has allowed the artist to take the paint right up to the edge of the leaves and apple, redefining and shaping these with the edge of the knife and the thick paint. Leaf tones are lightened to blend with the newly applied background, and the shadow is painted in raw umber.*

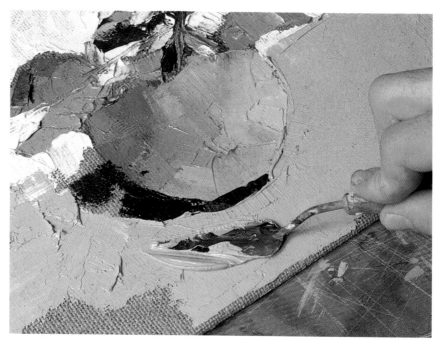

△ 7　*The table top colour is mixed from raw umber, white and a little lemon yellow, and laid in thick wedges of flat colour.*

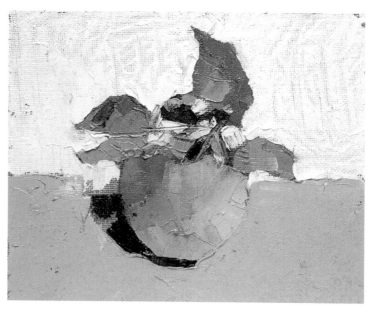

△ 8　*Patches of bare hessian are allowed to show through the paint in certain areas. Thus the completed painting combines the contrasting textures of the impasto oil paint and the coarse finish of the raw hessian canvas.*

TECHNIQUES

PAINTING OUTLINES

Your still-life painting inevitably starts with a drawn outline, which may be done in pencil, charcoal, paint or any other material. When the outline is a painted one, choice of colour is important and can be selected to blend or harmonize with other colours in the picture.

The tubes of paint shown here are predominantly grey. The artist therefore chose to paint the outline in a similar grey, so that the drawn line could eventually be blended into the painted image. The advantage here is that the initial drawing – carefully observed, with a fluid, linear quality – is not lost in the finished painting.

Pattern and line

Surprising numbers of still-life subjects contain an overall pattern which may at first seem to defy painting. Patterned fabrics and wallpapers – popular backgrounds in many still lifes – can be notoriously difficult, as can ceramic and other designs. You have to consider not only the pattern but also how the colour of that pattern changes, according to whether it is in light or shade.

Often, the best way is to treat the pattern, however complicated, as any other part of the painting – that is, to ignore the detail and paint it in broad, general terms. You aim to get a general impression rather than an exact rendering.

Pattern in context

However, sometimes a pattern is a specific and important part of the subject. The blue and white

eggcups here are just such an example. They call for accuracy, yet the linear blue pattern cannot be crudely overpainted in such a way that it would stand out from everything else in a still life.

The solution here is to paint the pattern colour first. Thus each eggcup is first underpainted in blue. This is painted not as a flat, even colour, which might make the finished pattern look flat, despite the fact that it is on a rounded form. Instead, it is applied unevenly and thinly, as it appears on the actual subject.

The main white, the background colour, is then painted over the blue. This is done quite boldly, and the tones of the white – the highlight and the shadow – can be painted and changed in relation to anything else in the picture. The blue pattern is left as crisp, cut-out linear shapes.

Linear patterns

▷ **1** *Instead of painting the blue pattern on to a white background, the artist starts by first blocking in the blue. When this is dry, the white is painted around the patterned shapes.*

▷▽ **2** *By leaving the white until last, the artist has greater control over the tones, and is able to introduce grey shadows to describe the rounded forms. The blue patterns stand out as crisply defined lines.*

Blended outlines

◁◁ **1** *The predominantly grey paint tubes are drawn in diluted mid-grey mixed from black and white.*

◁△ **2** *The artist moves on, painting in the subject with red and yellow – the local colours on the tube labels.*

◁◁ **3** *Light and dark greys are used to describe the form on the rounded tubes. The paint is taken up to the grey painted outline.*

◁ **4** *The initial grey outline has been blended into the rest of the painting, giving the painted tubes a crisply defined shape.*

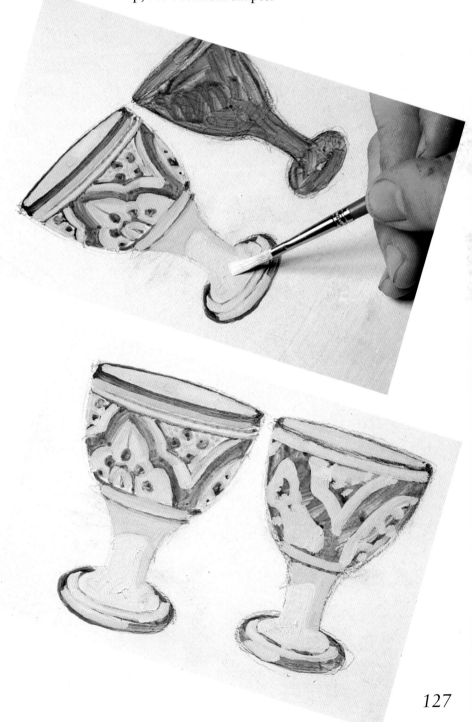

TECHNIQUES

WAYS WITH OUTLINE

Most initial drawings become integrated or covered up by the paint and are rarely visible in the finished picture. They are merely a guide for the ensuing colour. However, there are ways of using outlines that give them far greater importance and make them a feature of the painting.

Coloured outlines

A bold coloured outline will emphasize the shape of the subject, and can be used effectively to bring out the patterns and colours of a still-life arrangement. The artist has done this in the painting of a group of jugs on pages 130–135. The subject in this case is particularly rich in shape, colour and pattern, and the artist decided to emphasize these by starting with a coloured outline.

You can choose a colour that relates to the subject, using the local colour of a particular object for the outline. Thus a bright blue jug would be painted with a bright blue outline. Alternatively, you can give your subject an outline that is in complete contrast to the real colour.

When you use a contrasting colour for the drawing, the outline can affect all the other colours in the picture. For example, if you use an orange outline for a blue jug, both the orange and the blue will look brighter than if used separately. This is because orange and blue are colour 'opposites', and produce a particularly vivid optical effect.

Negative outlines

The French Fauvists often used a negative outline, or *anticerne*. Effectively, this means there is no outline at all; instead there are simply strips of bare

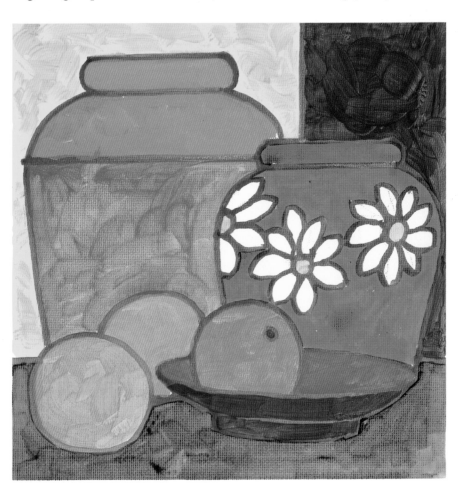

The objects here are brightly coloured, and their brilliance is further emphasized by the use of equally bright outlines in contrasting and complementary colours.

or white primed canvas showing between the patches of colour. The result is similar to that obtained with the coloured outline: it flattens the composition and isolates each shape from its neighbours.

With the *anticerne* technique, however, the dividing outline is white or neutral, so it does not directly affect the painted colours. It makes each colour look brighter merely by separating it from the adjoining colour.

Practically, you will still need a drawing before you paint. The best way is to make a light pencil sketch of the subject but not take the colour right up to the pencil line. The pencil will either not show or can be erased later, and you will be left with strips of bare canvas around each shape.

Coloured outlines

▷ **1** *Bright-red paint is used to draw the outline of the three boxes.*

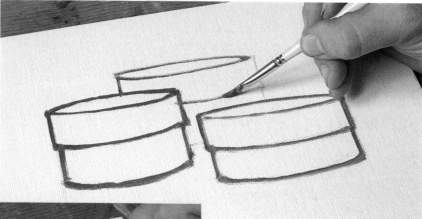

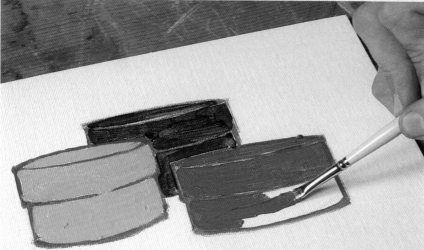

◁ **2** *The local colours – green, yellow and blue – are filled in without obliterating the initial drawing.*

▷ **3** *The artist adds a bright-mauve background. Again, the colour is taken up to the red outline without obliterating the colour. The red separates and enhances the three local colours, giving the overall image an added brightness and resonance.*

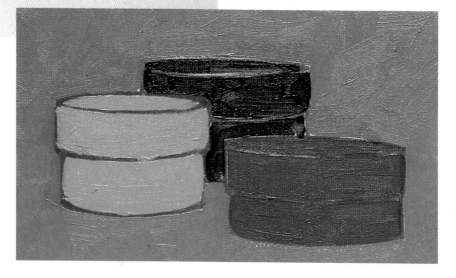

129

PROJECTS

PATTERNED JUGS

No two artists see a subject in the same way. What makes a great artist stand out from others is not necessarily superb technique alone but also a special and personal way of approaching the subject. Great paintings make us look at familiar objects in a new way, encouraging us to see as the artist chose to interpret, rather than view a slavish copy of what is there.

After seeing the swirling, powerful canvases of Van Gogh, can we ever again look at a sunflower without finding in it some of the movement and colour of those remarkable paintings?

Most artists look for particular elements in a subject, and develop and isolate those things in their paintings. One might work predominantly in tones, concentrating on the lights and darks of the subject; another might choose to emphasize the patterns or textures, and so on.

For the beginner, struggling to come to terms with the medium for the first time, this may all sound rather advanced. But in fact, choosing and concentrating on a single element in a subject is an excellent learning exercise and concentrates the mind in one direction.

Shape and patterns

Colour and pattern are the most striking elements in this arrangement of jugs, and the artist decided to concentrate on these aspects of the subject.

To make the most of the decorative elements, the objects are drawn as flat shapes; there is no attempt to make them look three-dimensional. There are no shadows or highlights in the painting, so that each patch of colour looks like a flat, cut-out shape arranged on the white canvas. The table top is deliberately distorted, and that too becomes a flat shape in the overall design. There is no realistic perspective, so no illusion of space is created.

Coloured outlines

The initial drawing plays an important part in the finished painting. Bright-blue outlines establish the subject as a design – a pattern made up of a series of flat shapes – from the outset, and these same lines become part of the colour scheme of the painting.

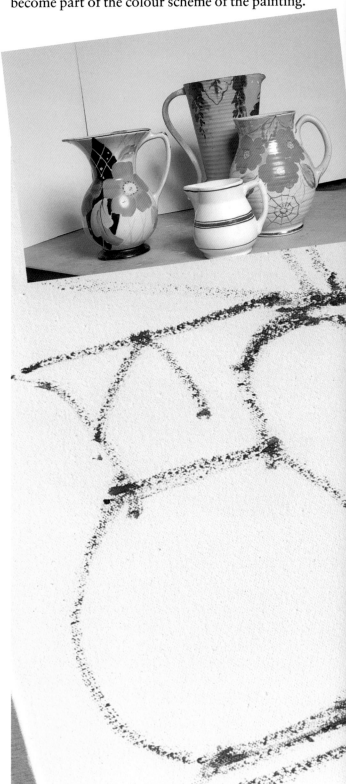

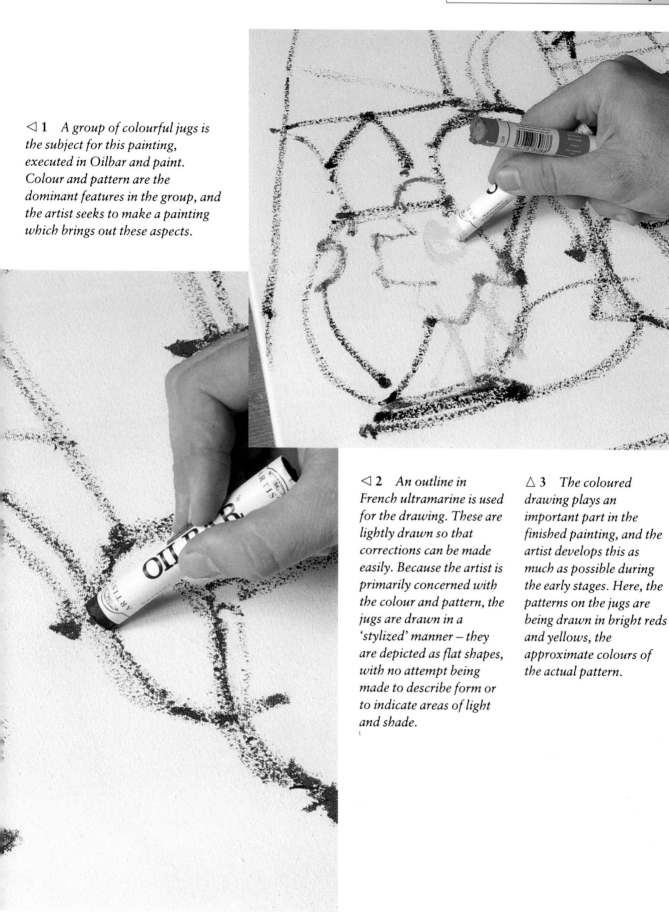

◁ **1** *A group of colourful jugs is the subject for this painting, executed in Oilbar and paint. Colour and pattern are the dominant features in the group, and the artist seeks to make a painting which brings out these aspects.*

◁ **2** *An outline in French ultramarine is used for the drawing. These are lightly drawn so that corrections can be made easily. Because the artist is primarily concerned with the colour and pattern, the jugs are drawn in a 'stylized' manner – they are depicted as flat shapes, with no attempt being made to describe form or to indicate areas of light and shade.*

△ **3** *The coloured drawing plays an important part in the finished painting, and the artist develops this as much as possible during the early stages. Here, the patterns on the jugs are being drawn in bright reds and yellows, the approximate colours of the actual pattern.*

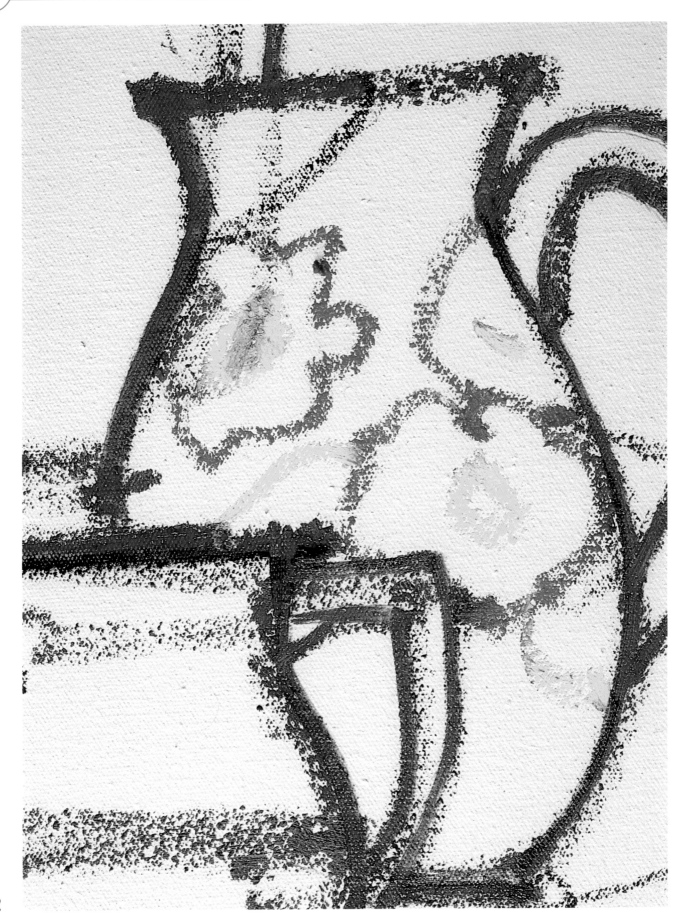

◁ **4** *During the drawing, corrections are made by laying one light line over another, incorrect, line. Before filling in any solid colour, the artist goes over the drawing with turpentine and a brush, strengthening those lines which will appear in the finished picture.*

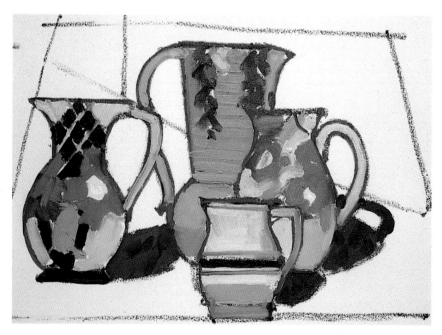

△ **5** *The drawing is now complete, and solid colour is added in oil paint. Colours are kept flat and bright throughout. The flowers are painted in cadmium red, the leaves in a mixture of French ultramarine, cadmium yellow and white.*

◁ **6** *The jugs are now almost complete, with each one painted loosely in the colours present on the actual subject. Motifs and patterns are simplified to suit the flat, graphic style of the painting. Detail and fine lines have been omitted in the interests of a broad, general effect.*

133

▽ **8** *The background is filled in with cadmium red. To enliven the colour, and prevent such a large area overpowering the patterned jugs, the artist uses Oilbar instead of flat red paint.*

△ **7** *Shadows are painted as flat shapes. Again, the shapes are literal and taken from the actual subject, but the colour is not. Shadows are painted in an exaggerated dark purple, mixed from black, French ultramarine and cadmium red, to fit in with the overall design of the picture. Here, the artist is removing excess black with turpentine so that it will not affect subsequent bright colours.*

134

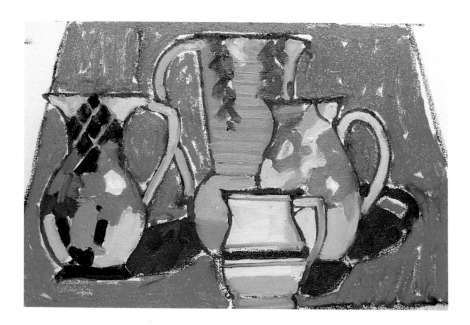

◁ 9 Flecks of bright white which have been allowed to show through the red break up the flat colour to produce a lively, textured background.

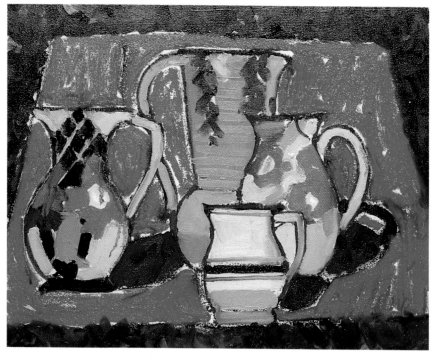

△ 10 The original blue drawing is a powerful element in the completed picture. Not only does it give the painting an overall unity but it also separates the shapes, making each colour look brighter than it would if used on its own.

TECHNIQUES

NEGATIVE SHAPES

A long-established exercise for art students is to draw negative shapes. This involves drawing not the subject itself, but the shapes and spaces within the subject. So, if you were drawing a still life with a jug, teapot and cups, you would not immediately draw the shapes of those objects, but would start by drawing the spaces between them: the background shapes and the shapes made by the handles.

This is not simply a topsy-turvy way of going about a drawing; it is actually the best way of making sure the drawing is correct, and that the composition fits properly on to the paper or canvas.

If your negative shapes are not right, then the teapot and cups will be distorted. You will spot this immediately, once you begin to draw around the shapes, because you know exactly what a teapot and cups look like. However, had you started drawing the objects first, you might not have noticed if either the spaces between them or the background shapes were wrong.

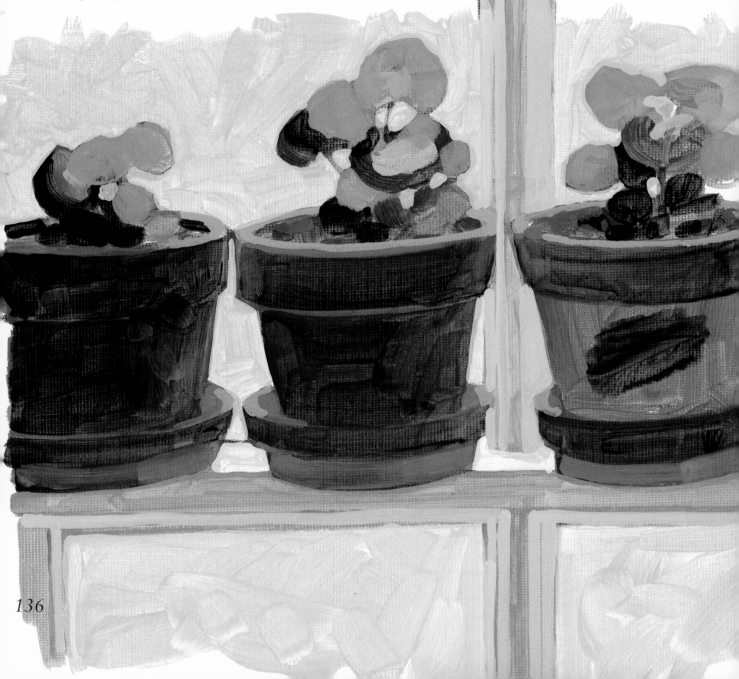

The exercise is a valuable one, because once you have made a conscious effort to see the negative shapes, you will always be aware of their existence and importance.

Background and surrounds

When starting to paint, there is a common tendency to make the subject too small in relation to the canvas. This is true of all subjects, but is particularly so with still-life ones, because they are often placed against a plain or uneventful background which tends to get overlooked. The result is lots of boring, formless background space which has to be somehow filled in, and which often fades away towards the edges of the canvas.

It is important, therefore, to treat both the background and the surface on which the objects are placed as a positive part of the composition. Backgrounds and surrounds have shapes which should be just as taut and considered as everything else in the picture. The shape and proportion of the canvas is very much part of this, because the edges of the canvas form the edges of the background shapes. They are the equivalent of a drawn line.

The illustrations here show various still-life compositions. In each case the first considerations have been the background, the surface on which the objects are placed and the spaces between the objects. The objects themselves have emerged automatically.

Negative shapes *The artist drew these pots of leafy geraniums by observing and drawing the shapes of the spaces left between the pots and leaves – the negative shapes. This approach ensured that the plants and pots were established correctly, both in relationship to each other and to their surroundings.*

137

PROJECTS

THINGS WITH HANDLES

A cluster consisting of jug and cups makes the subject here. The cups are similar, but each is different enough to make it a tricky subject to draw.

Instead of starting with the objects themselves, the artist begins by establishing the shapes behind the group. This approach helps to improve the composition as a whole. By starting with the negative shapes, the artist ensures that these make a positive contribution to the painting and are not merely incidental.

The drawing

Negative shapes were uppermost in the artist's mind when he made the preliminary pencil drawing. The first step was to mark the positions of the vertical background division and the horizontal line of the table, dividing the canvas into three basic sections. Only when these were established was the rest of the subject considered.

A major obstacle to good drawing is an inability to forget the nature of the subject – to draw what we know to be there rather than what we can see. The artist tried to forget, therefore, that he was drawing a familiar jug and cups, and instead sought to perceive them as unknown objects.

Handles particularly can be difficult to draw. Beginners inevitably make them too small and spindly in relation to the vessel. The width of a cup or jug handle changes, usually getting a lot thicker as it joins the vessel at its base. Because we know handles are handles, and have used them all our lives, we have probably never really noticed that their bases are often three times as thick as they are elsewhere. No wonder, therefore, that we tend to understate this when it comes to drawing them.

To overcome this problem the artist decided not to draw the handles at all. Instead, they emerged as resulting shapes when he had drawn the three

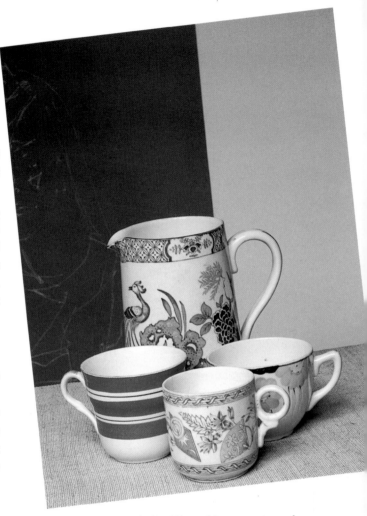

△ 1 *The subject consists of a group of cups and a jug standing on a plain table and placed against two contrasting background shapes. It is an arrangement in which the three surrounding shapes are as important to the composition as the subject itself.*

surrounding shapes – the background and table top, the basic shapes which we referred to above. The handles became evident only after the artist had drawn the background shape, taking this up to the outside contour of the handle and then drawing the shape of the space visible through the handle.

▽ **2** In the preliminary drawing, the artist starts by dividing the canvas into three main areas – the two background shapes and the table top. The jugs and cups are then fitted into the space allocated for them, in the centre of the composition. Here, the first background is blocked in with brown, mixed from raw umber and cadmium red.

▽ **3** The second background shape is then painted in a mixture of Payne's grey and white, with an added touch of the first colour mixture.

▽ **4** The table colour is mixed from white, red and raw umber. As each of the three main background areas is blocked in, the subject emerges as a strong negative shape which is now ready to be developed.

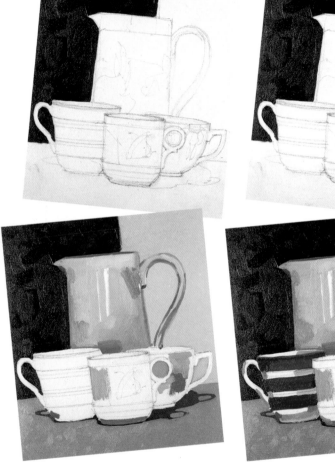

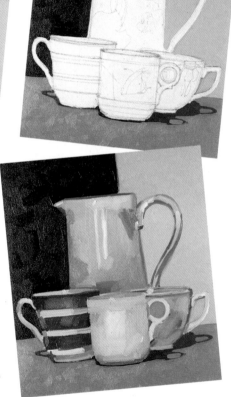

△ **5** The jug is painted in tones of grey, and the artist then moves on to the cups and shadows. Still approaching the subject through its negative shapes, the spaces between the handles are redefined and painted before starting on the cups themselves. The handles emerge when the surrounding background is blocked in.

△ **6** Using broad strokes, the artist works into the cups, establishing main shadow areas to describe the rounded form of the cups. The red stripes are also painted at this stage.

△ **7** In the finished picture, the subject and background are brought together as equally important elements. By tackling the negative shapes first, the abstract elements of the composition were established before the actual subject was developed. The jug and cups are effectively 'carved' out of the surrounding background areas.

139

More advanced steps

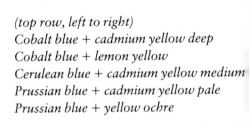

THE THEME of colour is developed in this chapter in a purely practical way. Most academic introductions to the subject illustrate the 'colour wheel', showing how each of the primaries – red, yellow and blue – has its opposite, complementary colour. Thus the opposite of red is green, the opposite of blue is orange and the opposite of yellow is violet.

Instead of reproducing the colour wheel, we put the complementaries immediately to practical use, with paintings designed to introduce basic colour-use as part of the development of specific pictures. Following the steps of the professionals, the examples in this chapter cover such related techniques as masking and glazing.

A natural extension of colour is tone, which recognizes and uses the light and dark properties of particular colours. Everybody knows what colour is, but tone is often overlooked, even though it is just as important.

This chapter also illustrates underpainting, in which the first stage of a painting is to lay monochrome tones. Colours are developed from this, leading to a harmonious whole.

(top row, left to right)
Cobalt blue + cadmium yellow deep
Cobalt blue + lemon yellow
Cerulean blue + cadmium yellow medium
Prussian blue + cadmium yellow pale
Prussian blue + yellow ochre

(centre row, left to right)
Alizarin crimson + lemon yellow
Indian red + yellow ochre
Cadmium red + cadmium yellow medium
Cadmium red + lemon yellow

(bottom row, left to right)
Cadmium red + cobalt blue
Prussian blue + alizarin crimson

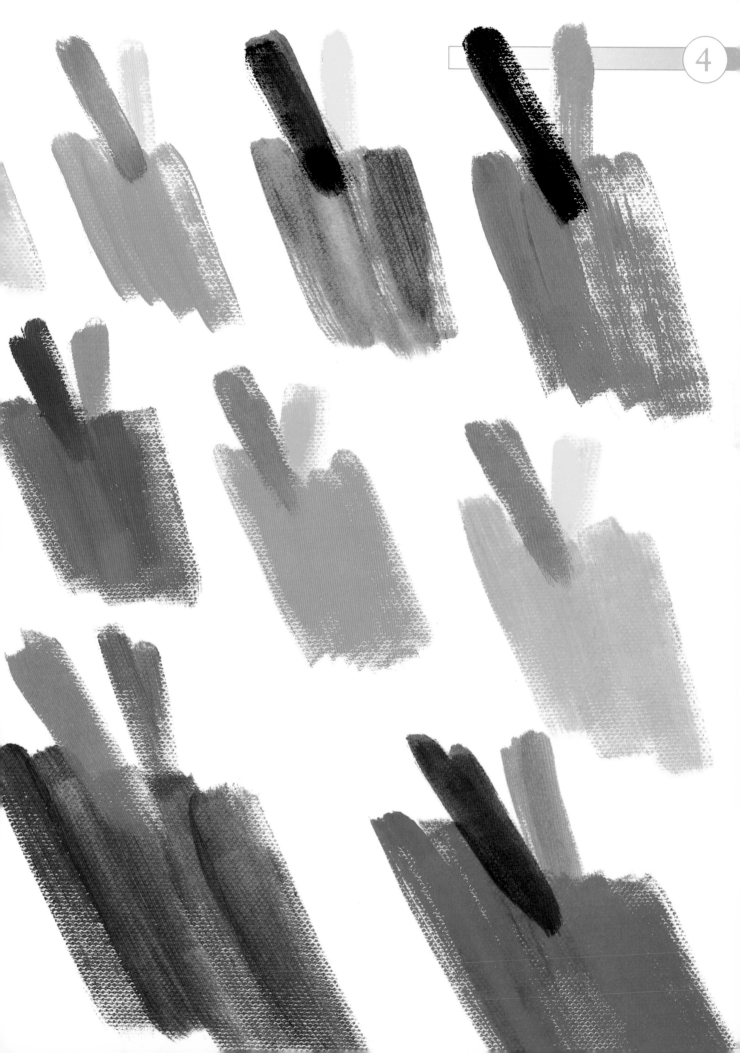

TECHNIQUES

PRACTICAL MIXING

Your basic palette already contains a fair number of colours – more than enough easily to mix any colour you are likely to need. The combinations are endless, and discoveries will be made in the course of your painting. However, a few informed experiments will familiarize you with the colour range and help you to become aware of the possibilities.

Primaries and secondaries

The primaries – red, yellow and blue – are the most flexible of all colours, and from these you can in theory mix any other colour you need, including the secondary colours – violet, orange and green. A little practice, using just the primary colours, will greatly increase your colour vocabulary and make colour-mixing a much less daunting prospect.

Strictly speaking, primaries and secondaries are pure colours that do not vary. But in practice there is no such thing as objective colour-mixing, and you will greatly increase the range of your palette if you start with two reds, cadmium and alizarin; two blues, French ultramarine and cerulean; and two yellows, cadmium and lemon.

The chart on the previous page shows how different the secondary colours can be when they

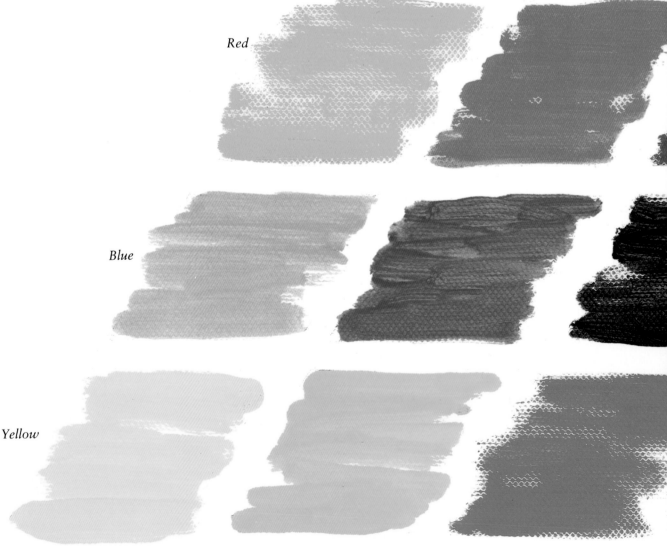

Red

Blue

Yellow

+ *white*

+ *black*

come from different reds, yellows and blues. You should also try varying the quantities of each primary colour, thus making yellow-greens, blue-greens and so on.

Tones

Some colours are pale; others are dark. The light or dark content of a colour is referred to as its 'tone', or tonal quality. Occasionally pale tones are referred to as 'tints'. To lighten the tone of a colour, you add white; to make a colour darker, it can be mixed with black.

In practice, however, the use of too much black in a painting can produce a grey, muddy appearance, and there are practical alternatives to darkening a colour simply by adding black. The three examples opposite show the results when the primaries are darkened by mixing with black, raw umber and Payne's grey.

Neutrals

A true neutral is mixed from the primaries but has no recognizable colour of its own. Strictly speaking, there is no such thing as a neutral colour, but in painting language a 'neutral' blue is one that contains a little red and yellow; a neutral red, one that contains some blue and yellow; and a neutral yellow, one that has a little blue and red mixed with it.

This sounds complicated, but all it means is that you can neutralize a colour simply by mixing it with a little of its opposite colour. Thus, if a red is too bright, you can tone it down with a touch of green, dulling the colour without changing it.

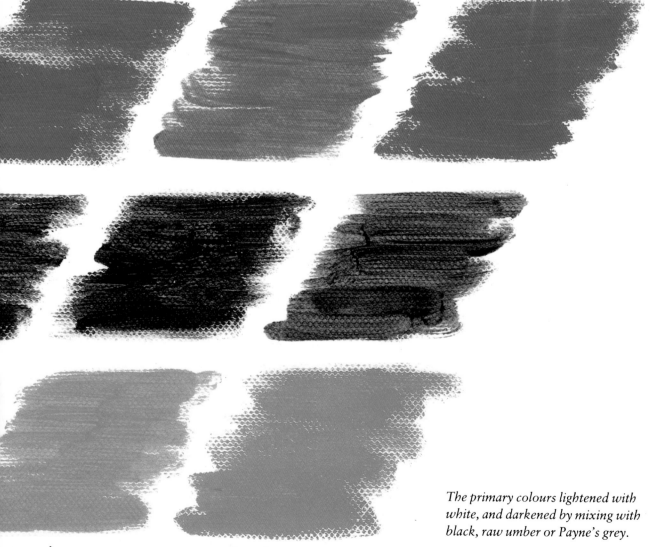

The primary colours lightened with white, and darkened by mixing with black, raw umber or Payne's grey.

raw umber + Payne's grey

143

TECHNIQUES

UNDERSTAND COLOUR

For the painter, colour is not so much a technical subject that can be worked out scientifically; rather, it is what makes painting fun and what inspires so many to take it up. The only way to get to know about colour is to have a go. Explore the possibilities and do not be afraid to experiment. The paints laid out on your palette are just the beginning – the basic ingredients for many recipes – and you can use them as you like. There is nothing sacred about the paints themselves; they are produced by a manufacturer. It is you, the artist, who decides how to mix and use the colours.

Local colour

When we talk of a green apple, a yellow lemon and so on, we are speaking of the actual colour of the object – the colour it is when not affected by light, shade or reflections. 'Yellow' and 'green' are useful labels for describing objects, but they are best forgotten when painting, because the colour of every subject is affected by other factors. An apple cannot be painted just green, or a lemon simply yellow.

Looking for colour

Take your lemon or apple, place it on any surface and look carefully to see how many other colours you can see in a single piece of fruit. You will find

that the shadow areas are not just grey, or even a darker tone of the local colour; and the light areas are not merely a paler tone. You will also see traces of many other colours, particularly those reflected from the surrounds and background.

The still-life paintings of Cézanne and the Impressionists are obvious and excellent examples of colour observed in this way. These artists not only saw colour but also manipulated their findings in a creative and imaginative way. Cézanne captured the 'appleness' of apples by selecting and exaggerating the colours he observed within them.

(left to right)
Local colour
'Found' colour
Coloured shadows

Colourful shadows

The shadow thrown by an object is never totally isolated from the object itself. Obviously the colour of the table or surface on which it is placed affects the colour of the shadow to a large extent. The table may be brown, but the shadow is never merely a darker tone of the same brown. It is inevitably affected by the colour of the subject.

Look at the shadow of the painted orange on page 151. The fruit is placed on a sheet of blue paper, but the shadow is deep purple – a mixture of the blue with added tones of orange.

Frequently, when painting a simple, brightly coloured subject, you will find the thrown shadow contains traces of an opposite or complementary colour. Thus a lemon might throw a purple shadow; a green apple, a reddish shadow; and so on. By slightly exaggerating these colours, the shadows will become a lively and interesting part of the whole subject.

TECHNIQUES

EASY COLOUR

A primitive or naïve painting is one in which the colour is used literally rather than visually – painted from knowledge rather than from looking at the subject. Children's pictures are often painted in this way, with the grass bright green because they 'know' it's green, a blue sky and so on.

These preconceived ideas about colour, often with us since childhood, are not easy to overcome in later life. This is why, when it comes to painting, we fall back on knowledge rather than observation. Yet in our everyday lives, most of us have a sophis-

ticated and highly developed sense of colour. This is usually manifested in the way we appreciate our surroundings, the way we dress or the way in which we decorate our homes.

So why can colour cause such problems when it comes to painting? And what is the best method of getting away from the crude colours of childhood and using colour in a creative and personal way?

A simple exercise

One very simple way to achieve a harmonious colour scheme in a painting is to mix a little of a selected colour with all the other colours you use.

Obviously, if the chosen colour is too strong, you will end up with a tinted painting – a picture which looks as if the subject has been viewed through a sheet of coloured glass. But if you choose a fairly neutral colour, one that corresponds with the

(inset)

Colour harmony *The colours used in this still life are predominantly warm earth pigments including the siennas and umbers. These were applied to a warm, neutral support of a similar tone, thus giving an overall unity to the finished picture.*

Colour perspective *A sense of space is achieved here by contrasting strong, warm foreground colours with a cooler, paler background.*

subject, it can act as a sort of visual binder to the painting and 'tone down' the colours without greatly changing them.

This is an elementary exercise, and a device that you will not necessarily want to use once you are more accustomed to mixing tones and colours. But it does demonstrate what a little 'toning' can achieve, and it gets you into the habit of mixing colour rather than using it literally or directly from the tube.

Colour perspective

Pursuing this idea a little further, you can create a sense of space in a painting by using a predominance of one colour in the foreground and another in the background. By separating distant objects from nearer ones in this way, you effectively create distance or colour perspective in the picture.

Colour perspective is common in landscapes, when the far distance is paler and usually contains more blue than the foreground. But the theory applies equally to still-life subjects, particularly those in which there is an obvious space between the foreground and background or, like the illustration here, there is a window or other extension of space behind the subject.

Cold colours tend to recede, while warm or hot colours stand out. So, if the furthest objects contain traces of cool grey, blue or green, they will fall back in the picture, especially if the near objects are painted in warmer tones.

Again, this is an exercise in colour behaviour and you will doubtless want to modify and develop it. But it is a useful way of tackling colour in painting, and one which is used by many artists.

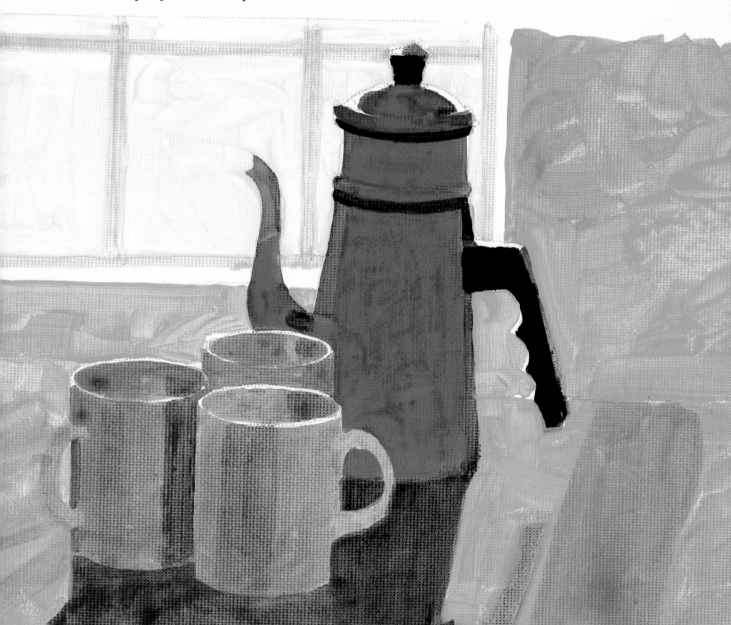

ORANGE ON BLUE

Here is a straightforward example of the use of complementary colours – oranges against a blue surround. Orange and blue are opposites on the colour wheel and are therefore complementary. When used next to each other in a painting, complementary colours create an optical effect which brings out the brightness in each colour. As a warm colour, orange tends to jump forward from the picture surface, while the cooler blue recedes.

This characteristic of opposite colours can be useful when the intention is to create a sense of space in the picture. It works here because the receding blue is the background to the oranges. Even so, the subject and its surroundings cannot be completely separate, and the artist must find ways to harmonize the composition, to bring the two together.

Cool shadows

To unite the subject with its surroundings, the artist has mixed cooler blue tones with the orange, and vice versa. The fruit is painted predominantly in warm oranges mixed from cadmium yellow, cadmium red and white – the local colours. In some shaded places, however, the artist has added alizarin crimson – a cooler, purplish red – to the orange mix, while the very dark areas are heavily tinged with the blue of the background.

The shadow is a mixture of blue, alizarin and touches of red and yellow.

Background shapes

The purpose of this painting is to demonstrate the use of complementary colours. Everything else, including the composition, is therefore kept deliberately simple and minimal, so as not to distract from the main theme of the picture.

A simple composition, however, requires as

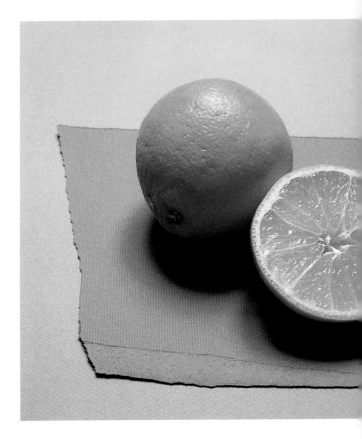

△ 1 *A simple subject is made interesting by being placed on a two-tone blue surface. The angular blue shapes, one of which juts in from the side of the composition, provide an interesting and contrasting background to the rounded oranges.*

much consideration as a complex one – sometimes more. When the elements are few and simple, each one attracts more attention than it would in a more complicated arrangement.

The artist is standing above the table top, looking down at the still life. No background is visible, but the oranges are standing on two sheets of blue paper. These shapes are as important to the composition as the oranges, formally dividing the canvas into two flat, angular pieces and so emphasizing the solid roundness of the fruit.

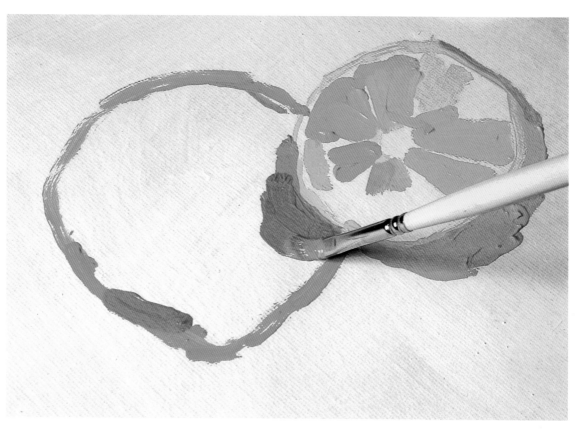

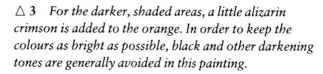

△ **3** For the darker, shaded areas, a little alizarin crimson is added to the orange. In order to keep the colours as bright as possible, black and other darkening tones are generally avoided in this painting.

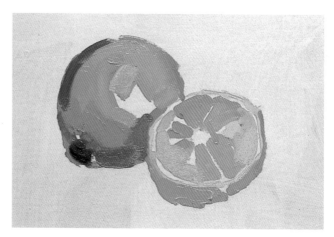

△ **2** The use of complementary colours is central to this still-life arrangement, and the artist starts by 'drawing' the fruit in paint, using various shades of bright orange mixed from cadmium yellow and cadmium red.

△ **4** The fruit is now blocked in with a range of orange tones, mixed from varying quantities of cadmium red and yellow. For deeper tones, the artist adds a touch of alizarin crimson and French ultramarine; for the lighter areas, a little white.

149

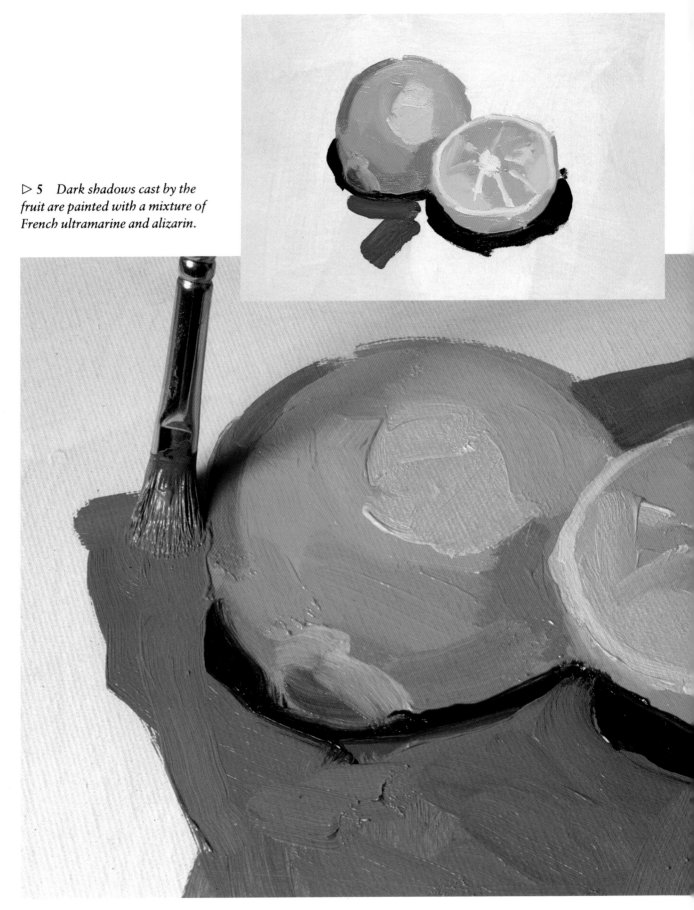

▷ 5 *Dark shadows cast by the fruit are painted with a mixture of French ultramarine and alizarin.*

▽ 6 *The sheet of blue paper is French ultramarine mixed with white. This is applied boldly with a large brush, and the artist takes the colour up to and over the shadows and the fruit, cutting into the contours in order to redefine the shapes.*

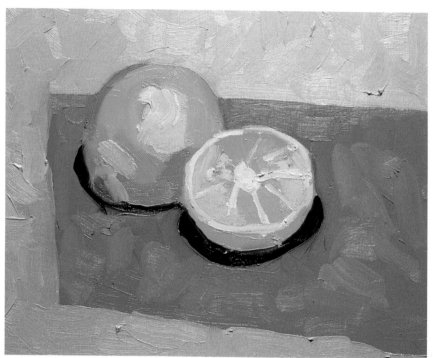

△ 7 *Finally, the blue table top is painted in French ultramarine blue and white mixed with a little raw umber. The painting is completed using a limited palette of just five colours – cadmium yellow, cadmium red, alizarin, French ultramarine and raw umber – with white. The relative purity of the colours allows the complementary orange and blue to work together, making the most of this very simple still-life arrangement.*

PROJECTS

SEASHELLS

These shells are more colourful than you might think, even though there is no strong colour among them. If you were asked what colour they were, you would have to say beige or grey. Yet the shells are actually much more varied than that – it is just that the colours are muted and neutralized. The artist sees and recognizes the potential in this subject and wants to convey a sense of colour in the painting. With this in mind, he selects a palette of cadmium red, Indian red, yellow ochre, cadmium yellow, French ultramarine, raw umber and white.

Black and white?

A mixture of black and white produces a strong, colourless grey which can look cold or warm, depending on the surrounding colours. One painter who uses a palette of warm earth colours finds he never needs blue because when surrounded by warm colours, grey mixed from black and white takes on the appearance of blue.

However, black and white are by no means the only way of making grey, as you can see from this painting. The greys are colourful, yet the artist had no black on his palette.

Coloured greys

If you look at the shells in this painting, you will notice that each grey and beige is different. Apart from the tonal variations – the lights and darks – you will find that every grey or beige has a 'colour': a pink, yellow, purple or other coloured tinge. Seen in isolation, each shell is either grey or beige, but when these 'coloured' greys are painted next to each other, the colours are bright and resonant.

Grey or neutral does not therefore mean dull. But as with all colour mixtures, they will become so if you overdo the number of pigments. The secret is to treat each mixed colour as if it were a pure, bright colour, straight from the tube. In other words, once you have mixed it, keep it separate on the palette.

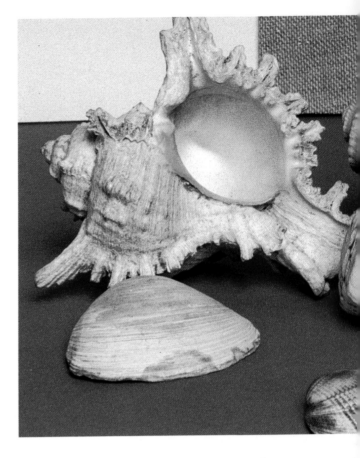

△ **1** *An assortment of shells is laid out ready to paint. Most of the colour in this subject lies in the red tablecloth, but the shells themselves contain hidden colour. For this reason, the artist lays out a varied palette of cadmium red, Indian red, yellow ochre, cadmium yellow, French ultramarine, raw umber and white.*

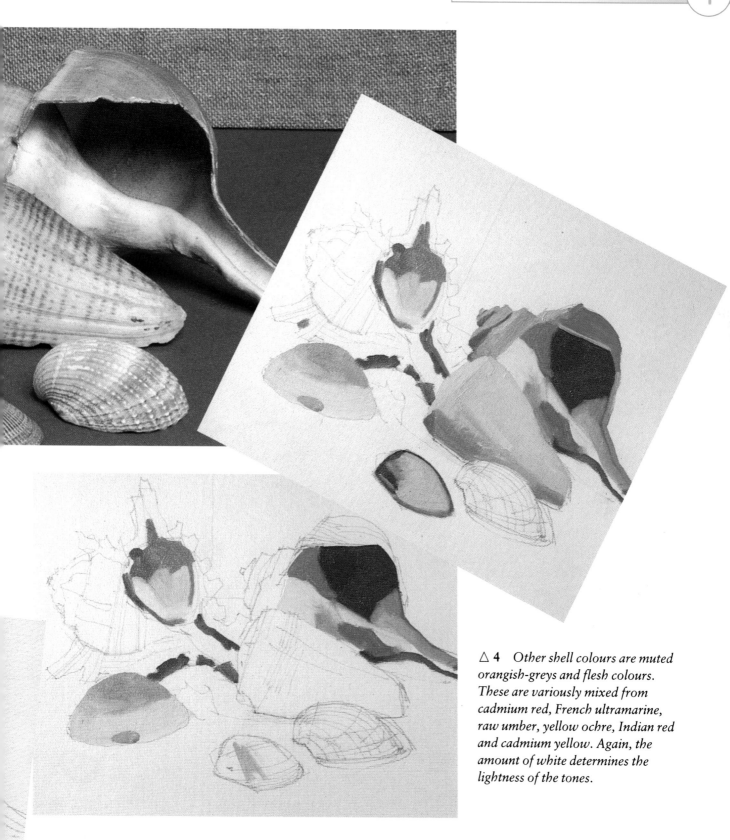

△ 4 Other shell colours are muted
orangish-greys and flesh colours.
These are variously mixed from
cadmium red, French ultramarine,
raw umber, yellow ochre, Indian red
and cadmium yellow. Again, the
amount of white determines the
lightness of the tones.

◁ 2 The artist starts with a
pencil drawing – a light outline
of the shells and the background
shapes.

△ 3 On close observation, many of the greys visible in the shells have
a pronounced purple or pink tinge. These are mixed from raw
umber, French ultramarine and cadmium red. Varying amounts of
white are added to obtain the medium and light tones.

153

▷ **5** *Working with the same colour mixtures, the artist continues to develop the shells. Each colour and tone is carefully related to its neighbours, so that the shells begin to stand out as three-dimensional objects. The very darkest colours represent the shadows and interiors of the shells.*

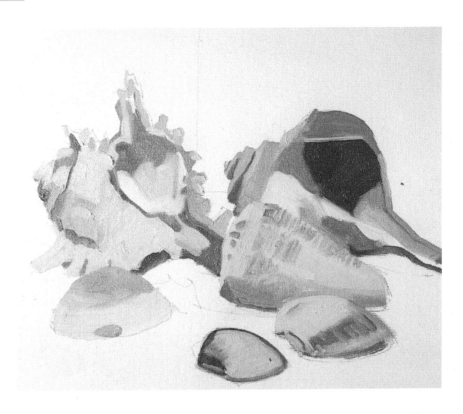

▽ **6** *The addition of a dark background – raw umber mixed with a little white – also helps to establish the shells as solid three-dimensional forms. This umber background brings out and emphasizes similar colours in the shell arrangement.*

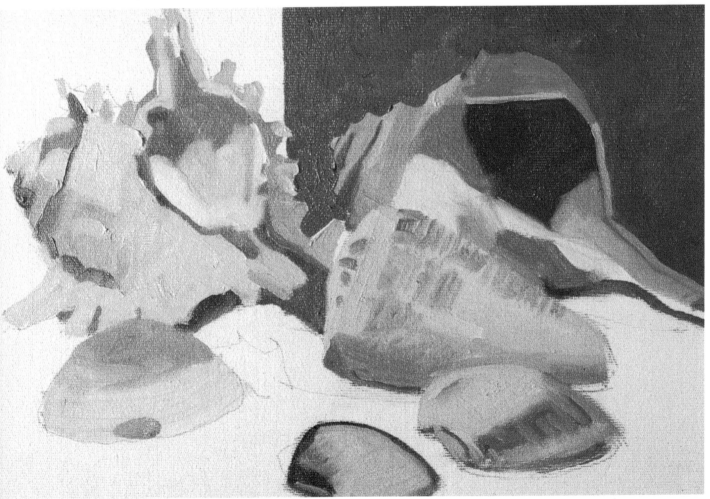

▷ 7 *The tablecloth is painted in Indian red, mixed with a little white, raw umber and French ultramarine. A stick of graphite is used to draw surface textures and patterns on the shells.*

▽ 8 *In the finished painting, the addition of the tablecloth and background affects the colours present in the painted shells. The red cloth and umber background pick out and emphasize similar colours in the shells; at the same time, the blue and purple tones in the shells also appear stronger because they contrast with the background and cloth colours.*

TECHNIQUES

TEXTURE WITH PAINT

Painting with a knife is only one way of creating texture in painting. The thick consistency of oil paints gives you the choice of applying the colour heavily, to create an impasto effect, or diluting the colour to apply it as a thin wash.

Glazes

Depending on the pigment, some paints are naturally transparent when diluted with turpentine; others remain opaque, however much you dilute them.

Traditionally, the use of transparent colour is known as glazing. By laying a thin transparent colour over another colour, the underlying colour will show through the glaze. The result is a shimmering combination of the two colours, quite unlike the effect you would get by mixing the two in a conventional manner. It is important to allow the first colour to dry before attempting to glaze over it.

Many painters, from the Renaissance onwards, used glazing to capture the transparency of flesh tones and the effect of light on folds of fabric. The technique is still widely used today.

Contemporary artists have the advantage of the new glazing media – viscous substances available in tubes – that can be mixed with any colour to give it a lustrous transparency. In the past, painters were limited to those colours that were naturally transparent. Even then, it was often difficult to dilute them with oil and turpentine without losing some of the strength of the colour.

Glazing with turpentine alone is never recommended. Colours tend to dry with a dull, lacklustre finish that defeats the purpose of the glaze because it deadens the colours.

Impasto

Oil paint lends itself to thickly impastoed textures that can be applied with either a brush or a knife. The only restriction to the thickness of paint you use is the amount of time it takes for very thick paint to dry. Even here, technology has an answer: you can buy effective drying media to mix with the colour, and this speeds up the drying time considerably.

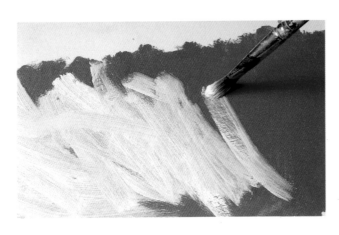

Sgraffiti
△ 1 *White paint is applied over a red base which has been allowed to dry completely.*

△ 2 *Here the artist has used the edge of a palette knife to scratch into the wet white, revealing the red underneath.*

On their own, oil paints are naturally slow-drying. Although your picture may be dry enough to work on if you leave it standing overnight, it can take weeks for the paint to dry properly – longer if it is very thick. Until it is completely dry, the paint is unstable, which is why manufacturers usually recommend leaving the finished painting for some weeks before applying varnish.

Other texture techniques

Oil paints may be a long-established and classical medium, but there is no reason why your own approach should not be entirely creative and personal. Sgraffiti, for instance, is the term used to describe any scratched texture on the painted surface – usually applied while the colour is wet.

In fact, any technique that gives you the effect you want is fine – provided, of course, that you do not introduce materials that are incompatible with oil paint. It is important to remember that water-based paints such as acrylic and gouache cannot be mixed with oils.

Possibly the most versatile texture-making tool you possess, however, is a paintbrush. With it, not only can you produce the dry-brush and broken-colour effects shown on this page, but you can also develop your own brushstrokes and ways of applying paint to create equally effective textures.

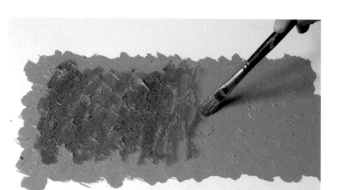

Glazing over impasto

△ **1** *An impastoed pink undercolour is allowed to dry completely before a thin blue glaze is applied. The blue is mixed with a little glazing medium to increase its transparency.*

△ **2** *The result is a textured, translucent violet – a combination of the blue and pink in which both of these colours are discernible.*

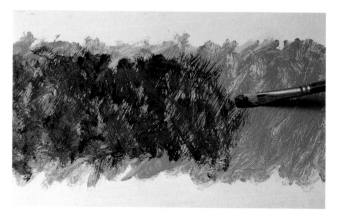

Broken colour

△ **1** *Short strokes of viridian green are painted over a dry, yellowish undercolour. To achieve this broken, scratchy effect – sometimes called 'scumbling' – the artist uses a semi-dry brush and applies the colour in light, feathery strokes.*

△ **2** *The result is a textured area of broken colour in which patches of yellow show through the darker top colour.*

157

ROSES IN A GLASS VASE

Flowers and foliage can be dauntingly difficult. Each bloom is a mass of folded petals; each leaf, a complicated structure of planes and delicate veins. Yet this vase of roses was painted at one sitting, and the artist has succeeded in capturing the essence of the subject without analysing every botanical detail.

Working 'alla prima'

This rapid, spontaneous way of working is sometimes known as 'alla prima' – literally, 'at the first' or 'at one go'. Such paintings are often done with a minimal preliminary drawing, sometimes with no drawing at all. Here, the artist has started with a light sketch in oil pastel – a quick but accurate guide for the paint.

As with all alla-prima work, the sketchy effect belies the care with which the painting has been planned. It is an approach which calls for accuracy and great powers of observation. The paint itself may be laid at speed, but you can do this effectively only if you know exactly where you are going to put the colour. Colour and rendering on the roses are simple in the extreme, but every dab of paint has been mixed and placed with deft accuracy.

The leaves are simplified into three tones of green; the roses are painted almost as flat shapes in a limited range of yellows, reds and pinks. There is no detail in either the flowers or the leaves. Apart from the single stroke of thick colour that represents each furled petal, the artist has not attempted to describe the three-dimensional form of the roses.

Dynamic impasto

Cut flowers in a vase have an explosive composition which is often lost in more finished paintings. This is simply because it is difficult, in the same painting, to retain a sense of movement while also depicting detail. Here, the thick brushstrokes capture exactly

△ **1** *The initial drawing is a lively, minimal sketch done in oil pastel. It indicates the position of the vase and roses, and contains just enough information to act as a guide for the paint.*

the explosive growth in the arrangement of flowers, leaves and stalks.

An important aspect of this painting is the flat blue background. This is taken up to the edge of the subject, but the artist applies the colour in swift, decisive strokes, using the thick paint to define and sharpen the shapes of the flowers and leaves.

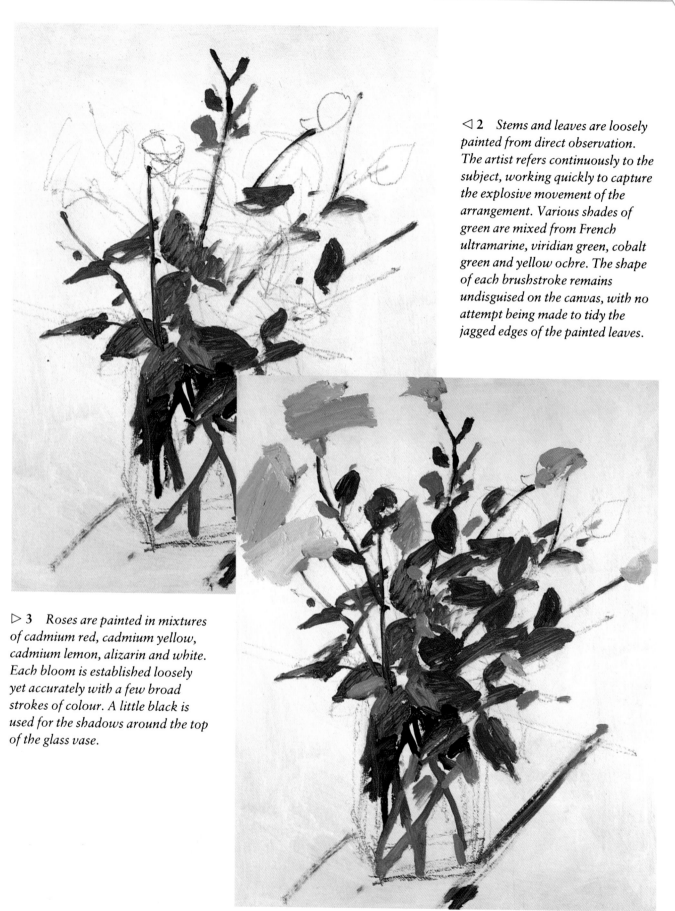

◁ **2** *Stems and leaves are loosely painted from direct observation. The artist refers continuously to the subject, working quickly to capture the explosive movement of the arrangement. Various shades of green are mixed from French ultramarine, viridian green, cobalt green and yellow ochre. The shape of each brushstroke remains undisguised on the canvas, with no attempt being made to tidy the jagged edges of the painted leaves.*

▷ **3** *Roses are painted in mixtures of cadmium red, cadmium yellow, cadmium lemon, alizarin and white. Each bloom is established loosely yet accurately with a few broad strokes of colour. A little black is used for the shadows around the top of the glass vase.*

▷ **4** *A close-up of the flowers shows how each bloom has been established in a few seconds, using thick paint and partially mixed colour. Yet, because the artist works closely from the subject, the strokes are sufficiently accurate to create a convincing impression of roses.*

▽ **5** *The background is mixed from cerulean blue and white. The artist takes this opportunity to redefine and sharpen some of the flowers and foliage by cutting into the shapes with the blue paint.*

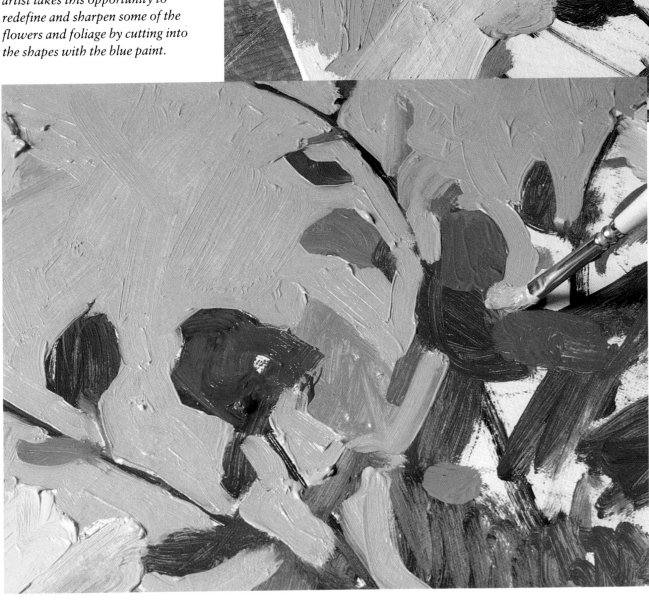

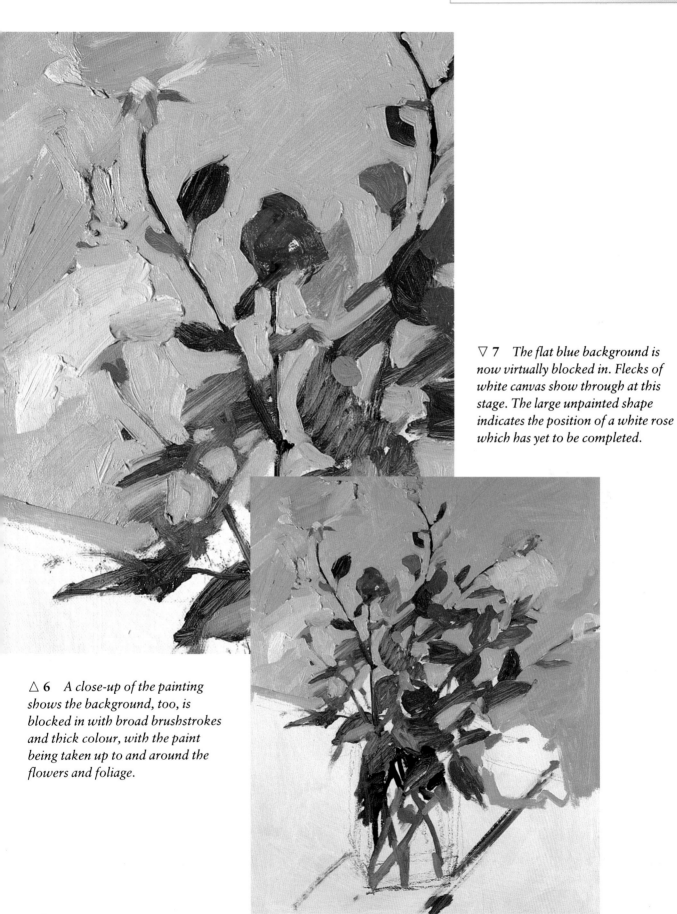

▽ 7　*The flat blue background is now virtually blocked in. Flecks of white canvas show through at this stage. The large unpainted shape indicates the position of a white rose which has yet to be completed.*

△ 6　*A close-up of the painting shows the background, too, is blocked in with broad brushstrokes and thick colour, with the paint being taken up to and around the flowers and foliage.*

161

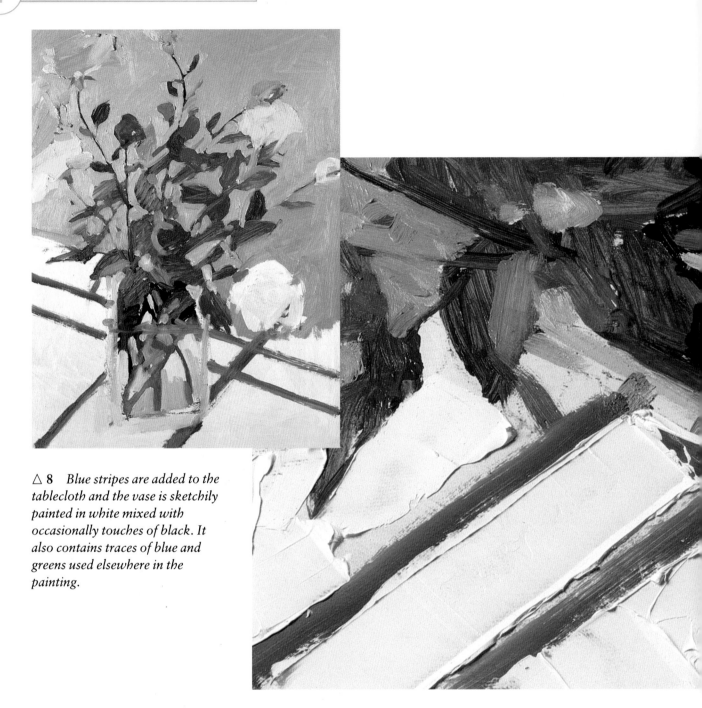

△ **8** *Blue stripes are added to the tablecloth and the vase is sketchily painted in white mixed with occasionally touches of black. It also contains traces of blue and greens used elsewhere in the painting.*

△ **9** *The tablecloth is laid thickly in pure white, applied with a small painting knife. Once laid, each impastoed stroke is left untouched; the textured knife strokes and ridges of paint become part of the finished painting.*

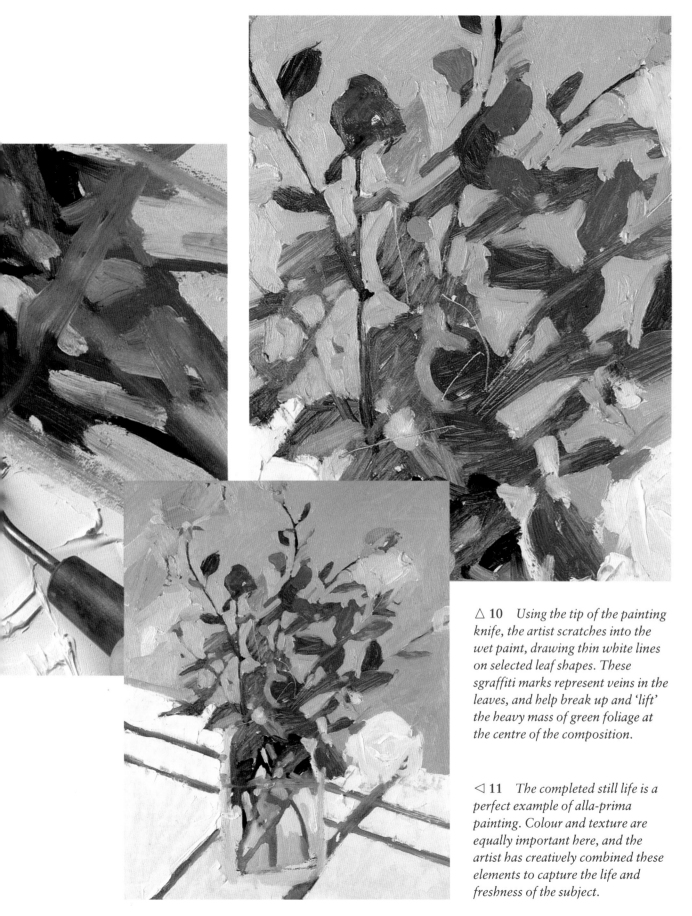

△ **10** Using the tip of the painting knife, the artist scratches into the wet paint, drawing thin white lines on selected leaf shapes. These sgraffiti marks represent veins in the leaves, and help break up and 'lift' the heavy mass of green foliage at the centre of the composition.

◁ **11** The completed still life is a perfect example of alla-prima painting. Colour and texture are equally important here, and the artist has creatively combined these elements to capture the life and freshness of the subject.

163

TECHNIQUES

UNDER-PAINTING

A useful and very common way of starting any painting is with a monochrome underpainting. The underpainted colour should be diluted with turpentine to an extremely thin consistency. This is partly because thin colour dries quickly, allowing you to carry on with the painting almost immediately, and partly because a thin wash will not affect subsequent texture or colour.

Overall tone

A primed canvas is not necessarily the best starting point for an oil painting. Apart from distorting each colour and tone as you paint it – the white prime makes everything else look much darker in comparison – the prime is generally too bright even to represent the palest tones of most subjects. A sensible first step, therefore, is to give the whole support a coat of thin, medium-toned colour.

The colour for this thin underpainting depends on the subject. Usually, a neutral colour is best because it does not interfere too much with subsequent colours. But if your subject contains a lot of one colour, you may want a contrasting underpainting to counterbalance this. For instance, if you are painting an arrangement of red earthenware pots, a green underpainting which is allowed to show through in places will enhance the reds and can add zest to the picture.

One of the most natural ways of starting a painting is to block in some of the main colours and tones. Once these are established, it then becomes

Underpainting

▽ 1 *Mix the oil colour with turpentine to a thin, runny consistency. Underpainting can be done with either a large brush or a cloth. A cloth will generally produce a lighter, more even colour. Here the artist applies a pool of diluted paint to the centre of the support and starts to spread this with a clean cloth.*

△ 2 *Continue spreading the paint, using the rag to smooth the colour out towards the edges of the canvas.*

easier to add and develop later colour. The initial tones – the lights, mediums and darks – must be correct in relation to each other, and it is far easier to establish these relationships if you start off with a medium-toned canvas. Against this mid-tone, you can then begin to establish the lights and darks of the composition.

Underpainting is very flexible, and can be used to suit your particular way of working.

Tonal underpainting

An alternative start to a painting is to skip the overall underpainting and begin immediately by blocking in the main tones with thin washes of one colour. If you do this fairly loosely, using a large brush, the intimidating whiteness of the primed canvas will soon bcome broken up into manageable areas of tone, and you can take the painting from there. The approach is similar to the overall colour underpainting, but you accomplish two stages in one. The oil sketch on pages 166–7 was started in this way.

Acrylic paint

Thick oil paint can take some time to dry, so if you particularly want an opaque or thick colour, you can do the underpainting in acrylics. The quick-drying colour enables you to start work in oils almost immediately.

An acrylic underpainting can be taken to any stage. You may simply want to tint the canvas with a flat coat of colour. Or you may decide to do much of the initial painting in acrylics, changing to oils for the final stages when the slower-drying, more malleable oil paint is better for blending and detail.

Incompatible paints

It is important to remember that oils and acrylics are not usually compatible, and should certainly never be mixed together when painting. Although it is possible to use oil on top of an acrylic base, it is not wise to reverse this order, because the oily base will eventually repel the acrylics.

▽ 3 *When the underpainting is dry, the canvas is ready to work on. The drying process will be considerably speeded up if you use a hair-dryer.*

GARDEN TOOLS: SKETCH

This is a colour sketch for an anticipated, later oil painting. Its purpose is to enable the artist to work out the main tones and colours in the composition before being committed to the finished picture.

Because this is an exploratory sketch, the artist starts with a light charcoal drawing. There is nothing final about charcoal – mistakes can easily be corrected and the lines rubbed back by flicking the surface of the canvas with a dry cloth to remove excess charcoal dust. This initial drawing was rubbed back and redone several times before the artist was happy with the composition.

Tonal underpainting

A tonal underpainting in diluted raw umber is mixed to block in the light, medium and dark areas. The same colour is also used to strengthen and define the charcoal drawing. For both the redrawing and the tonal underpainting, the colour is mixed with a lot of turpentine to give a thin, washy consistency. Slightly more paint is added for the darker tones. The umber wash is laid lightly and loosely, and the diluted colour is easily removed with lots of turpentine and a large brush or rag. This enables the artist to move the paint around until the lights and darks of the subject have been broadly, yet accurately, established.

Raw umber is a useful and popular colour both for underpainting and for painting the initial drawing. The greenish-brown earth pigment is more transparent than many paints, and can provide a lively and light start to a painting. It is a clear, cool colour that is sufficiently subdued to harmonize with subsequent colours, yet dark enough to represent the deep tones of most subjects.

△ **1** *For this preliminary colour sketch, the artist makes a light outline drawing on the canvas in charcoal. Charcoal is easily erased, allowing the artist plenty of scope for trial and error in the early stages of the sketch.*

▽ **2** *When the drawing is complete, excess charcoal dust is flicked off the canvas with a clean, dry cloth. The result is a light outline that is clear enough to follow, but not so heavy that the charcoal will mix with subsequent painted colour and cause this to go muddy.*

Local colour

Once the tonal composition is complete and dry, the artist is able to move on to develop the rest of the sketch. Using the tonal underpainting as a guide, local colours are blocked in and adjusted until the overall arrangement works as a whole. At this stage, nothing is brought to a conclusion. Detail and last-minute adjustments are left to the final painting.

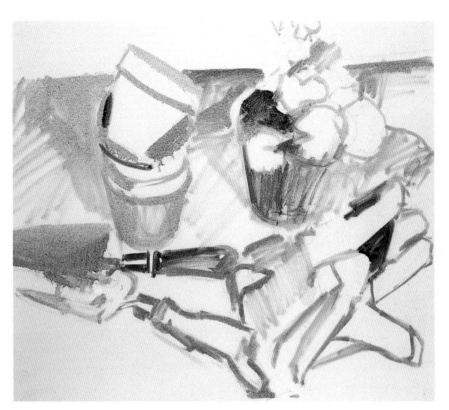

△ **3** Using the charcoal outline as a guide, the artist starts to block in the main areas of tone with raw umber diluted with turpentine. The paint is applied loosely, enabling the artist to manipulate and change the tones until each is correct in relationship to its neighbours.

▷ **4** The tonal underpainting is now sufficiently developed to give the artist some idea as to where the dark and light areas of the painting will fall.

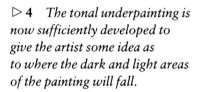

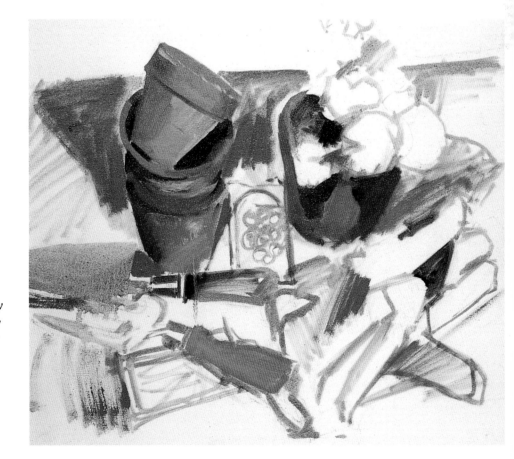

▷ **5** The underpainting is now dry and the artist takes this opportunity to develop the colour sketch, trying out various colours and colour combinations. Depending on their success in this sketch, the trial colours will be either adopted, rejected or modified in the final painting.

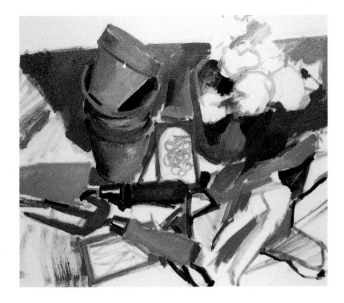

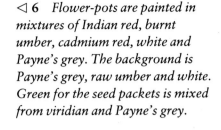

▷ **6** *Flower-pots are painted in mixtures of Indian red, burnt umber, cadmium red, white and Payne's grey. The background is Payne's grey, raw umber and white. Green for the seed packets is mixed from viridian and Payne's grey.*

◁▽ **7** *Much of the canvas surface is now blocked in. The object of this sketch is to work out relating tones and colours, rather than produce a finished work. Brushstrokes are, therefore, left deliberately rough and approximate; no attempt is made to render detail.*

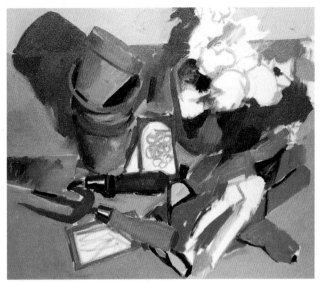

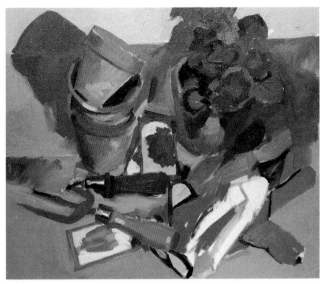

△ **8** *Most of the tones are now blocked in and the artist feels these work well, with one or two minor corrections.*

◁ **9** *The shadows directly behind the pots are too light in relation to dark areas elsewhere in the painting. To darken the shadows without making them too dense, the artist uses a stick of graphite.*

△ **10** *The geranium leaves look dense and heavy, and the artist lightens them with sgraffiti lines made with the edge of a painting knife. This effectively lightens the solid colour without altering the overall tones.*

▷ **11** *In the finished colour sketch, the main colours and tones have been worked out and broadly established. The artist is now able to use this sketch as a starting point for a more finished painting.*

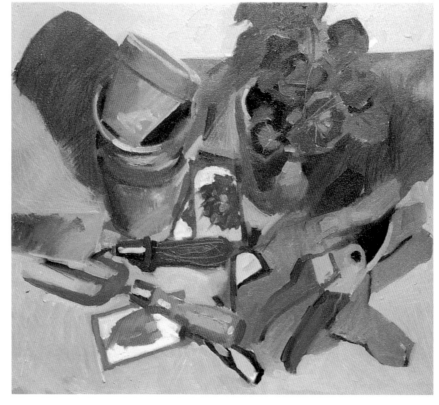

169

TECHNIQUES

MASKING

Masking is used to help you make crisp shapes and sharply defined edges. This, however, seems to be a contradiction when it comes to using oils.

Oil paint is a malleable medium, used mainly by artists who appreciate the textural qualities of brushstrokes and knife marks or the controlled tones and subtle blending made possible with oils. The medium, therefore, is best suited to brushwork, to freehand painting.

Not all painters wish to be totally committed to the spirit of the medium, however. Some artists are attracted to the graphic aspects of a subject, and find hard edges and sharp shapes suit their style of painting. There may also be times when you want a crisp edge or a straight line in an otherwise freehand painting, and find a brush or knife too clumsy to achieve this. You may want occasional

Masking tape

△ **1** *Masking tape can be used to create a straight edge or cut to obtain a jagged or wavy edge. In this picture, the artist is cutting a jagged edge with a sharp scalpel.*

△ **2** *The unwanted tape is removed by peeling it back from the support. The remaining cut edge – the mask – should be pressed down firmly on to the support.*

△ **3** *Thick paint is applied up to and over the masked edge. If the colour is too thin, it will seep under the tape.*

△ **4** *The mask is lifted clear of the surface, taking care not to smudge the wet paint.*

sharply ruled lines or mechanical shapes in your picture, even if most of the composition follows a freehand style.

You should not be inhibited about breaking away and using oils for sharper definitions but you have to be careful. Remember that straight edges can look out of place in freehand oil paintings.

When to mask

You may wish to divide a background with a particularly sharp line that requires emphasis. Your subject might be seen *contre-jour* – against the light – and you may want the dark silhouetted shapes to stand out particularly clearly against the bright background. The bottles and window frames in the painting overleaf are one such example, and the artist uses straight lines to emphasize the graphic qualities of the subject.

The quickest, most effective way of getting a cleanly painted edge to the colour is to use a mask. This protects the rest of the canvas, enabling you to paint right up to and over the edge of the masked area. When the mask is removed, you are left with a crisp mechanical line.

Masking materials

For a straight edge, use the special masking tape available at art shops and decorating stores. This is a soft, tacky tape that comes in various widths and can be removed without pulling the underlying paint away from the canvas. The tape will not adhere to wet paint, so the colour underneath must be dry before you start to mask.

A torn or jagged edge can be obtained by tearing or cutting the tape to the shape you want, then painting over it.

An alternative to masking tape is to use paper or card. Tear or cut this to the shape required, then hold it down firmly on the canvas as you paint over it. To remove the mask without smudging the paint, take one corner and carefully lift it clear of the surface without moving it across the canvas.

Paint for masking must always be fairly thick. If it is too runny, it will seep under the tape or paper mask and spoil the line.

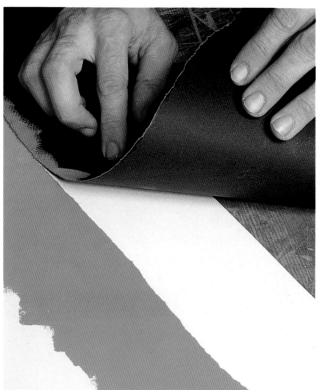

Paper mask

△ 1 *A mask can be made from a sheet of thick paper or thin card. Lay the sheet along the edge to be masked and apply thick colour up to and over the edge of the mask. Because the paper mask is not self-adhesive, it should be held firmly or taped in position as you paint.*

△ 2 *To remove the mask, take one corner and lift the sheet clear of the surface without touching the wet paint.*

PROJECTS

GLASS BOTTLES

A row of bottles standing against the sunlight is shown up as a pattern of stark shapes contained within the silhouetted frame of a sash window. It is an unusual subject in many respects, chosen by the artist for this reason. Rather than being changed in order to make a more conventional painting, the offbeat features have been deliberately emphasized.

Breaking the rules

An absence of obvious space within the subject is the first exceptional characteristic. A more conventional set-up would show the bottles grouped together, but here they are arranged side by side in a row on the window frame, and are therefore on the same plane. In addition to this, the bottles are viewed from a full-frontal position – you cannot see the sides of the bottles. Apart from the highlights on the glass, their volume is assumed rather than described.

Secondly, the composition is deliberately formal. The artist has placed the subject almost centrally on the canvas, and has used the window frame and panes to divide the picture symmetrically. A conventional approach would have been to offset these, to give the painting a more naturalistic appearance. The formality is further emphasized by the window frame, which is placed squarely on the canvas, with the horizontals parallel to the sides of the canvas.

The lack of space within the subject creates a flatness which is consciously accentuated by the artist, who chooses to paint the backgrounds as a flat colour instead of depicting the brick wall which is there in reality.

Masked bottles

The sharply defined bottles standing against the light are central to this painting. Each is different,

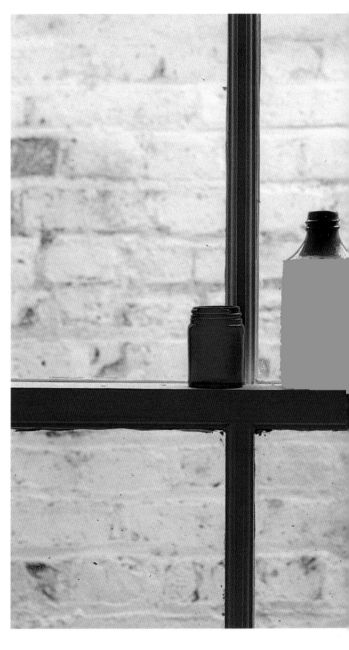

△ 1 *A row of bottles is lined up* 'contre jour' – *against the light. With the light behind them, the bottles stand out starkly, almost as silhouettes.*

both in shape and colour, giving the impression of a row of cut-out shapes. To re-create this starkness on the canvas, the artist uses masking tape to paint the straight edges of the bottles.

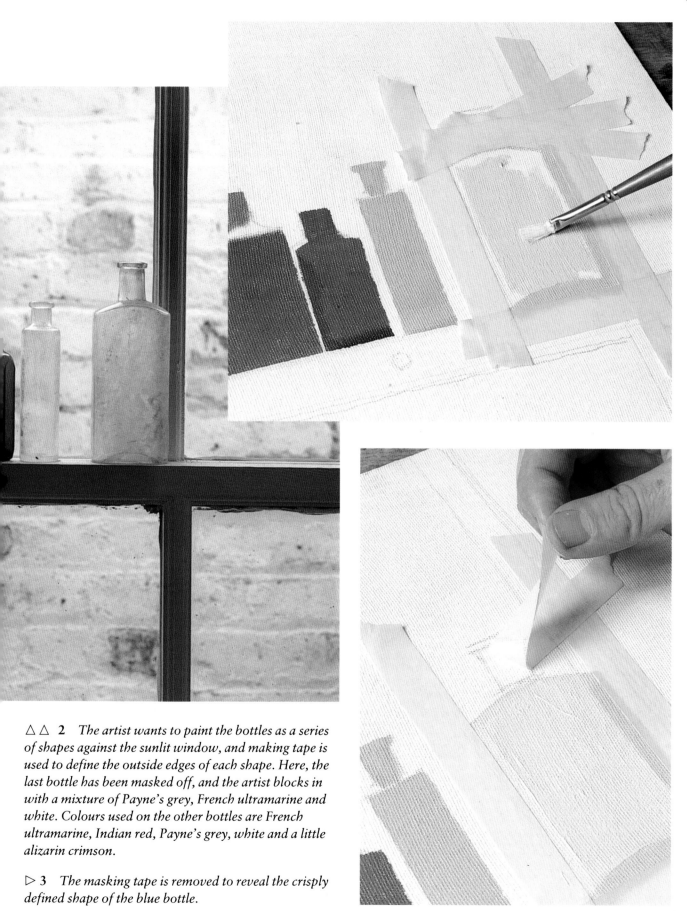

△△ **2** *The artist wants to paint the bottles as a series of shapes against the sunlit window, and making tape is used to define the outside edges of each shape. Here, the last bottle has been masked off, and the artist blocks in with a mixture of Payne's grey, French ultramarine and white. Colours used on the other bottles are French ultramarine, Indian red, Payne's grey, white and a little alizarin crimson.*

▷ **3** *The masking tape is removed to reveal the crisply defined shape of the blue bottle.*

173

▷ **4** *Masking tape is used along the straight edges of the sash window, which are painted in Payne's grey and white, with a touch of Indian red.*

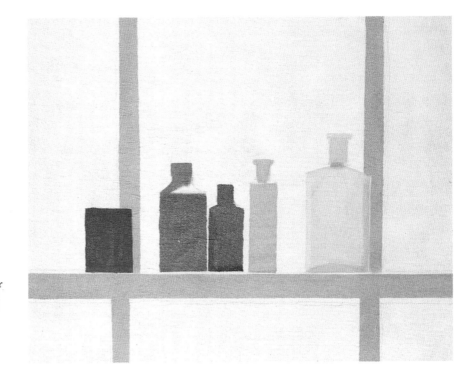

▽ **5** *Shadows and highlights are added in darker and lighter tones of the initial colour. These are painted as flat, cut-out shapes in order to retain the graphic qualities of the subject.*

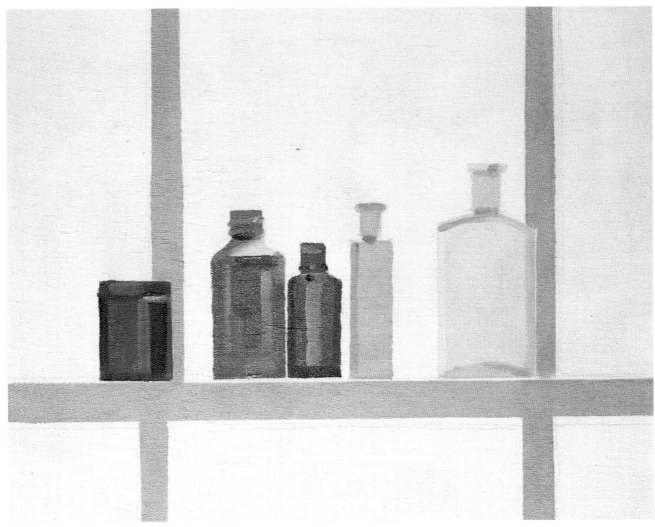

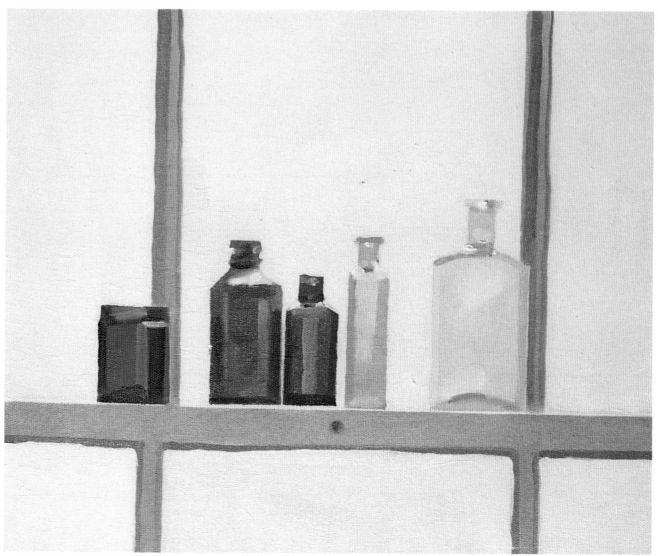

◁ **6** *The artist chooses to ignore the background bricks present in the actual subject. Instead, the background is painted in white mixed with a touch of Payne's grey.*

▽ **7** *In the completed painting, the subject has been simplified in order to re-create the essential elements of the subject. Straight lines and crisp shapes are created with masking tape; highlights and shadows are painted as simple, flat-shapes; and the bleached-out background has been rendered as a flat, light tone.*

Painting
Portraits in Oils

Jenny Rodwell

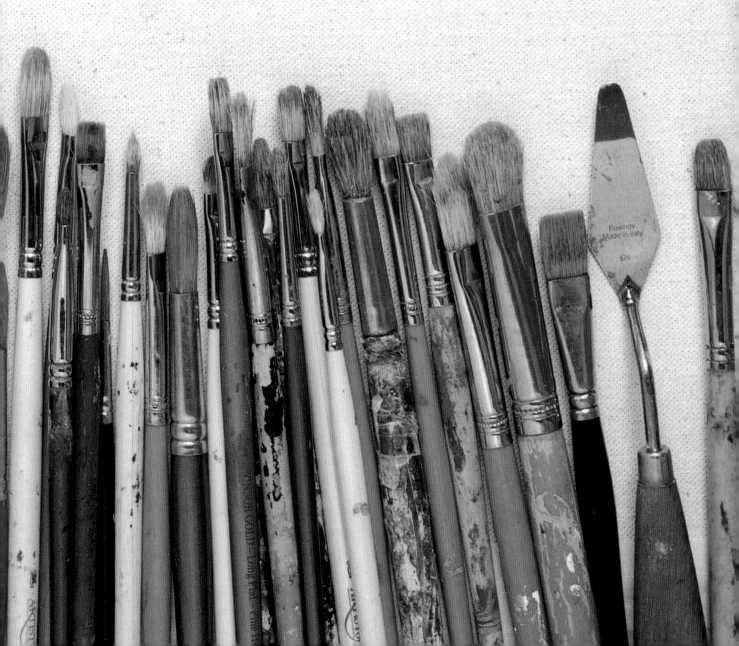

CHAPTER 1 CHAPTER

Introduction

Mᴏꜱᴛ ᴘᴇᴏᴘʟᴇ feel they can judge a portrait by one simple test: is it a likeness? The fear of this 'test', and the belief that there is some secret behind 'getting a likeness', prevent many from trying portrait painting for themselves. But there is no secret – it is a matter of careful preparation before you paint, and skill attained by practice and by the grasp of certain basic principles and techniques.

This book traces the vital preparatory steps, and introduces you to principles which will help you to paint what you see, rather than what you think should be there, so that the 'likeness' will come about of its own accord.

No two human faces are the same as each other; similarly, no two artists follow exactly the same procedures. Principles there may be, but there are no rigid rules in portrait painting – so for this book professional painters have undertaken projects which you can follow step by step, while the artists speak about their own individual ways of working.

The book is about oil painting. Oil is a forgiving and malleable medium, but thought and planning are still needed. The right subject – whether someone you know or a stranger – needs to be posed against a background, with thought given to composition and lighting. Preliminary drawings and sketches often help.

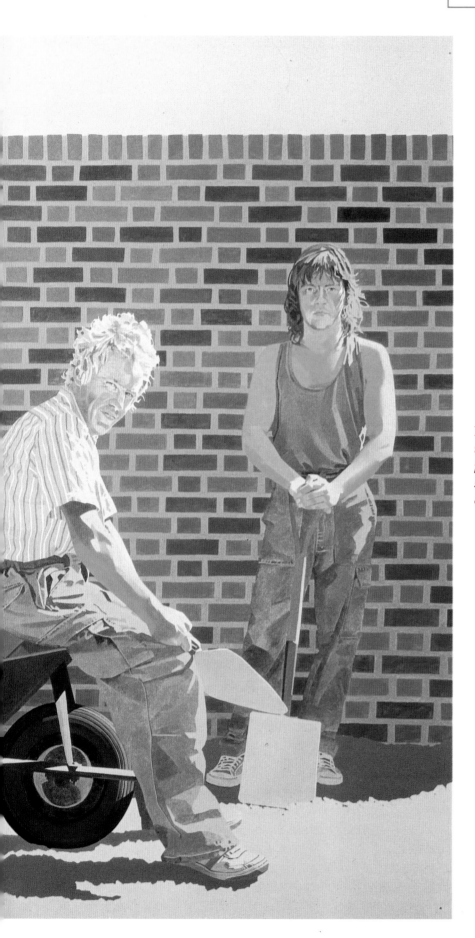

Double portrait *In an unusual
version of the classical double
portrait, Ian Sidaway's painting
shows two workmen with the tools
of their trade.*

THE LIVING FACE

The portrait once depicted not the living but the dead. The death mask allowed viewers to see the faces of those long gone, but in a way that was 'out of context' – with no background; just an isolated effigy with features frozen in what was usually a composed, expressionless manner.

The modern portrait artist, whether a painter or a photographer, confronts a much more complex set of problems. The faces are almost always those of the living; faces which need to convey feelings, mood and character. What is more, the people portrayed are not always set in isolation. Individuals are often positioned in environments which themselves have a story to tell.

The illustrations on this page show that there is no single way of painting a portrait. The approaches can be so varied that you have an enormous freedom of choice – but that same freedom calls for planning. There are questions to be answered even before setting up your easel. How can you best express the special qualities and characteristics of your subject? Do you want your portrait to be formal or informal? Will you paint just the head or do you prefer the whole figure? Will the figure be in a setting or do you want a plain background?

If you choose to place the portrait in an environment, make the setting positive. Suppose you decide to paint an individual in a domestic or work setting. In these cases, you would be painting not just a depiction of a person but an 'interior'. The Dutch painters of the sixteenth and seventeenth centuries mastered this approach brilliantly. Their subjects are actively interwoven with their settings: they play their musical instruments in furnished corners by open windows; they pour from earthenware pitchers in working kitchens.

There is another way in which the subject is integrated into the environment. Some artists make it quite clear that the subject is inside his or her home – an intimate touch is added.

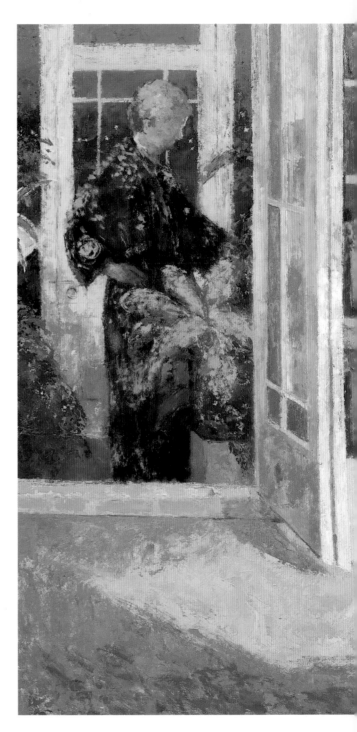

The isolated subject

Sometimes, however, the artist wants the face or figure to say it all, without background. One approach can be to set the figure against a plain wall that does not distract. But even in this case the wall usually has tone and texture, indicating that space exists between the figure and its background. Thus the figure is in three-dimensional space.

Alternatively, the environment can be removed

altogether, as in the painting on this page by Norman Shawcross, who paints his subject against the stark whiteness of the primed canvas.

Portraiture as a record

Perhaps more than any other artist, the portrait painter has played the historic role of official recorder. Just as we catch a glimpse of the past by reading a biography, so we can look back through the centuries by viewing people who have been preserved in portrait, not as dead masks but as living characters.

In the fifteenth century, for instance, the Dutch artist Jan van Eyck (d. 1441) was the equivalent of an official photographer or witness at the betrothal of the man and woman portrayed in the famous 'Arnolfini Wedding'. The painting is vivid evidence that the event took place.

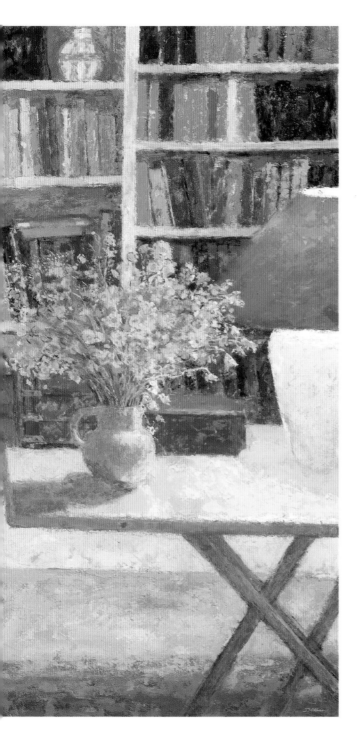

△ **The important setting** *In some compositions the setting is as important as the subject. 'Interior Evening' by Jack Millar shows how a figure can be the focal point yet occupy only a small part of the picture.*

▷ **Minimal background** *In his portrait of writer Francis Stuart, Norman Shawcross leaves the background as flat white, without attempting to create an illusion of three-dimensional space.*

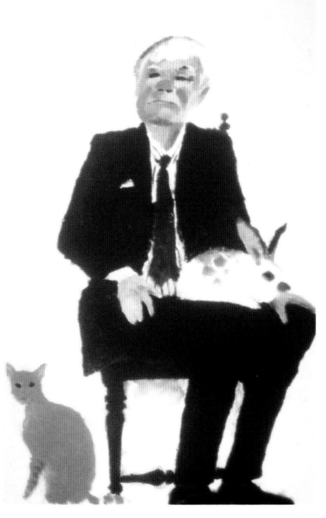

THE GOOD LIKENESS

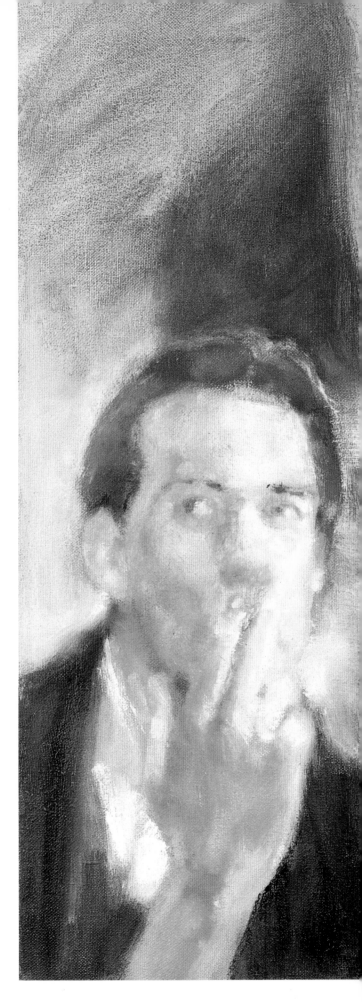

Portrait painters often face an awesome moment of truth: is it a 'good likeness'? This is one of the most difficult areas of portrait work, but there are guidelines which help to overcome the problems.

Instant attraction to detail can be a trap. The beginner may fret because the 'eyes are wrong' and consequently spend far too much time on this feature alone. The result could be that the eyes stand out from the rest of the face, often with overbright whites and a glassy stare.

An experienced artist, on the other hand, sees the eyes in relation to the other features and to the face as a whole. No single feature is more developed than another, and the whole face is kept in a state of flux until all the relationships are correctly established. Look closely at the majority of portrait paintings and you will see that the eyes are often no more than perfectly placed flicks of paint.

The human face is made up of different features – eyes, nose, chin, mouth and so on. As single elements they are far less important than you might think. What matters much more is how the features relate to each other.

The likeness, therefore, is not a mysterious ingredient. If you get the basic proportions and drawing right, then the painting will look like the sitter. It is a test of observation and accurate drawing rather than a special gift of vision. Quite simply, a good portrait is a good painting.

Character and gesture

Artists differ over whether it is a good idea to 'know your subject'. Many find it helpful to paint a sitter they know. Not only are they familiar with the face but they are also more relaxed with the subject. The 'Artist's Father' is one of several studies done of his parents by Humphrey Bangham.

Other artists prefer to paint a stranger. An unknown sitter helps them to take a fresh look at the subject. The painter then begins work free of any preconceptions.

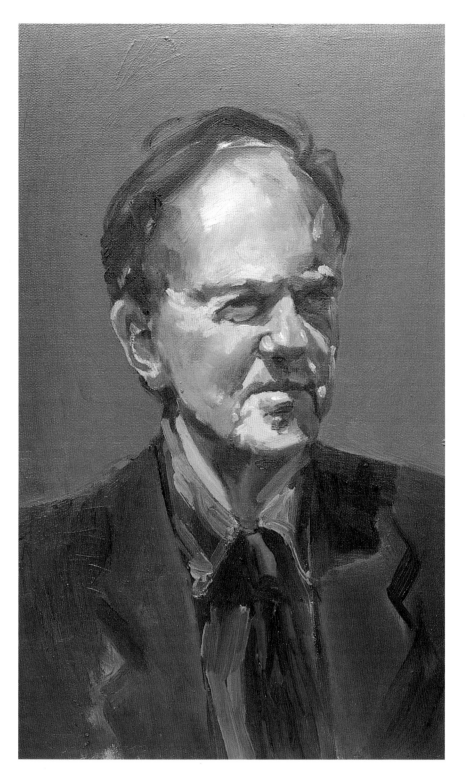

◁ **The familiar face** *Artist Humphrey Bangham is most at home when painting faces he knows well. This portait of his father is one of several studies of the same subject.*

◁ ◁ **Movement and gesture** *'Young Man Smoking' by Suzanne O'Riley captures a fleeting moment as the subject raises a cigarette to his lips.*

Sometimes a person is characterized – recognized – more by his or her gestures than by any physical feature – a typical tilt of the head, an expression, a certain way of sitting. Look carefully for the clues.

In the painting on this page of the young man smoking, the likeness has more to do with characteristic movements and facial expressions as he lights a cigarette than with physical likeness.

So, even when painting a stranger, spend a few minutes chatting before you freeze your model into a pose. This will give you the chance to observe your subject moving and talking. Informal drawings and quick sketches before painting will also allow you to weigh up your subject.

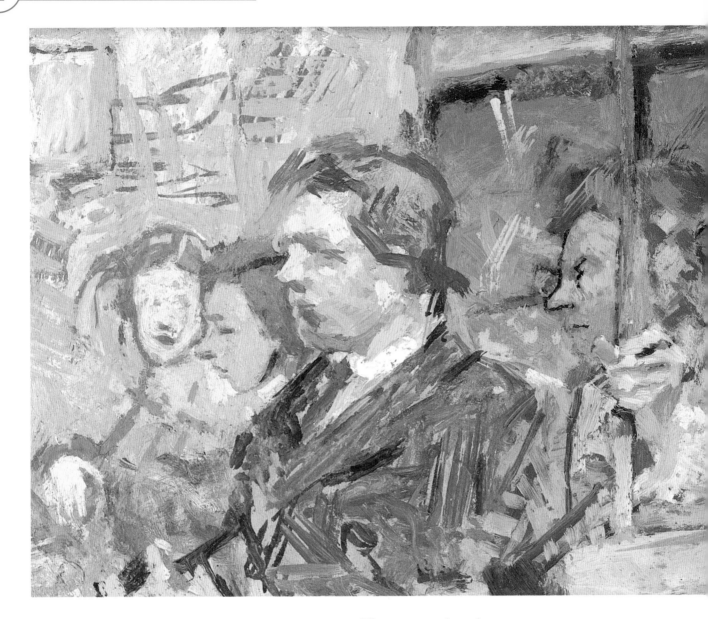

CONTEXT

The velvet and lace of some historical portraits offer obvious clues about the subject – showing their wealth and often their rank. But clothing plays another, purely pictorial, role as well. It adds texture, tone and colour to the painting as a whole. This is particularly the case nowadays, when easily available fabrics say less about economic and social status but nevertheless give the artist plenty of visual scope.

Thus, although the face tells us a lot about the character of the subject, the rest of the painting can often reveal much more.

The conversation piece

This is the term for a genre in which two or more people are usually depicted seated or posed informally, often husband and wife or other family members, against the setting of their own home, gardens or grounds.

Here, the setting gives sitters an instant identity – a peep into their lives. Good examples, which also fascinate historians, are the conversation pieces of the eighteenth century, such as those by the English artists Thomas Gainsborough (1727–88) and William Hogarth (1697–1764).

The modern equivalent of a conversation piece would include a subject or subjects in their place of work – office, studio or building site. The workmen with their barrow and tools on pages 4–5 and this

◁ **Groups** *This study of commuters on the Underground by Brenda Holtam is a rapid colour sketch of people who were not aware they were being painted.*

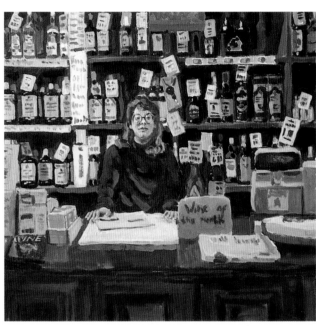

△ **Places of work** *'Oddbins' by Alastair Adams. The artist finds that the workplace is often more unusual and visually stimulating than a domestic setting.*

woman in her wine-shop workplace are good examples.

Double portraits and groups

When painting two or more people in the same portrait, it is even more important to develop the painting as a whole. Don't treat the work as two separate portraits which happen to be on the same canvas. There may be two subjects, but visually you are painting the same image, so treat the composition as an integrated whole, making the colours, tones and textures work together across the whole of the painting.

The formal and informal

Artists talk of two distinct categories of portrait –
the formal and the informal. One of the differences between them is that in the former the subject generally looks directly at the artist or poses especially for the picture. He or she is obviously aware of the artist.

When the subject's attention is not focused on the artist, then a certain tension is released which makes for a more relaxed, informal portrait. In double and group portraits, the attention of the sitters may be focused on each other. There are tensions here, but they are different ones. They lie between the sitters themselves, perhaps, as they look at each other; or their attention may be held elsewhere as they look at something either in or out of the picture.

In the painting by Brenda Holtam, the subjects are travellers on the Underground and are seemingly unaware of the artist. Conversely, the painting of the workmen is obviously posed. The subjects are posing specifically for the portrait and both are looking directly at the artist. 185

THE SELF-PORTRAIT

Look around any art gallery, and look at the portrait examples in this book. There is no single, correct way of painting a portrait. Artists develop their own approaches through trial and error, and often through looking at the work of others.

One of the great drawbacks of portrait painting is that the artist is often restricted by the need to please. This is particularly the case with professional portrait artists, who are usually commissioned on the basis of previous results. They become typecast into working in a particular way, and development and experiment become impossible.

To offset this, painting your own portrait provides the perfect opportunity for trying out new approaches and different techniques. With yourself as the sitter, you are not obliged to struggle with a tight or representational painting, and there is no one to please except yourself. For the beginner, this is probably the best and most accessible way of learning how to paint portraits.

Stepping outside ourselves

Whatever its advantages, the self-portrait does present certain problems. For a start, we all have a self-image. We think of ourselves in a particular way, which often has nothing to do with how others see us. This is why, when we look in the mirror, we adopt a certain expression.

When painting yourself, therefore, you should try to be honest – to adopt the honesty of work which comes more easily when painting a complete stranger. You must be able to step outside yourself and overcome the utter familiarity of your own face sufficiently to make accurate and objective visual statements. (Possibly this why so many great portraits have a particularly intense or haunting look.)

The Dutch painter Rembrandt (1609–69) painted himself at various stages throughout his life, documenting his progress from confident, successful young artist to disillusioned and poor old man. The

portraits reflect the rise and fall of his fortunes and popularity.

In a similar way, the self-portraits shown here are from a series by contemporary painter Alan Stones. Again, the images are a personal record – in this case of troubled and then eventually happier times in the artist's life.

△ **Setting up** *Artist Alan Stones at work on one of his self-portraits. The positioning of the easel, mirror and light source is all-important. Allow enough space to enable you to stand back from the work and assess progress.*

Two of a series of self-portraits painted by Alan Stones over a period of two years.

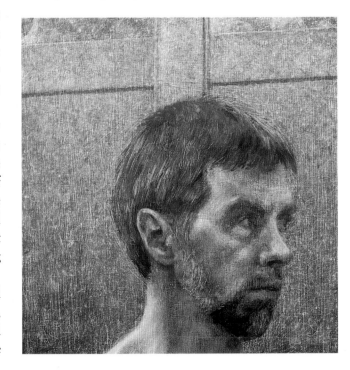

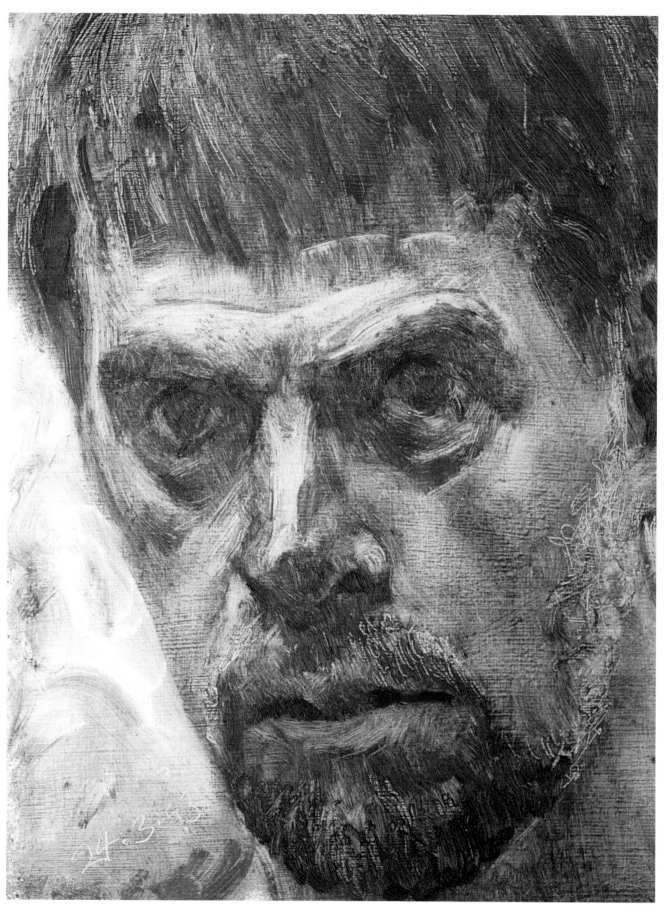

Thinking ahead

*E*VEN IF your portrait consists of only a head and shoulders against a plain background, the background and composition need careful planning. Where will the subject be positioned and how will you deal with the surrounding shapes?

There is an unlimited choice of backgrounds, both outdoors and in your home or studio. But perhaps the most satisfying is the one you create yourself, building it up so that the background arrangement takes on its own life.

The French artist Edouard Vuillard (1868–1940) took enormous delight in pattern and decoration. His figures almost always appear before a cacophony of wallpapers, printed fabrics, woven designs and any other manufactured material. It is a good idea to keep a selection of old curtains, bedspreads – anything giving a choice of colour or pattern.

To help you think about background and composition, follow the well-tried technique of cutting a rectangular shape out of a sheet of paper or card and viewing your subject through the frame. Move the frame in much the same way as a photographer moves a camera in order to find the best shot. Alternatively, cut two L-shaped brackets which can be moved around and adjusted to form a rectangle of any proportion.

188

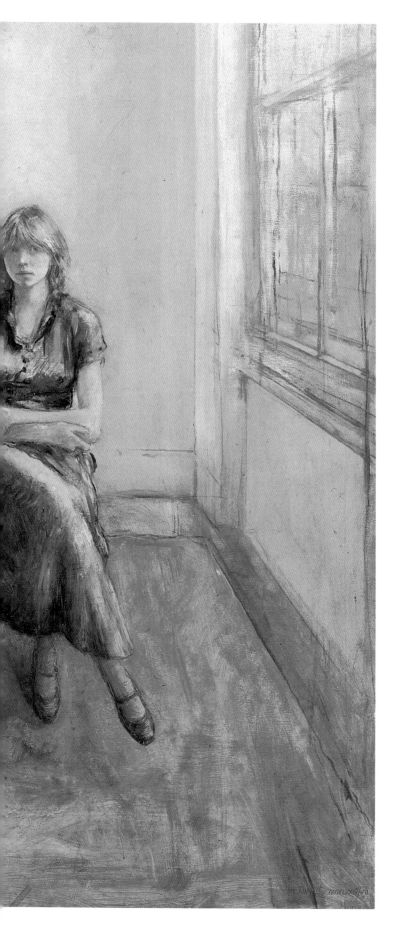

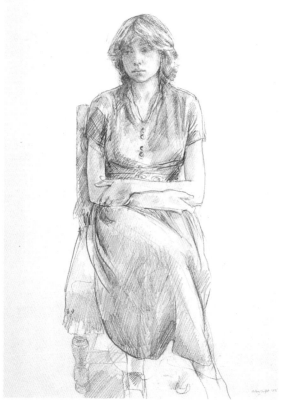

The figure sits alone in an empty room, giving a sense of space and solitude to this portrait. Antony Dufort painted the picture from life with the help of preliminary drawings.

BACKGROUNDS

The background is not an afterthought. Too many beginners plunge straight into an attempt to capture the features of a sitter before even thinking about the composition as a whole. Plan the background as part of the picture. This may involve arranging a special background or moving the sitter to a different location.

To professional portrait painters, choice of background can be critical. Sitters, too, often have strong ideas about this, and many want to be portrayed in a setting of personal significance – perhaps the workplace or a special room in the home.

These factors can extend the portrait into a more complex and interesting work. Often, they call for as much attention to be paid to the background as to the person being painted. The portrait becomes an interior with other elements, such as artefacts and furniture, which must be arranged and incorporated into the composition.

The alternative to a busy background is to opt for a minimal or plain backdrop to ensure that the surroundings do not dominate the main subject. Even this should be planned in advance, though, because it will still play a vital role in the finished painting.

Plain backgrounds

A sense of space is important in all paintings. If your portrait is painted realistically, in three-dimensional terms, with light and shade to describe the form, then an illusion of space has already been

▽ *The background affects how we perceive a subject. Busy backgrounds can confuse the image, unless the background colour is unrelated to the colours on the subject. Warm backgrounds bring out the warm flesh tones; a cool background emphasizes cooler tones. A light background shows up the shape of a darker figure; a darker background blends with dark tones on the subject.*

Dark background

Light background

Warm background

created on the canvas. A flat background can contradict this visual illusion, which is why backgrounds are rarely painted as completely flat colours, even when the sitter is portrayed against a plain, featureless wall.

A background wall is almost always uneven, particularly when the subject is lit from the side, causing the part of the wall closest to the light source to be lighter in tone. Thus the painting of a flat wall will usually be graduated – going from light to dark behind the figure.

Tone and colour

Whatever background colour you choose, that colour will be picked up and emphasized elsewhere in the painting. This is particularly relevant with portraits, because flesh tones of all races tend to contain a normally unnoticed mixture of colours, ranging from warm pinks, browns and yellows to cool blues and greens. Thus a cool background will pick up cool shadow tones, giving the whole painting an overall coolness. A warm background tends to emphasize the pinks and yellows of the flesh, giving the portrait an overall warmth.

The paintings in this book show that artists normally choose to illuminate the sitter with a strong side light. This is a classical portrait-painting technique, popular because it shows the form of the face clearly in well-defined planes of light and shade. Thus lit, however, one side of the face is strongly illuminated while the other is in equally strong shade. This makes the background tone particularly important. With a light background, the illuminated side of the face often merges with the background; against a dark background, the same thing can happen to the shaded side of the face.

The side-light approach is fine, provided it produces the desired effect. The demonstration painting on page 219, for instance, is deliberately set up in this way because the artist chose to soften the contour on one side of the subject's face. However, if you want the head as a whole to stand out from the background, then you must select a medium-toned background, or one that provides enough contrast for the subject to stand out clearly.

Busy background, intrusive colour

Cool background

Busy background, contrasting colour 191

THE RIGHT POSE

It is important that your sitter is comfortable from the start. A natural position will look and feel right and will be easier to hold for a long time. An awkward pose, as well being difficult to maintain, will be reflected in the painting. Try several different poses, asking your sitter which feel right and which don't.

Normally a portrait subject will be seated. This means he or she can keep the pose for relatively long periods. With a standing pose, remember to allow for frequent rests for the subject. Professional artists' models take a fifteen-minute break every forty-five minutes – more if they are holding a difficult pose. Don't get so carried away with your painting that you completely forget the needs of the sitter. If necessary, ask your subject to tell you when it's time for a rest.

Angles of the head

In many portraits, the composition consists quite simply of a full-frontal view, with the subject looking directly at the artist. This approach works well for many painters, particularly when the artist is interested primarily in the character of the sitter, rather than in the background and the surroundings. For the beginner, the full-frontal might seem attractive because it sounds easy – but this is not necessarily the case.

The nose, eye sockets and underlying structures are less prominent when you are looking at the face from the front; the forms of the features can be seen less clearly. There really is a three-dimensional structure to the full-frontal face, yet the inexperienced do not look for this. Instead, they tend to fall back on preconceived ideas of what they know should be there, rather than looking at what they can actually see. The result might well be a squashed nose, staring eyes and a pancake face, similar to the pictures done by children.

Do not let this difficulty put you off the full-frontal view. Just don't presume that it is necessarily

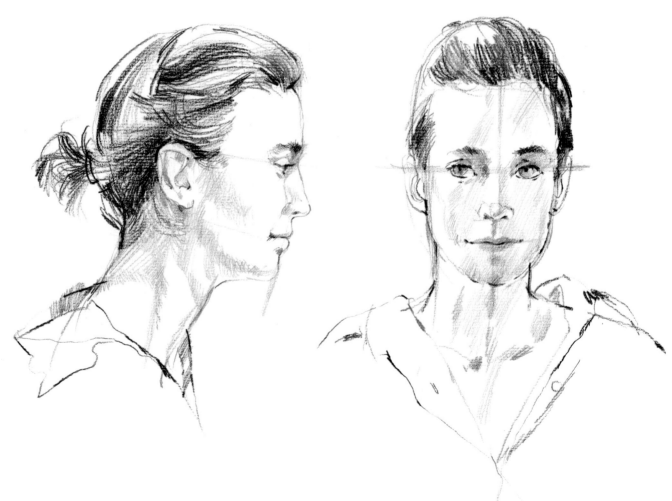

the easiest to paint. As an alternative, however, you can paint your subject in profile, presenting an absolute side view of the face – especially effective if the subject has prominent or distinctive features.

A more natural view lies half-way between a profile and a full-front view and is sometimes referred to as a three-quarters view.

Marking the pose

Finding exactly the same pose after a break can be tricky. You will find it helpful if you mark the sitter's position with chalk or strips of masking tape so that he or she can easily get back into the same pose. For a painting which takes several sittings, mark the position of the chair legs as well.

Inevitably, sitters relax during a long session, so it is wise to give your subject a few minutes to settle down after each break before starting to paint. It is also a good idea to get your sitter to fix his or her eyes on a constant point – this way the angle and direction of the head will remain constant.

Fabrics are more problematic, for you will never get pleats and folds in clothing to fall in exactly the same place twice. Perhaps the best approach is to keep clothes and drapes in a sketchy, fluid state in the picture until the final stages. Another approach is to paint the clothes as they first appear and then ignore any subsequent changes.

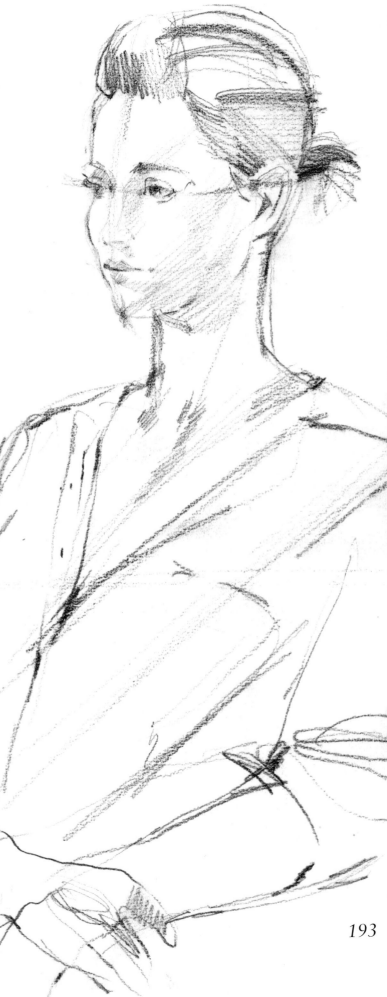

Two classical portrait poses are profile (far left) and full-frontal (left).

A three-quarter view (right) combines the advantages of the profile and full-frontal view.

LIGHTING

So you pose your sitter and arrange the background, and begin the painting . . .

At first, everything is fine, but after a while the subject begins to change before your very eyes. Shadows appear, highlights that had not been so noticeable. Tones and colours seem to have changed.

You forgot to think about the lighting.

The effects of natural light are notoriously inconsistent, changing not only with the time of day but also with the weather conditions, which can alter radically from minute to minute. Yet, despite this – and despite the need for a constant light source to illuminate the subtle colours and forms of the human face – most artists prefer natural light. It is softer and does not distort colour.

If you choose to work by natural light, a north-facing one is undoubtedly the best, because it is more constant and does not cast heavy, changing shadows across the subject's face. Light from other directions, particularly the south, is subject to harsher shadows and starker contrasts.

In an ideal world you would paint at similar times of day and at similar stages in the weather. In the real world, you should be aware of the problem, establish a plan for colour and tone and stick to it. Sketches and photographs can be helpful here.

Daylight substitutes

Ordinary artificial light bulbs are less sympathetic than natural daylight and distort the colours on the subject. More seriously, they also distort the colours laid out on the palette, sometimes making it difficult to see the difference between one tube of colour and another, let alone to differentiate between the more subtle and similarly toned flesh colours.

One solution for the portrait painter is to use daylight bulbs. These are not identical to natural lighting, but they are a reasonable substitute and have the advantage of consistency. You can use daylight bulbs instead of natural lighting or you can install bulbs by a window and use them to replace the daylight as it fades or changes.

△ *The subject is lit from behind, obscuring the features in dense shadow and making the face too dark to paint.*

△ *A white screen, placed on the nearside of the subject, provides a soft reflected light which shows up the features.*

Direct or diffuse light

A strong directional light produces emphatic areas of light and shade. Some artists like the dramatic effects of chiaroscuro, as these exaggerated shadow and highlight patterns are called, because the features and underlying muscle structure of the subject are so clearly defined. Typically, chiaroscuro paintings show the subject against a dark background, with bright highlights where certain features catch the directional light.

If you find a directional light source is too strong,

Front lighting

Side lighting

Top lighting

the effects can be softened by placing a white sheet or gauze across the offending window or lamp. Alternatively, you can soften the shadows on the face by placing a white screen or sheet on the shaded side of the subject. This can be adjusted to produce a soft, reflected glow on the dark side of the face.

A broad overhead light would enable you to follow the example of Leonardo da Vinci (1452–1519) and light your subject from above. Leonardo did this to re-create as closely as possible the effects of natural sunlight, because that is how we normally perceive people and it therefore allowed him to get a better likeness of the sitter. He argued that if you met a close friend who was illuminated from below, the face would look so unfamiliar that you would probably not recognize it.

Lighting is one of the most important factors in portrait painting, so it is well worth spending some time discovering the possibilities. It is a mistake simply to sit your subject on the nearest chair and start painting. If you can't move your source of light, try moving the subject and see what a difference this can make.

COMPOSITION

Even if your portrait is a full-frontal view of a head and shoulders against the simplest background, you should still consider the composition. Too much empty space around the figure can make the painting look sloppy and unstructured. Too little space and the figure appears squashed and cramped.

The background has 'shape'; it is not just leftover space. So you should treat this positively and establish the areas of background as shapes in their own right. And it is not only shape; the background also consists of tone, colour and texture, all of which have a bearing on the actual subject.

Scale and proportion

A portrait is not necessarily small. It can be as big as you like, especially if you want to include most of the figure and a lot of background as well. Keep an open mind about the scale of your picture. Eventually, you may decide that a particular size suits you best, but initially you would do well to experiment and explore different possibilities.

Normally we think of a portrait as being vertical rather than horizontal. The figure or human head fits conveniently into a vertical rectangle, which is why it is often referred to as a 'portrait' shape. Used horizontally, the same rectangle is called 'landscape'.

Again, we should not make assumptions but should consider every possibility before automatically starting to paint on the good old 'portrait' rectangle. It sometimes make a refreshing change to see a portrait treated in an unusual way, perhaps on a horizontal rectangle, with the figure offset to one side; or perhaps on an exaggeratedly tall rectangle, as the artist has done with her painting on page 182.

The illustrations here show a few of the many different ways in which a typical portrait subject can be planned and painted.

Space and harmony

The object of most compositions is to create a harmonious balance of shapes and colours and to avoid any discordant or uncomfortable element in the picture.

Portraits are naturally harmonious in that the human face is an automatic focal point, and the viewer's eye is immediately attracted to that point. Even so, bad planning and clumsy handling can destroy this natural advantage. It is possible, for example, to put a figure too close to the edge of the support. This is especially damaging if the subject is looking outwards, past the frame, because the viewer's eye, and interest, are then led out of the picture. A clumsily positioned hand or arm can have a similarly discordant effect.

Portraits containing more than one figure are generally arranged so that the subjects have equal importance in the picture, but not in every case. With two or more sitters, there is greater scope for composing the subject within the canvas area, and you should aim to make the subjects complement each other without imposing a rigid symmetry on the painting.

The model sits on a garden seat against a wide background of flowers, foliage and stonework. Before starting to paint, the artist views the subject through two L-shaped brackets, moving these around to find suitable compositions for a portrait painting.

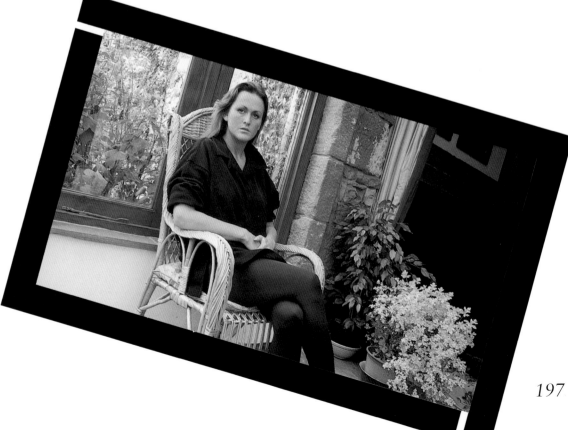

A whole range of expressions shows just how much a change of mood can alter the human face.

THE HUMAN FACE

We have seen most of our friends and acquaintances in different moods – smiling, pensive, relaxed, agitated and so on. We come to recognize them in these moods, and the recognition is so automatic that we tend not to notice the dramatic facial changes that each change of mood brings.

A change of expression is a structural change. As the underlying facial muscles contract or relax, they completely alter the contours and surface forms of the face. It is important, therefore, to consider the facial expression of the sitter before we start painting.

It is not just a question of whether the finished portrait makes the subject appear happy or sad. The expression is important in another way, one which is often ignored – the simple matter of how possible it will be for the subject to maintain a particular facial expression throughout several sittings.

Keep it general

We have said there is nothing mysterious about the ability to get a good likeness. Obviously the likeness is important, especially when the sitter is usually

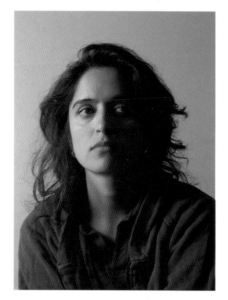
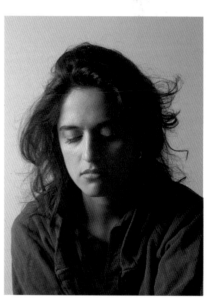

there for that very reason. But it should not become an obsession. Although it is difficult to do this, try to forget you are painting a person. Try instead to see your subject as an arrangement of forms, shapes, colours and tones. Get these right and the likeness will take care of itself.

It is the correct relationship of one element to another that creates an accurate likeness. Remember, the spaces between the features are as important as the features themselves. It is no good painting the perfect nose if the nose is in the wrong place.

Remember that it is a great mistake in portrait painting to pay too much attention to detail. The problem is that when a certain part of the face has been painted in great detail, it requires enormous

willpower to change it should it prove to be wrong.

One very good way of avoiding the temptation to overdo the detail is to use large brushes. In this way, you are forced to concentrate on the overall image, and it becomes easier to keep the painting in a state of flux and change.

It is important to avoid the abnormal stare that often results when inexperienced portrait painters overestimate the importance of eyes. Eyes may be the natural focal point of the face, but they should not be painted in more detail than the rest of the face. The commonest mistake is to make the whites of the eyes too bright. Take particular care to relate the whites of the eyes to the surrounding tones; they are usually darker than you think.

Basic anatomy

You don't have to spell or pronounce sternocleido-mastoids to be a portrait painter, but it helps to be aware of them. They are part of the structure of the head and shoulders, and it is important to the artist to know a little anatomy.

Medical knowledge is unnecessary, but it is best to adopt a logical approach when you are drawing and painting, so that you understand how surface changes in the face and torso are caused by muscular movements under the skin.

For instance, the portrait artist takes note of how the head is attached to the neck, and how the movement of the neck affects that of the head. This action is caused by two muscles which pass from behind each ear to the breastbone: the sternocleidomastoid muscles. If you can be aware of their presence and what they do, then your portrait will be the more convincingly structured and therefore more realistic and naturalistic.

In an infant's face, the eye sockets are disproportionately large. A child's jawbone is underdeveloped and the features tend to be in the lower part of the face. The growth of teeth makes the jaw more prominent, lengthening the face. Adult bones usually keep their shape but, as cartilage changes and teeth are sometimes lost, there is an apparent shrinkage of the head in old age.

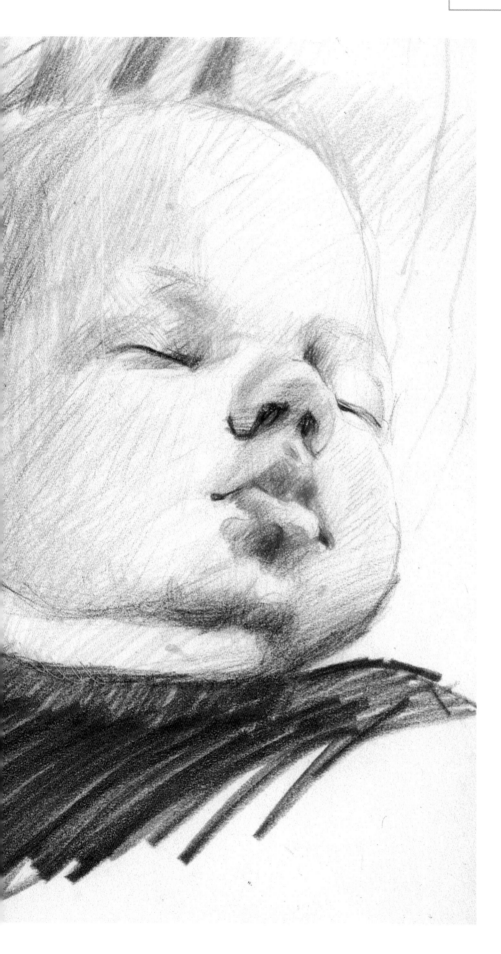

Preliminary drawing *The facial proportions of babies and young children differ from those of adults. Humphrey Bangham used coloured pencil for this exploratory drawing of one of his children.*

HEAD AND FACE

It is now time to pause for a brief excursion into anatomy, to take a look at what happens under the skin. We know that facial expressions make a considerable difference to the portait – that you cannot make a person smile simply by turning up the corners of the mouth, or make the same person look sad merely by making the mouth turn down. Such expressions are caused by muscular movements which affect the whole face, so to paint a convincing expression means knowing a little about the muscles themselves.

The head

The skull is made up of two basic parts – the cranium and the jaws. The cranium, which encloses the brain, dictates the shape of the head. It varies considerably from person to person, and can be an important and distinctive part of a portrait. It is useful to establish the shape of the cranium correctly in the early stages of the portrait, because other features can then be positioned correctly in relation to this. A thick head of hair can obscure this shape, but the hair itself is dictated by the bony shape underneath.

The cranium of a young baby is larger in relation to the face than that of adults.

The muscles

Muscles in the face are used in order to speak, eat, blink and sniff. In other words, they are connected to the facial orifices – the mouth, the eyes and the nose.

▷ *The rounded surface forms of the human face make it hard to differentiate between light and shaded areas because the two merge gradually on the rounded surface. Here, the artist has ignored the 'roundness' in order to establish the forms in visible planes of light and shade.*

The muscles around the mouth are particularly significant. They form the lower part of the face, and are the 'mound' which causes the mouth and lips to stand proud of the facial structure. The lips are not just a flat shape painted on to a flat face. They are part of an arrangement of forms which make up the lower half of the face.

Similarly, the top of the face is dominated by the eye sockets and the muscles which open and close the eyes. Some of these muscles surround the eye cavities; others join the brow of the eye to the forehead and scalp. The visible parts of the eyeballs are relatively small and can be painted only in the context of the bone-and-muscle structure which contains them.

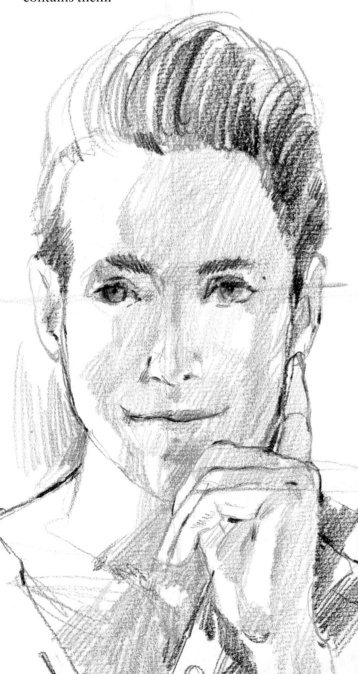

Facial 'planes'

For the artist, it is not particularly helpful to know the names of the various muscles, but it is essential to know that they are there and to be able to see how the internal structure affects the external features.

The painter sees muscles as forms covered by flesh. These are made visible as the light catches the face, showing up the 'planes' – the highlights and shadows, and patches of warm and cool skin colour. These are the parts which together form the whole: the sitter's face.

The best way to understand the concept of planes is to imagine an origami ball – a paper structure which, instead of having a continuous, rounded surface, is made up of tiny, regular, flat surfaces. These surfaces are known as planes and each catches the light in a different way.

In a similar way, the human face can be observed as a series of planes – not regular, like those on the origami ball, but corresponding in shape and size to the bones and muscles underneath. In the illustration here, the artist has used oil paint to pick out the facial planes in observed warm and cool flesh tones.

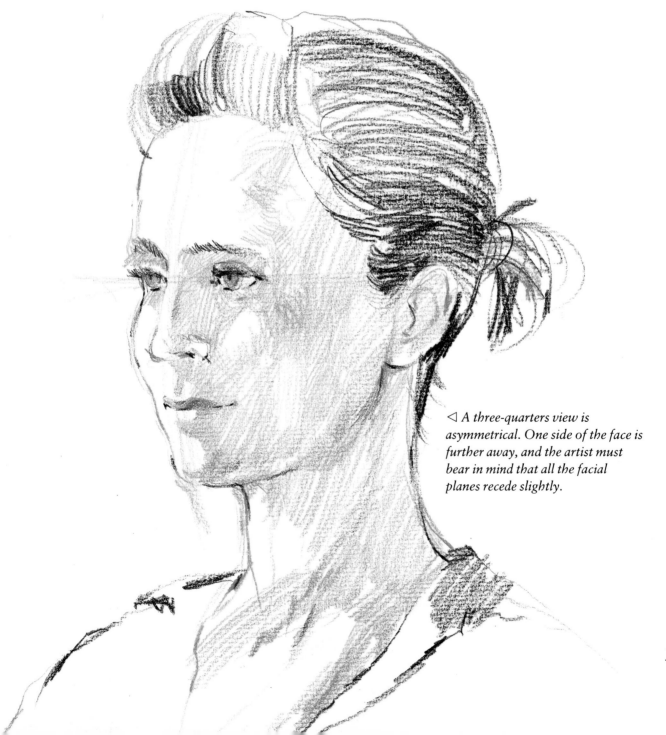

◁ *A three-quarters view is asymmetrical. One side of the face is further away, and the artist must bear in mind that all the facial planes recede slightly.*

HANDS

Hands and arms are rivals to the face, drawing attention away from it. If you want to include hands in your portrait, they must be painted and positioned with care; the hands and arms inevitably become an important part of the composition.

Because they are more or less the same colour and tone as the face, hands and face are perceived simultaneously. This can be turned to your advantage, and you can use the similar tones to create a harmonious balance in the composition. But if the hands are clumsily positioned or badly painted, they will create discord and become an unwelcome focal point.

Composing the hands

Clasped hands are perhaps the most used compositional device in portraits. In such paintings, the arms form an enclosed shape, with the head at the top and the clasped hands at the bottom. This arrangement is usually comfortable to look at, but the composition can appear very symmetrical, especially when the clasped hands and the face-form are the same size and a similar shape. Avoid this symmetry by offsetting the figure, or at least offsetting the hands so they do not fall directly under the face.

A similar rule applies when the hands are positioned separately – perhaps laid on the sitter's knees or resting on a desk or table. Here, too, the composition can be very dull and symmetrical, with the hands forming the base of a regular triangle. One solution is to avoid having both hands on the same level.

It is always a mistake to allow fingers, hands or bare arms to go off the bottom of the picture. This cut-off point becomes an immediate focus, and the viewer's attention will be drawn towards the bottom edge of the picture when it should be resting on the face and figure.

Drawing and painting hands

Hands are much simpler to draw or paint than might at first appear. Difficulties arise only when artists try to paint each finger separately, without seeing the fingers and thumbs in the context of the rest of the hand.

Clasped hands, hands on knees and hands holding a book – common positions for the hands in many portraits. When drawing these hands, the artist started by making light construction lines showing the main planes and directions.

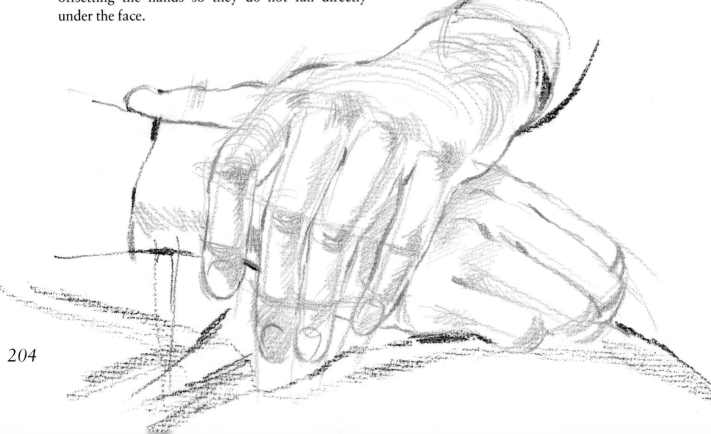

Hands can and should be simplified. Whether you are looking at a clenched fist, an open palm or a relaxed, drooping hand, it is a good idea to start with some basic construction lines. If you can first establish the planes across the hand, knuckles and wrist, as the artist has done in the illustrations here, then the underlying structure of the hand will be sound, and the fingers can be integrated into this.

We often see portraits in which the hands have been suggested – roughly sketched and blocked in – instead of being painted in the same detail as the rest of the painting. Sometimes, the hands are no more than a series of well-placed brush-strokes. Usually, the reason is that the artist wants to establish the hands without distracting attention from the face.

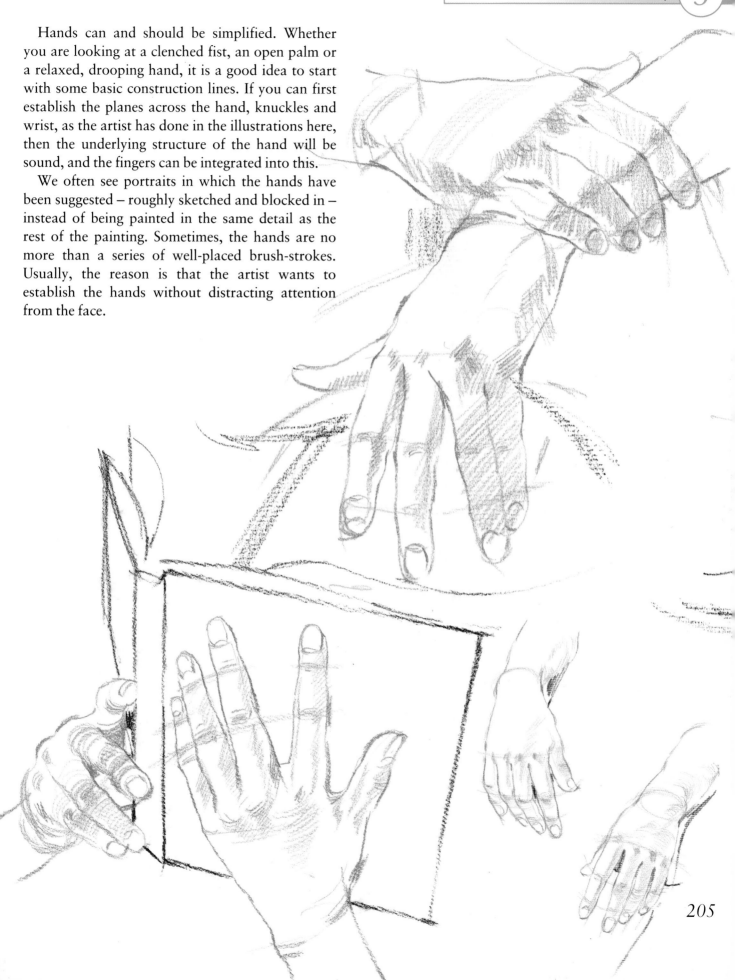

FLESH TONES

Have no preconceptions about the colour of skin. Once you look very closely at the skin tones of the subject, you will realize how hugely the colours can change from one part of the face to another. Some of these variations are changes in the local colour within the face – a red nose or pink cheeks, for instance. But by far the greatest reason for colour changes is that skin picks up and reflects surrounding colours, and can also look completely different depending on whether it is in the light or the shade.

The local colour of the skin affects the tones, but does not greatly influence the range of cools and warms, or the colours we choose for the palette. With both light-skinned and dark-skinned people, the local colour determines the basic tones to some degree, but the direction and strength of lighting are what really create the final colour variations. Black skin is more affected by reflected light than white skin, but in each case it is the relationship between the light and dark areas that is important to the painter.

Colour temperature
Highlights and shadows are never simply a lighter or darker version of the same general skin tone. Each has its own colour temperature, and you will see that shadows contain more grey, blue, green and cool purples, whereas lighter areas generally contain more warm browns, yellows, reds and oranges.

Approaches to painting flesh differ considerably. In the Renaissance, it was common to underpaint the flesh areas with a mixture of terre-verte and lead white. The cool green underpainting, showing through the warmer skin tones, gave the subjects a rather ethereal look.

Modern and contemporary artists still use glazing techniques similar to those employed by Renaissance

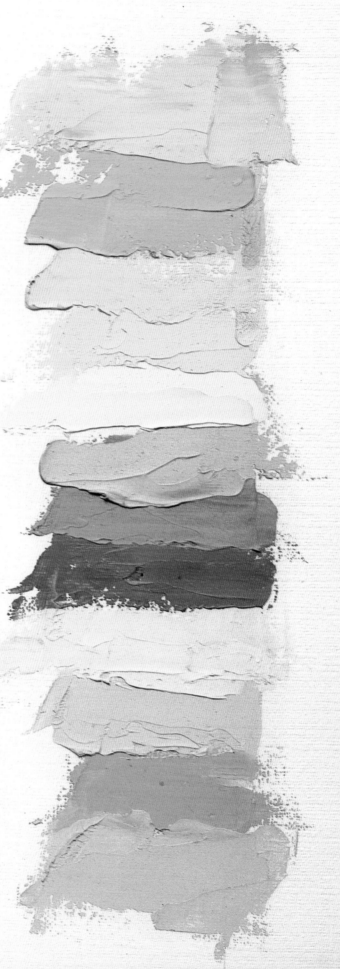

▷ **Warm tones** *Some random light skin colours mixed from white, Indian red, cadmium yellow and alizarin crimson.*

painters. They find the transparent layers of colour ideal for re-creating the translucent, subtle quality of human skin.

Choosing a palette

Choice of colour is a personal one, and most artists develop their own palette after considerable trial and error. The artists who produced the demonstration paintings worked in colours of their own choice. As a rule, the palette was the artist's standard one, with the quantity of colours adapted to suit the subject.

Although the overall palette differed from artist to artist, certain colours were used by all of them when painting the flesh tones. The common colours were yellow ochre, raw umber, white and a brownish red – either burnt sienna, Indian red or Venetian red. Each artist also used at least one blue and a strong, light yellow.

With experience, you will develop your own choice of colours, and for the step-by-step demonstrations you will need the colours used by the artist. As a general guide, however, you do not need a vast range of colours. In fact, initially you would be wise to stick to a limited one, adding to it as you feel the need to experiment and expand your repertoire.

The following colours will give you a basic palette and are perfectly adequate for the newcomer to portrait painting: white, black, cadmium red, alizarin crimson, cadmium yellow, yellow ochre, ultramarine, burnt sienna, raw sienna, burnt umber and viridian. Additional colours used by artists in the step-by-step projects are cerulean blue, manganese blue, Prussian blue, Naples yellow, Venetian red, flesh tint, Payne's grey and vermilion.

◁ **Cool tones** *Shadow colours achieved by adding small amounts of cobalt blue, viridian green or Payne's grey to the warmer tones.*

207

Portrait projects

*T*HIS SECTION of the book is purely practical. It covers techniques and methods which are particularly appropriate to portraiture, and demonstrates how these are applied in an actual painting. We asked a number of artists to make a contribution. Each has brought his or her own ways of working, and each employs different techniques and principles. The artists also chose different materials and worked from their own choice of palette.

Ian Sidaway works systematically and accurately, often enlarging a precise preliminary drawing on to the canvas using a grid system. Both the technique and its application are clearly shown in his portrait of a young girl. Suzanne O'Riley, on the other hand, works more intuitively. She often makes small colour sketches, but these are more for exploratory reasons than as a specific stage towards the final product. These are two of the diverse approaches employed by the artists.

You are advised to use these projects as guidelines for work of your own choice – with your own subjects. The projects illustrated here are for you to enjoy and learn from.

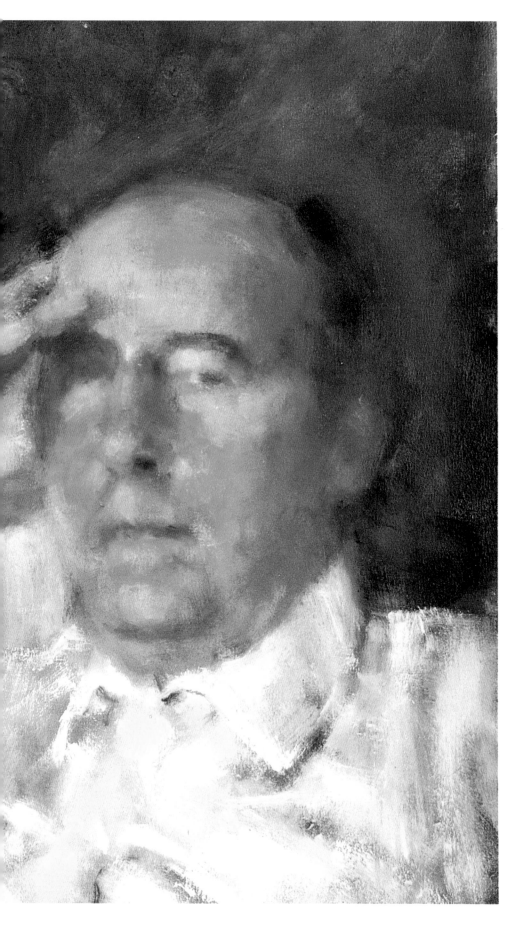

Suzanne O'Riley painted this portrait of Doug Hayward with soft brush-strokes and undefined patches of colour. Seen from close-quarters, the image is hazy and blurred. Looked at as a whole, the softly laid colour describes a solid, structured figure.

TECHNIQUES

COLOUR SKETCHES

Tiny colour sketches are a good starting point for a portrait. They allow you to see at a glance how the finished portrait will look, and whether it is worth pursuing a particular pose.

These pocket-sized sketchbook colour notes were made by artist Suzanne O'Riley, who painted the portrait on the following pages. Suzanne usually starts with a sketchbook miniature, saying it gives her a feel for the subject. She is not interested in detail at this early stage, and often paints these miniatures with a very large brush.

The sketches were done in oil, with the palette that Suzanne will eventually use for the actual portrait. She likes to do them spontaneously, without having to think ahead and prepare her surface. She also likes to use the same colours and materials that she will eventually use in the finished portrait.

As well as being a useful first step towards a larger painting, these tiny preliminary sketches are delightful in their own right. Some of the sketches shown here were developed later as larger portraits. The artist was able to see from each sketch whether the lighting, colours, tones and composition were workable, and whether or not they would translate effectively on to a larger scale.

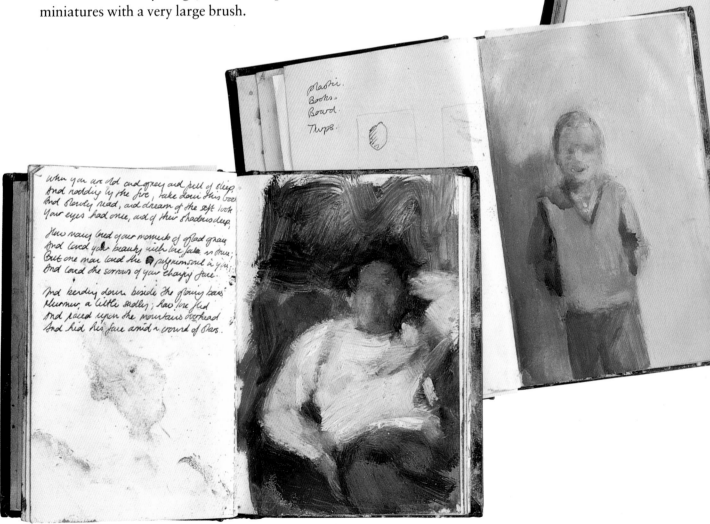

Tiny colour sketches made in a pocket-sized sketchbook by Suzanne O'Riley. The artist often makes these quick oil sketches before starting on a larger work of the same subject.

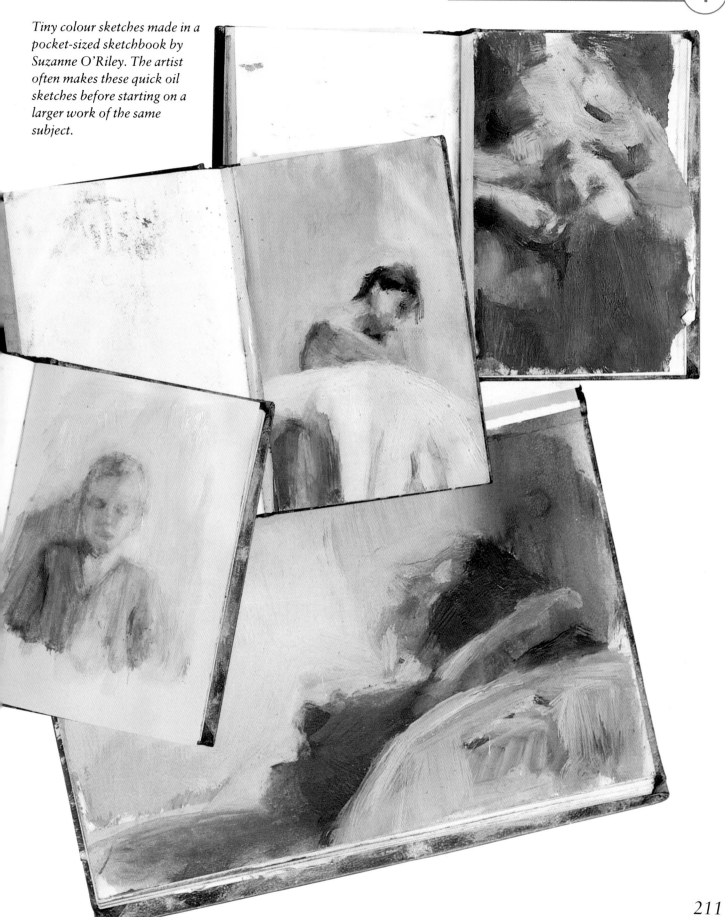

TECHNIQUES

PRELIMINARY DRAWINGS

The practice of making a preliminary drawing prior to starting a painting is a usual one, especially with portrait artists. The human face is a complicated structure; it takes time to become familiar with the features, expressions and other component parts.

And there is another reason for a preliminary drawing. It is quite common to hear portrait artists say they like painting subjects they know well. Unfortunately, with professional portrait artists at least, the majority of sitters are total strangers. Not only does the artist have to become acquainted with a new face but he or she often has to produce a portrait that fits in with the sitter's self-image. Frequently, portraits which are actually perfect likenesses are rejected by sitters simply because they do not portray the subjects as those subjects see themselves.

A preliminary drawing therefore serves two purposes. First, it helps the artist to get to know a face before painting it. Second, it tells the sitter what to expect. The preliminary drawing can be shown to the sitter, who can, at this early stage, say whether this is how he or she wants to be portrayed in the final painting.

Why charcoal?

Suzanne O'Riley used charcoal for this preliminary drawing before going on to do the painting on the next page. Charcoal is one of her favourite media, both for quick sketches and for more finished

△ *The artist looks at the model in various poses and makes drawings to help her decide on a final composition. After trying various angles, the sitter is positioned facing the direct light of a window.*

▷ *The first trial drawing shows the model in profile. The artist uses charcoal on paper, rubbing back to the white paper with a kneadable eraser to create highlights.*

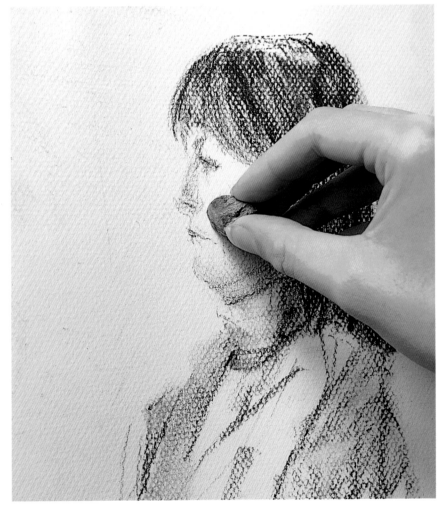

drawings. Some of her large charcoal drawings take two or three days. This sketch was done very quickly, the object being to get down a lot of information in a short time.

If you are not used to making preliminary drawings, charcoal is an ideal medium. Not only can you work quickly but you can also rub out and change things easily while still keeping the drawing lively and fluid. As you can see from these pictures, Suzanne O'Riley uses the side of the charcoal stick to block in large areas of tone. She then rubs back into the charcoal, 'drawing' with an eraser to create highlights and light tones.

Broad and chunky, charcoal is good for the novice because it is too clumsy to be used for detail. Thus the temptation to overwork a drawing or to make it too tight ceases to be a problem. Charcoal comes in various sizes: the large sticks are very chunky and used mostly by stage designers for drawing up backcloths.

The other great advantage of charcoal is that you can work on a large scale. You can, if you wish, make your drawing as big as the proposed painting. If you are happy with your drawing, it can be transferred easily on to the support without enlarging or making any scale adjustment.

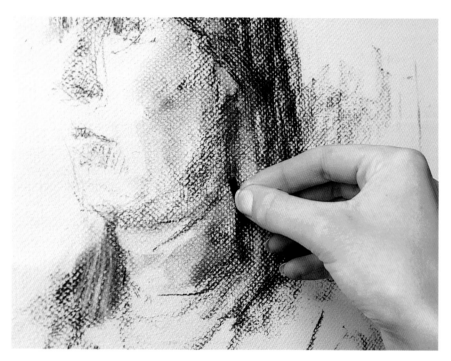

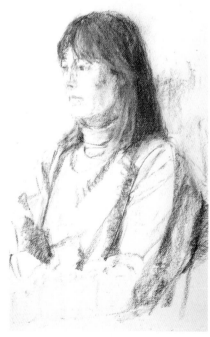

△ *A drawing showing a three-quarters view of the model, also done in charcoal. Here the artist blocks in areas of tone using the side of the stick.*

◁ *To acquaint herself further with the model, the artist makes a charcoal sketch in a pocket-sized sketchbook.*

◁ *A small sketchbook study done in oils. The same colours will eventually be used in the larger painting.*

213

PROJECTS

PORTRAIT OF LESLEY

The most striking aspect of this portrait is that everything is painted in very general terms. Yet, as a whole, the portrait works beautifully. The eyes are observed and painted in exactly the same way as the rest of the subject, with no pupils, highlights or any of the other details which we 'know' are there. Suzanne O'Riley paints exactly what she sees – broad strokes of tone which, from close-quarters, are unrecognizable blobs.

As in all of her paintings, the lighting here is important. The subject is lit by natural daylight from the window at one side. This softens the far side of the face, which appears to merge with the blue of the background – some of the flesh colours being tonally very similar to the cool blue of the wall. In the finished painting there is no visible defining contour line between face and background.

Flesh tones

The planes of light and dark, warm and cool, are closely observed and established but painted as soft strokes of colour, not harshly defined shapes.

This is partly because the artist uses the technique of looking at the subject through half-closed eyes. The resulting hazy view obscures much of the local colour and enables her to see clearly the areas of light and shade which describe the form. Also, she paints these with large brushes, moving to and fro, relating one tone to its neighbour and obliterating detail until she is satisfied with the result.

Suzanne O'Riley says she always spends time observing and then 'allows the hand to react to the eye'. She often paints while gazing at the sitter, not looking at the painting for quite a few seconds. 'You must look for form,' she says. 'Forget you are painting a nose or eye, just concentrate on what you can see. And above all, don't worry about the likeness. That will come if everything else works.'

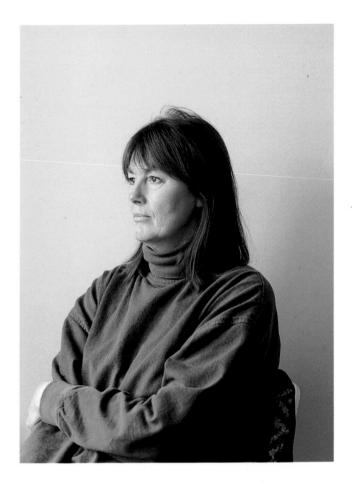

△ **1** *After making a number of preliminary sketches, the artist decides on a three-quarters view for the portrait, with the model sitting in front of a plain blue wall.*

◁ **3** *Working on a tinted canvas, the artist paints an outline in Payne's grey and Prussian blue – 'always a light outline because it is easier to correct'. She starts to lay the background in Prussian blue and white.*

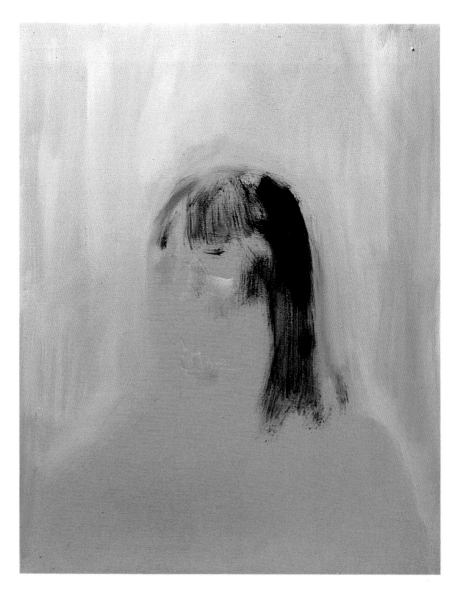

▽ **4** *The background colour is taken up to the head with a large brush. Bold strokes are used to redraw the contours of the head with background colour.*

◁ **2** *The artist says her palette tends to change according to mood. Colours in this portait include Payne's grey, Prussian blue, Naples yellow, burnt sienna, raw umber, yellow ochre, cadmium red deep, flesh tint and terre-verte. She never uses black.*

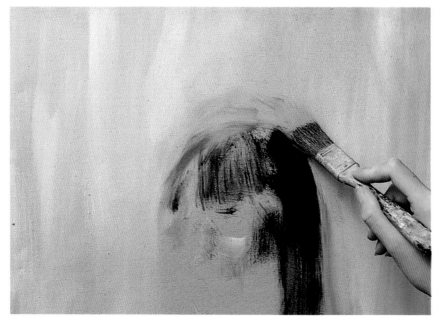

215

▽ 5 *Light and dark sweater colours are painted in mixtures of viridian and white. For the face, the artist works across the image, using three or four different brushes to block in patches of light and dark in approximate tones. Flesh tones are painted in mixtures which include yellow ochre, flesh tint, Naples yellow and 'a lot of blue'. The artist deliberately uses big brushes, forcing herself to concentrate on general areas rather than detail.*

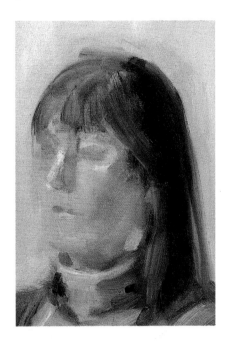

▷ 6 *The main tones and colours are now established. The artist works quickly to develop the whole picture instead of concentrating on particular areas.*

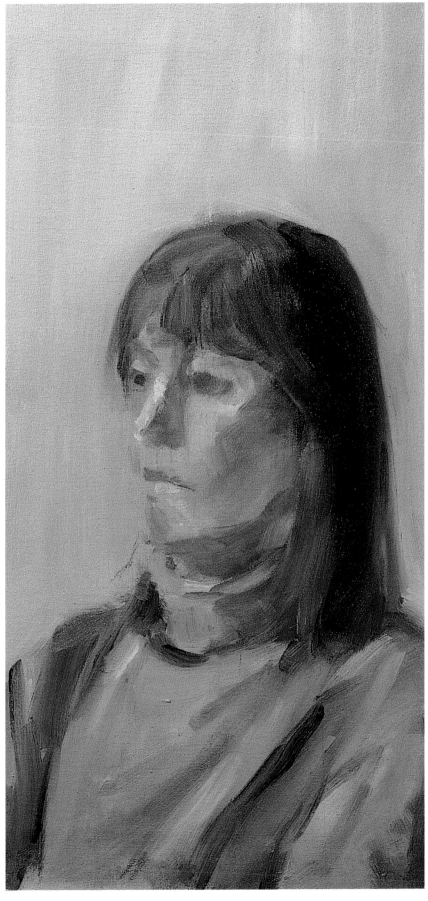

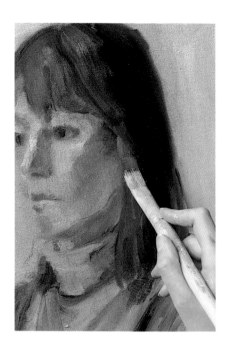

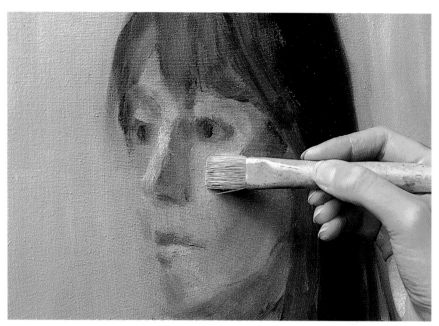

△ **7** *The hair is treated in exactly the same way as the face, background and sweater – in loose strokes of tone. Here, the artist paints a broad plane of highlight into the hair.*

△ **8** *Still working with a large brush, the artist develops the flesh tones. As before, the strokes are broad and general. 'I paint what I see, not what I know to be there,' she explains. 'My hand always reacts to my eye.'*

▽ **9** *Overlaid strokes of light and dark flesh tones are built up. Gradually, the underlying facial forms emerge – the result of closely observed planes of light and shade.*

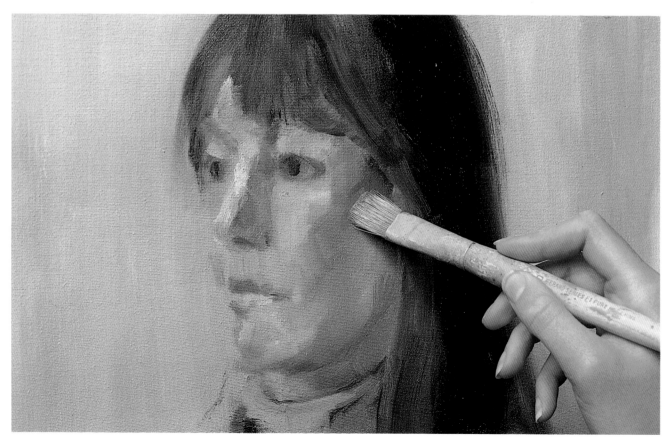

△ **10** *A close-up of the skin and hair shows only subtle differences between the patches of colour. There are no stark tonal contrasts and no linear brushstrokes. The hair is painted in mixtures of burnt sienna, viridian, Naples yellow and 'lots of blue'.*

▽ **11** *Eyes are kept very general. The artist has established them as patches of loose tone, with no highlights and no deep shadows. The pupils were not visible and were therefore not painted.*

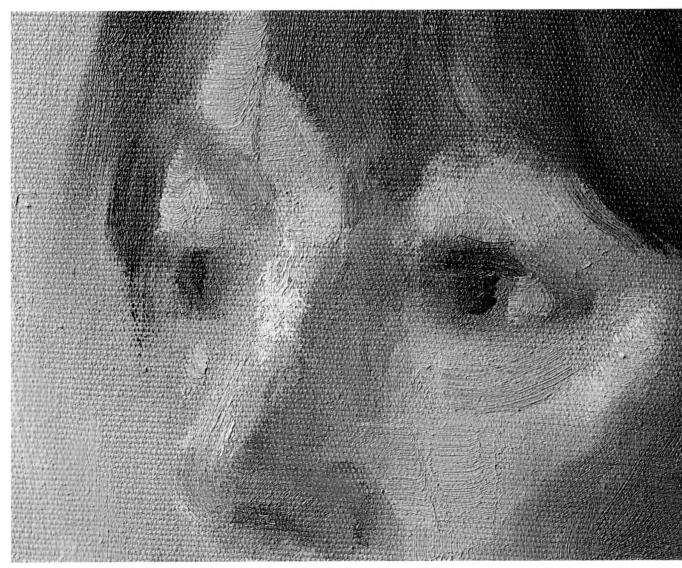

218

◁ **12** *The sweater is sketchily painted in light and dark mixtures of viridian and white, toned down with colours used elsewhere in the picture.*

▷ **13** *Despite being painted against a flat background, the artist has created a sense of space and perspective by allowing the model's face to recede into the background. The face has no defining line and the cool flesh tones furthest away from the artist merge into the blue of the background wall.*

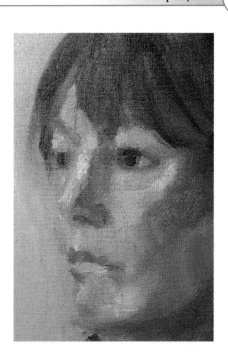

▷ **14** *In the completed portrait, the broadly painted individual areas come together to form a solid, structured figure.*

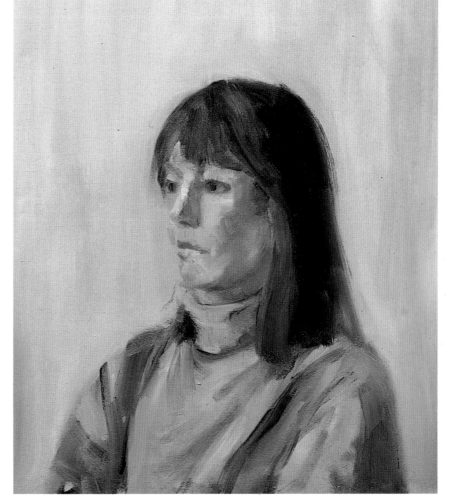

219

TECHNIQUES

FROM DRAWING TO PAINTING

We have seen that many painters start work with preliminary studies. These may take the form of tiny sketches, detailed drawings, colour studies and so on. The approach varies, but the purpose is the same – to find out as much as possible before committing paint to canvas.

Sketches and preliminary drawings are usually fresh and spontaneous. The artist is not afraid to use loose, scribbly strokes because it does not matter how the drawing will 'look'.

Enlarging the drawing

When you have made a sketch or drawing which satisfies you, it is a simple matter to enlarge and transfer this on to the canvas so that it is ready to paint. The secret is to transfer the image without losing the freshness of the original sketch.

First, divide the canvas or painting surface into a number of equal squares or rectangles using pencil and ruler. Next, draw a grid over the drawing, making the same number of squares or rectangles of the same proportion as those on the canvas. Now –

the tricky part – transfer the image a square at a time on to the canvas.

Keep the drawing loose and fluid. Avoid making the new image too small or cramped. If you feel this is happening, switch to charcoal so that the new drawing is chunky and bold. Try drawing from the shoulder or elbow rather than from the wrist. This way, the drawing will be more fluid and free. It is not necessary to transfer every detail from the small drawing. Sometimes the merest outline is a sufficient guide for the paint, and you can always refer back to the original small drawing as you paint.

Working from photographs

Photographs are often a useful additional reference, especially for details. The camera records a split second and you can use this as a means of establishing folds in clothing, the way the hair falls and other changing or unstable elements.

Most painters, however, do not work solely from a photograph. A camera is unselective and tends to make the subject look flatter and less interesting than it really is. The human eye works in reverse, selecting and emphasizing those elements which make the portrait interesting.

This may sound like old-fashioned teaching and you may not be convinced until you have actually tried to work from a photograph. When you do, you will find it surprisingly difficult to get tonal contrast, depth and life into your picture unless you have drawings or some other form of reference to back this up.

Many portrait painters take extensive photographs of the sitter, as well as making a number of drawings. These can be referred to in between sittings, when the model is not available, but they will rarely suffice for long as a substitute for the sitter.

▽ **1** *The artist intends to use this watercolour study as the basis for a larger oil painting. To draw the image accurately on to the larger canvas, he first measures and divides the study into a grid of squares.*

△ **2** *The canvas is then divided into the same number of squares. Now, the artist draws the image on to the canvas, copying a square at a time from the smaller watercolour on to the large canvas.*

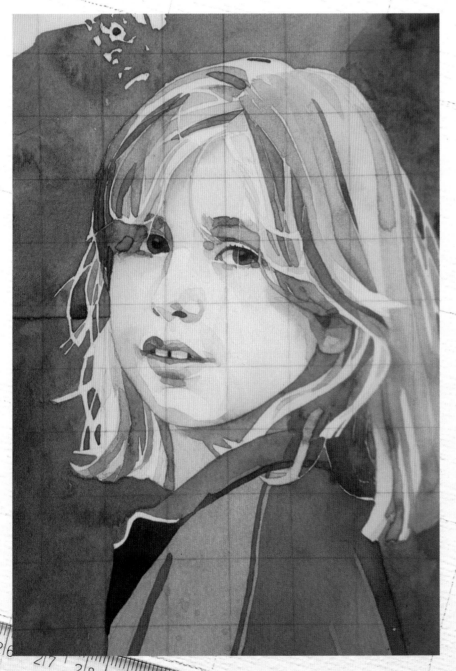

△ **3** *The image on the small watercolour is transferred to the large canvas ready for painting. You can use charcoal, oil pastel or paint as an alternative for the large-scale drawing.*

221

PROJECTS

YOUNG GIRL

This is the only portrait in the book that was not painted directly from the model. The artist, Ian Sidaway, likes working from detailed references – here a photograph and this watercolour sketch.

Preliminary studies

Ian Sidaway trained as an illustrator and his paintings have a precision and graphic quality which reflect this period in his life. He is not an artist who makes rough preliminary sketches. His preliminaries are detailed drawings and watercolours – complete works in their own right. He finds them useful to show clients prior to starting on the final painting because they are a good indication of how the finished portrait will look.

The watercolour here was used to work out the balance of tones within the composition. By the time he started the oil painting, the artist knew exactly where the planes of light and shade fell on the girl's face. He had also worked out the tonal arrangement, and knew which parts of the figure would be light or dark in relation to the background.

Patches of colour

Ian Sidaway's approach to painting is not the traditional one of developing the whole image simultaneously. Although he does go back over his work, adjusting colours and tones, his approach generally is a systematic one. He draws in detail exactly where each plane of light, each patch of colour, will be. Then he starts to paint, moving from one precisely drawn patch to another. Each new tone and colour is related to its immediate neighbours as he works across the canvas.

Unusually, Ian Sidaway does not feel it necessary to get rid of the white canvas before being able to assess colours and tones. Although certain areas are modified as is thought necessary, each tone and colour is essentially right in relation to the image as a whole. The technique looks effortless, but it actually calls for a practised eye and a lot of planning.

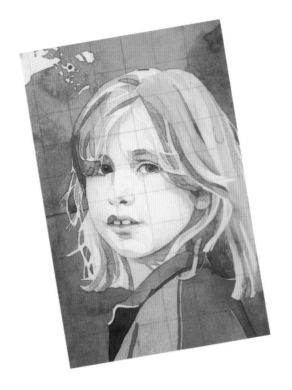

△ **1** *Before starting the portrait in oils, the artist first took reference photographs of the subject and made this watercolour sketch.*

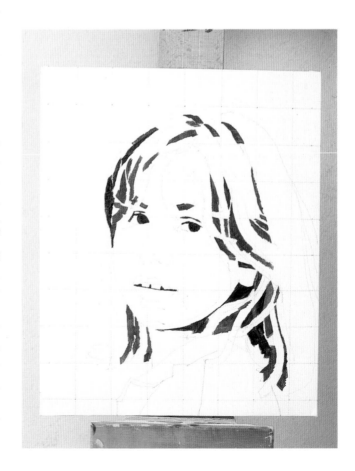

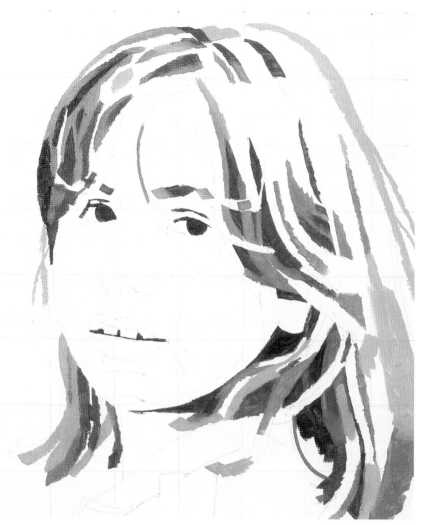

◁ **3** *For the mid-tones of the hair, the artist adds a little yellow ochre, chromium orange and titanium white to the first mixture.*

▽ **4** *The lightest hair tone is obtained by adding more white to the previous colour.*

◁ **2** *Beginning with the dark tones, the artist blocks in facial shadows and some dark hair tones with a mixture of French ultramarine and raw umber. Other dark hair tones have added cadmium red and yellow ochre.*

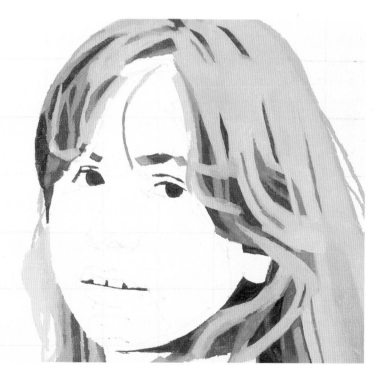

223

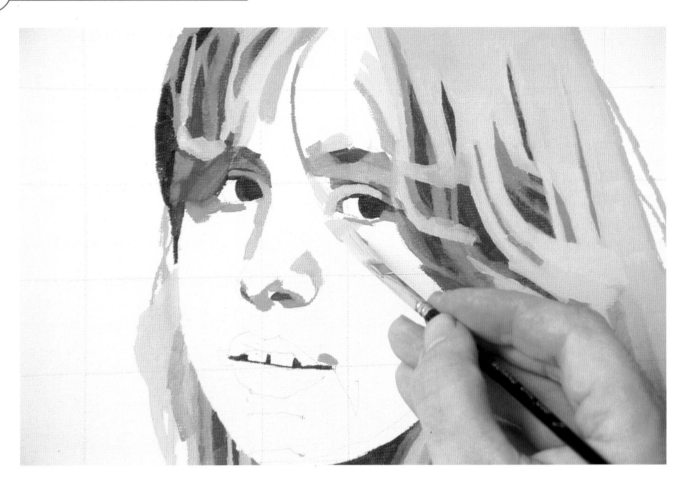

△ **5** *For the dark and mid-tones of the face, the artist modifies the light hair mixture by adding cobalt blue, cadmium red and titanium white.*

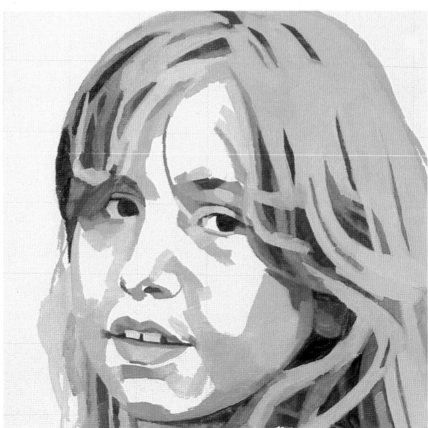

▷ **6** *Hair and flesh tones are painted in the same basic colours. By changing and modifying the basic mixtures in this way, a harmony of colour and tone is achieved throughout the whole image.*

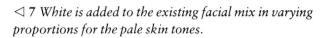

◁ 7 *White is added to the existing facial mix in varying proportions for the pale skin tones.*

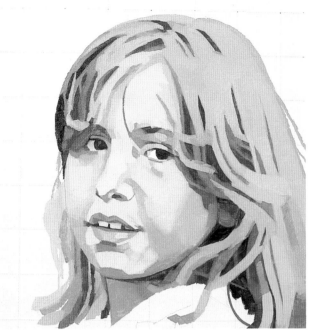

▽ 8 *The girl's shirt is blocked in with black. Here the artist paints the lighter areas in grey.*

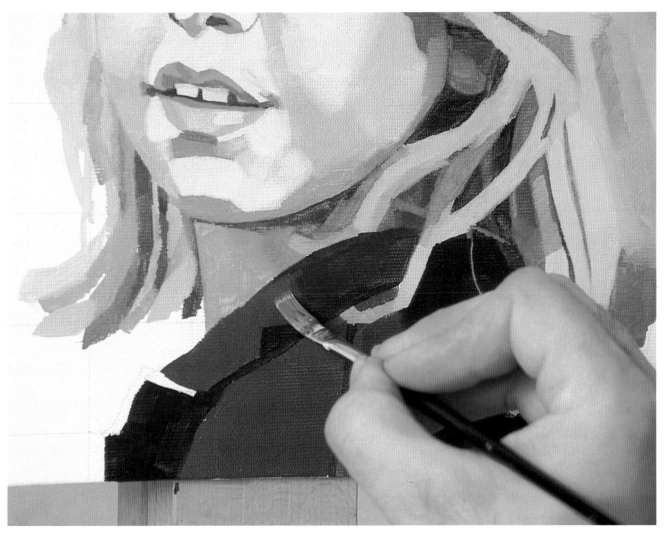

△ **9** *Using a mixture of sap green and lemon yellow, the artist starts to paint the background foliage in short, loose brush-strokes.*

◁ **10** *The background is now complete. The background green is taken up to and around the figure, cutting crisply into the hair and shirt in order to clarify and redefine the shapes.*

226

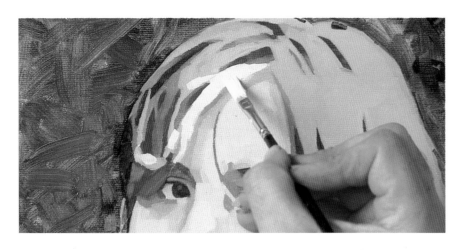

◁ **11** *Finally, the highlights of the hair are painted, with the lightest hair tone mixed with titanium white.*

▽ **12** *The artist used just nine colours for this portrait: raw umber, cadmium red, French ultramarine, yellow ochre, titanium white, chrome orange, cobalt blue, sap green and lemon yellow.*

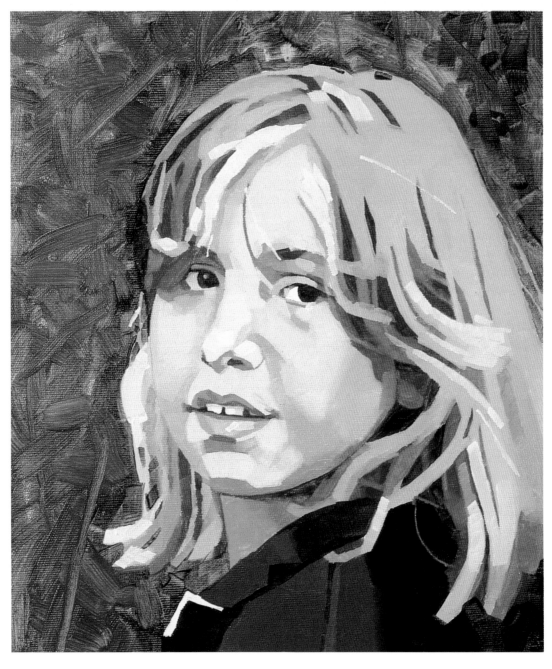

TECHNIQUES

DRAWING IN OIL

You might find it easier to make the initial outline drawing in oil pastel or Oilbar rather than in paint. This simplifies the early stages of the painting and means you can concentrate entirely on the drawing, without having to worry about mixing paint and choosing brushes. Both materials are completely compatible with oil paint. The initial drawing can be covered up as the picture progresses, or the lines emphasized and used in the painting.

Martin Stamford is not a purist when it comes to oil painting, and he is quite happy to introduce other elements into the picture if he feels this will create interest or produce a livelier image. Because he mixed Liquin with the paint in the earlier stages, the paint dried relatively quickly and he was soon able to use both oil pastel and Oilbar on top of the dry colour. In his painting on pages 234–241, he redrew the fabric folds and added highlights to complete the picture.

Oilbars

Oil paint has no equivalent, but it has a rival. The new Oilbars are paints in stick form. They can be used instead of paint and many oil-painting techniques can be achieved equally well with the painting sticks. They can also be used with oil paints and oil pastels – as the artist Martin Stamford does in his demonstration portrait.

The sticks come in three sizes – the smaller ones are good for linear drawing; the largest are very chunky and suitable for large-scale work. Before using a stick of Oilbar, you must remove the waxy sealant that keeps the colour soft. The sealant re-forms to protect the stick, so it must be removed each time you start work.

Oil pastels

Oil pastels are long-time favourites for strong colour effects and for quick sketches. They are very much a medium in their own right and as such do not really have a place in a book on oil painting. However, many artists use oil pastels and oil paints together in the same work and, for this reason, it is useful to look at some of the effects which can be achieved.

Although colours can be dissolved and blended with turpentine once they are on the canvas, oil pastels are not a subtle medium and it is not easy to obtain close tonal effects. Their strength lies in their boldness and immediacy and it is in this capacity that most artists use them.

The nice thing about both oil pastels and Oilbars is that there need be no colour-mixing prior to painting. Oilbars are much softer than pastels and they can be mixed. Oil pastels are quite hard and are difficult to blend unless you dissolve the colours with turps. But as linear media, complementary to the paint, they are both superb.

Line drawing in oil pastel and Oilbars *The finer lines are made with oil pastel, using the sharper edge of the end of the stick. Oilbar is used for broader, softer lines.*

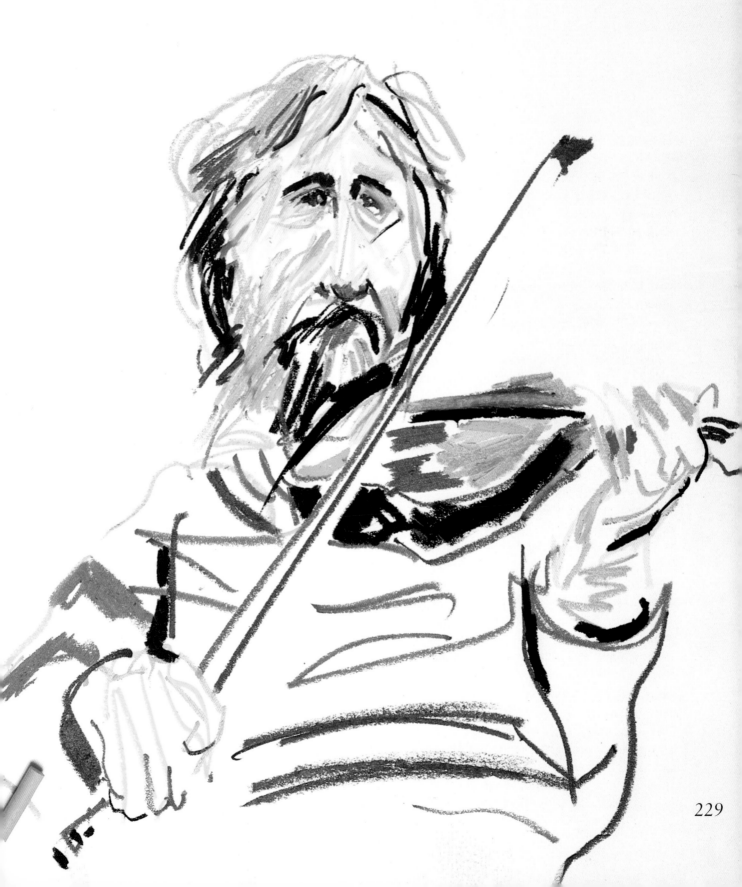

PROJECTS

EXPLORING MEDIA

There are no rules about what to use for your working drawings. Draw with any medium you like and feel free to experiment with different combinations. The only restrictions are those which come from the materials themselves, because certain things do not mix. Oil-based materials will not work with water-based ones, for instance. But even here, oil and water create interesting effects when they resist and run off each other. Basically, then, you can draw with anything that makes a mark.

Before embarking on any drawing, whether it is a preliminary sketch for your portrait, a thumbnail sketch or a more finished drawing, consider your options. Different materials bring out different aspects of what you are drawing. You can choose from pencil, charcoal, technical pen, ballpoint pen, dip pen and ink, coloured pencil, pastel, crayon and many more.

Three approaches

The same model sits in three poses. In each the lighting is changed and she is wearing different clothes. Before starting to paint, artist Martin Stamford was anxious to exploit the qualities of each pose and to draw it in a new way, using different materials, each chosen to capture the special qualities of the pose.

The first pose is one of contrasting tones and strong light; there is very little colour. The artist chose white paper and chunky charcoal to capture the emphatic lights and darks of the subject. He then used a kneadable eraser to rub back into the dark tones, creating highlights on the hair and face.

The second pose is more subtle, with very little colour, but a perforated straw hat causes flecks of light to fall across the model's face. The tiny shapes of speckled light call for a more detailed approach and for this the artist chose graphite pencil.

△ ▷ **Charcoal** *Because the subject is mainly black and white, the artist finds chunky charcoal ideal for blocking in the broad areas of contrasting tone.*

In the most colourful pose, the sitter wears a bright turquoise shirt and poses against a white wall. The light falls on the figure from two points – the windows on each side of the model. The fluid lines of the shirt are important here and the artist used a combination of pencil and oil pastel – the pastels to block in areas of bold colour, the pencil to define the sweeps of fabric and a minimum amount of tone.

△ ▷ **Pencil** *Fine lines are made with the sharpened point of a hard (H) graphite pencil; areas of shadow are blocked in with the edge of a softer (4B) point.*

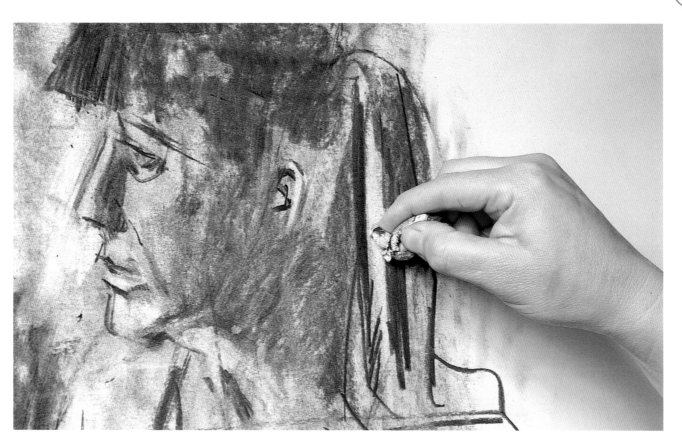

▷ ▷ **Mixed media** *This
quick sketch was done with
graphite pencil and oil
pastels – pencil for the fine
lines and oil pastel for areas
of bold colour.*

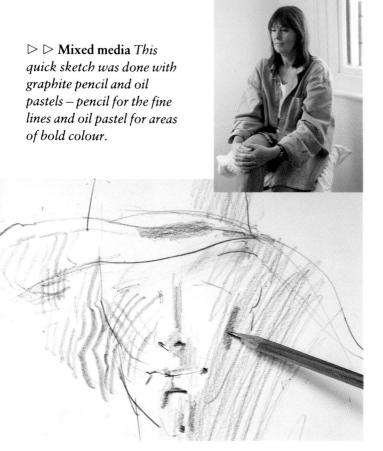

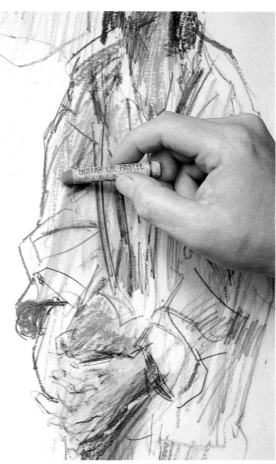

231

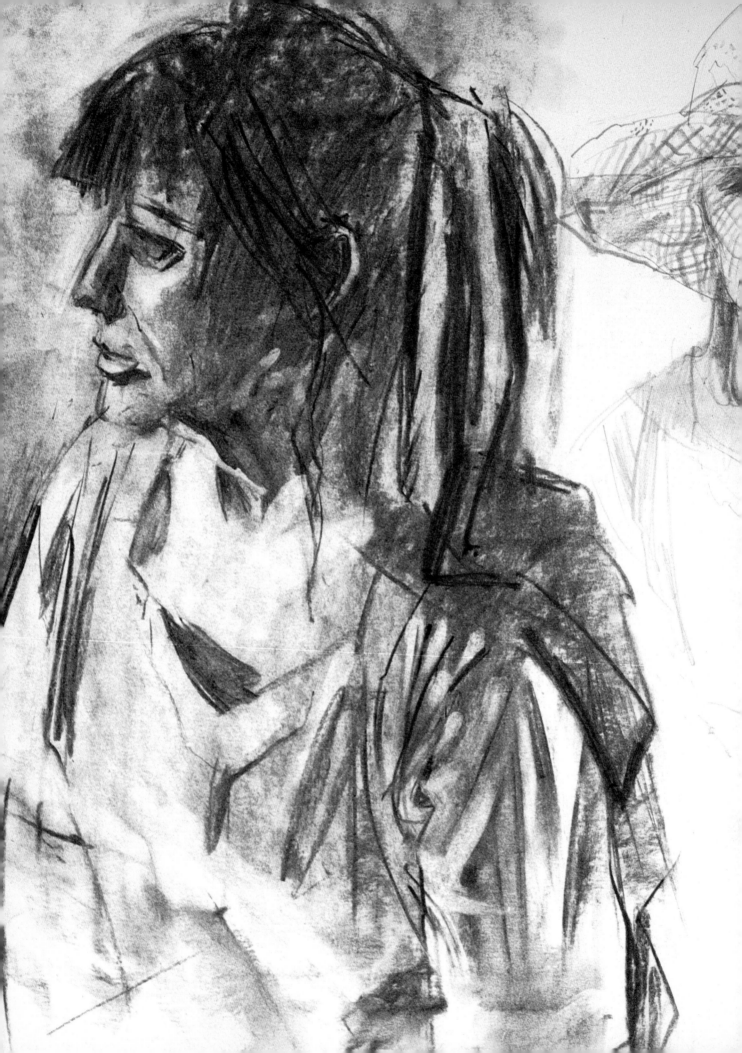

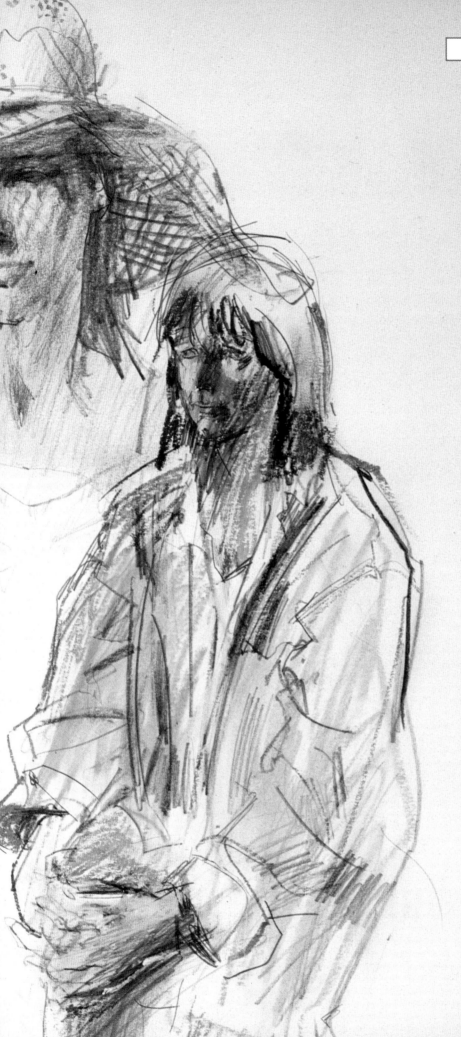

When we asked Martin Stamford to do the demonstration painting on the following pages, he started by making these drawings. The main objective was to find the right pose and composition, so the model was asked to wear different clothes and colours for each pose.

Each pose has certain qualities, and the artist chose his materials accordingly: charcoal on white paper for the tonal sketch; pencil to convey the line and dappled light of the sun hat; oil pastel for colourful drapery.

PROJECTS

PORTRAIT IN PROFILE

This mixed-media picture was done in oil paints, oil pastels and Oilbars. Artist Martin Stamford is a great advocate of Liquin and used this with the paint, which then dried quickly enough for the pastels and Oilbars to be used on top. The combination of colour and texture turns a formal pose into an unusual and lively portrait.

Before starting, Stamford spent a lot of time deciding on the pose. The drawings on the preceding pages were part of the decision-making process. His great concern was lighting. The sitter is between two windows, which produced equally strong light on her front and back, making the subject look too symmetrical. After trying several different poses, he decided upon a profile with strong frontal light. The second window, behind the sitter, was covered with a white sheet to soften the effect.

Don't forget the corners!

When planning the painting, the artist was careful not to make the composition too symmetrical. The subject was therefore placed slightly to one side of the canvas, while the shapes of the surrounding background were also taken into consideration. The background shapes are positive and make a contribution to the painting as a whole. There is no superfluous empty space around the subject.

When painting portraits on a rectangular support, it is easy to forget the corners and merely fill them in with background colour. Martin Stamford says he is always conscious of this common oversight. His advice is to use the whole rectangle to make sure the shapes formed by the background are as strong as those formed by the subject itself.

Classical beginnings

In the early stages, the portrait is painted in a classical manner, with the initial drawing being done in diluted blue paint. From this point onwards, tone and colour are applied across the entire image. No part of the painting is brought to a finished state because Stamford likes to keep the whole piece in a state of flux for as long as possible.

'I create an image in order to develop it, not to finish it,' he explains. 'The painting will tell me when it is finished. As it is, I always paint for tomorrow.'

△ **1** *After making several exploratory sketches, the model is seated in profile looking towards the window.*

△ **2** *During the initial stages, the palette includes white, yellow ochre, cerulean blue, light red, raw umber, monestial turquoise, cerulean blue, black, cadmium yellow and terre-verte.*

▷ **3** *Working on primed hardboard, the artist paints an outline in a very diluted wash of blue and black.*

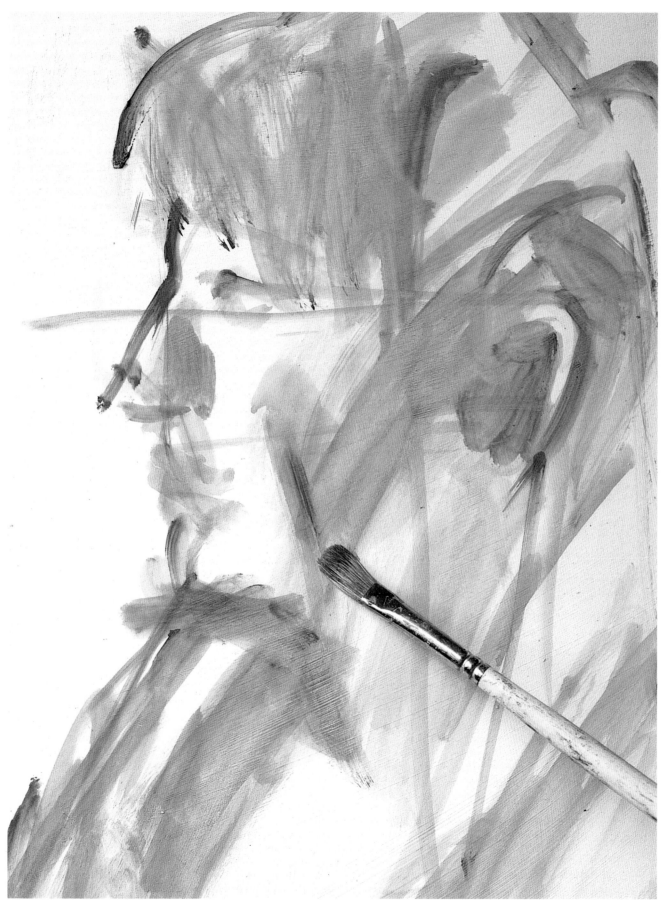

▽ **4** *Colour goes in early – flesh tones are yellow ochre, light red and raw umber, mixed with a very little white – 'just enough to reduce the colours without turning them chalky'.*

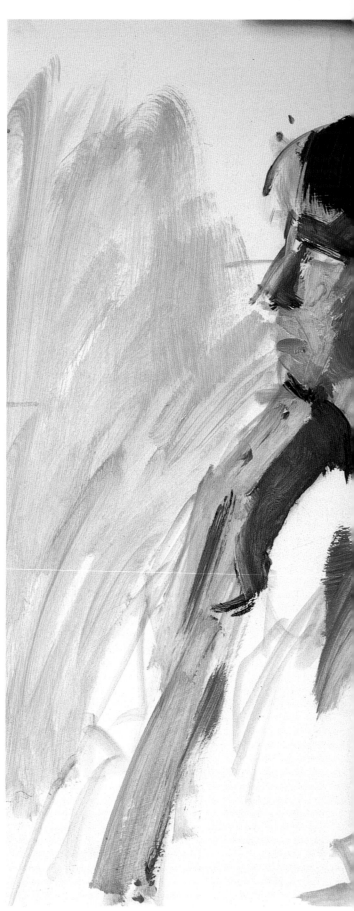

▷ **5** *Main colour areas are established. The hair is raw umber; the shirt, light and dark mixtures of cerulean, raw umber, monestial turquoise and white.*

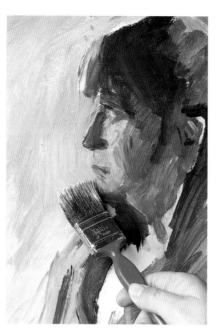

◁ **6** *Facial tones have been developed and the background is painted with a small decorator's brush.*

▽ **7** *The artist stresses that brush-strokes should not follow the form of the subject – especially the curved and rounded forms of the human figure and face. His own strokes cut across the form in strong directional planes.*

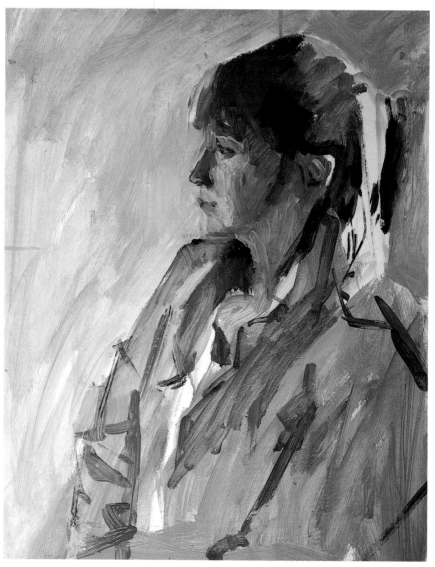

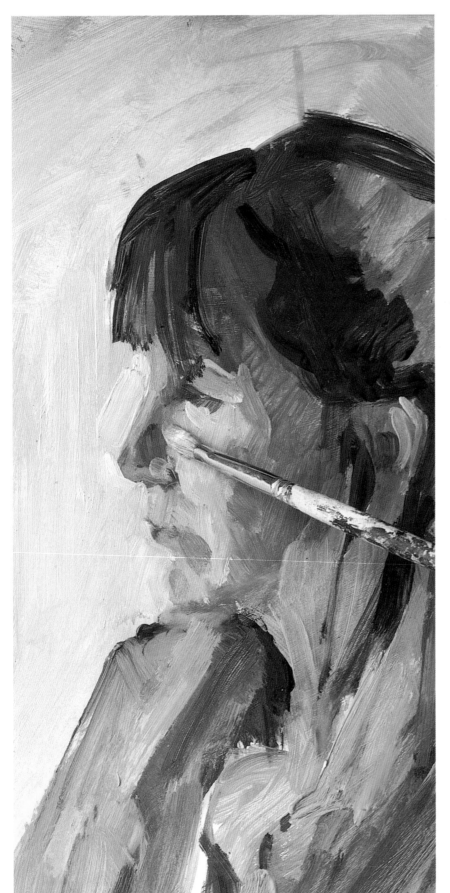

◁ **8** *The artist works into the flesh colour, establishing carefully observed patches of cool shadow. These are made by mixing basic skin colours with blue.*

△ **9** *The folds of clothing are developed and emphasized. Here, highlights on the shirt are painted in thickly impastoed pale blue applied with a large brush.*

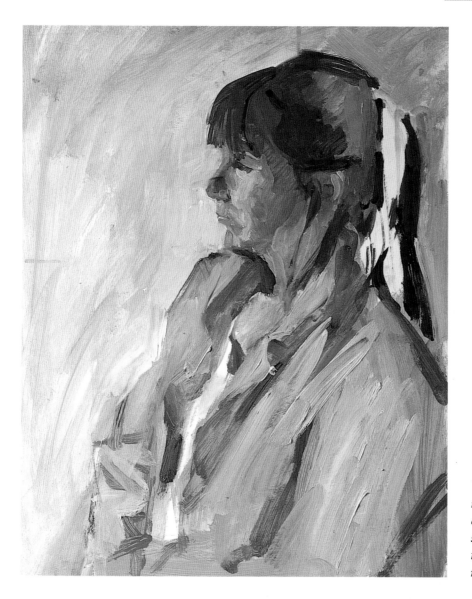

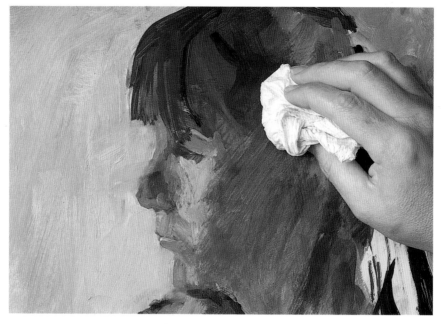

▽ **11** *Feeling the paint is too thick in places, the artist removes excess colour with a tissue. Again, he stresses the importance of keeping the painting flexible and 'on the move'.*

△ **10** *Colours and tones are now in place. The whole image is developed evenly as the artist follows his own advice: 'Never finish one part or focus on a particular area. Keep it all general.'*

239

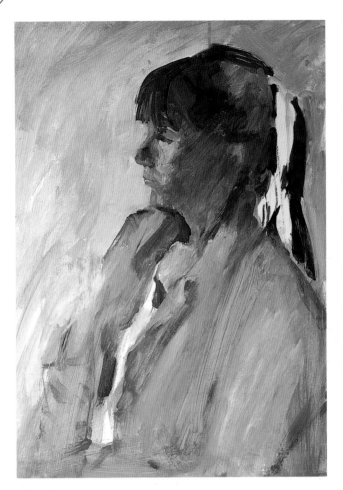

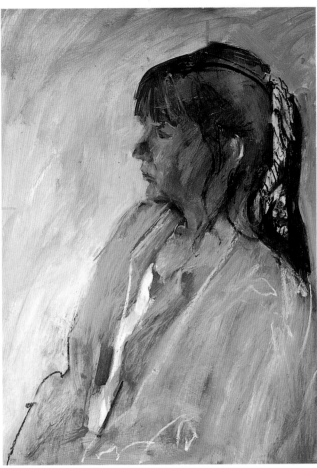

△ **12** *In certain parts of the portrait, the paint has been wiped back almost to the primed board, leaving those areas thin enough to be reworked.*

▽ **13** *Liquin and turpentine speed up the drying-time of the paint. The artist is now able to develop the paint with Oilbar and oil pastels by introducing bright flecks of colour.*

△ **14** *White Oilbar establishes and defines highlights. The artist feels the narrow area of white T-shirt is important to the composition because it divides the shirt into two positive shapes.*

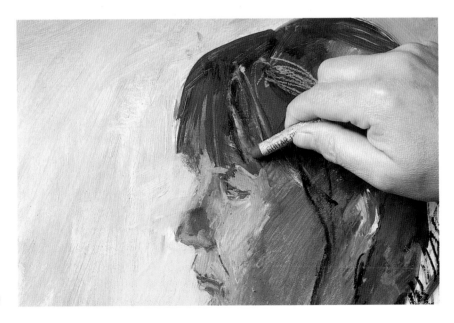

▷ **15** *The finished painting retains the vigour of the early stages. The secret, says the artist, is to make every shape alive and interesting – especially the shapes of empty background.*

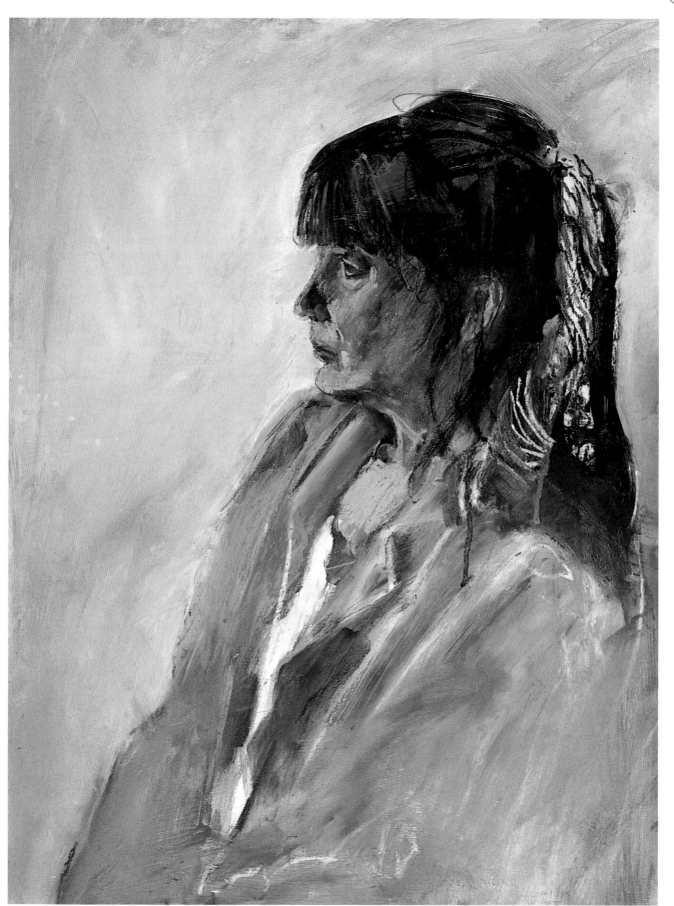

PROJECTS

THE ARTIST'S FATHER

The painter of this and the next portrait is Humphrey Bangham; the sitter is the artist's father. The artist has painted this face several times before and is familiar with every aspect of it. For the purpose of these paintings, the familiarity was a bonus because the artist was free to concentrate on the techniques and work in hand without having to spend time getting to know a new face.

The artist prefers to start work with the paint, so there were no sketches or preliminary drawings for this painting. However, he took trouble to arrange the pose and lighting. He also spent time looking at and planning the composition before starting to paint.

A classical start

The initial painted drawing is done in raw umber – a traditional beginning. The paint is diluted with turpentine and mixed with Liquin. Humphrey Bangham says he now uses Liquin in most of his work. He likes the flowing consistency it gives to the paint. He also finds that it dries to a 'tacky' finish quite quickly, providing the best surface on which to scumble, or achieve broken colour.

When not working on a tinted board, the artist likes to obliterate the primed white canvas as quickly as possible, because he finds this interferes with ensuing tones and colours. This he does with diluted raw umber and white, with touches of ultramarine for the cooler tones. The result is a near-monochrome underpainting – a classical beginning when painting in oil.

Flesh tones

Once the tones of the picture have been established, the artist prefers to use little or no white. He finds that white makes the colours look chalky, and the paints dry more quickly without white.

The artist paints the planes of light and shade in broad sweeps, keeping the whole image alive and in a state of flux. As the image develops, he says, the colours and tones become stronger. Very pale tones on the features show the direction of light across the head; the light source thus defines the form.

△ *The sitter is made comfortable, while the artist considers how he will approach his new study.*

△ 1 *There is a strong directional light here, leaving one side of the model's face in the shade.*

△ **2** *The palette includes burnt umber, burnt sienna, yellow ochre, raw sienna, French ultramarine, Indian red, cadmium yellow, vermilion and geranium lake.*

△ **3** *For the initial outline drawing, the artist mixes raw umber with enough Liquin to thin the colour and give the paint a smooth flow.*

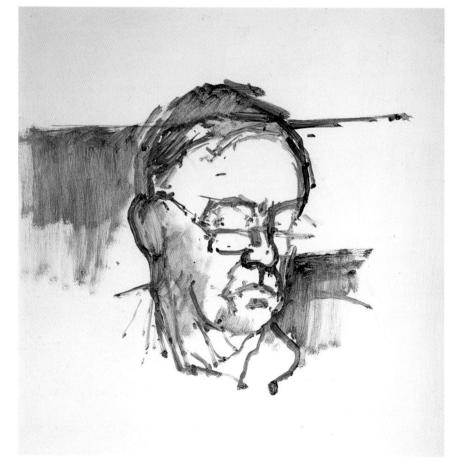

◁ **4** *The artist feels an accurate and structured drawing is essential for this type of painting. He constantly checks the position and proportions of the subject in relation to surrounding vertical and horizontal elements.*

243

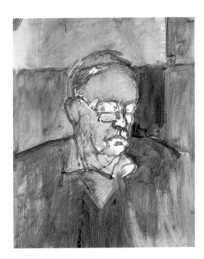

△ **5** *To get rid of distracting white canvas, the main areas of tone are quickly washed in with umber and grey.*

▷ **6** *Flesh tones are painted as broad strokes of warm and cool colour. Humphrey Bangham prefers to start with the cooler tones – mixed mainly from white, raw umber and ultramarine.*

▷ ▷ **7** *Background tones are strengthened. The artist takes the background colour up to and around the subject, redefining the contours of the head and face. Here the artist uses a fine brush to clarify internal facial contours.*

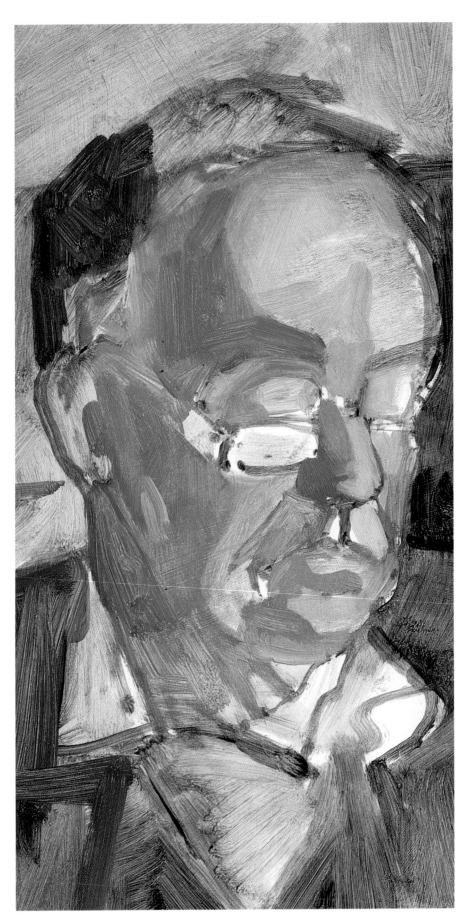

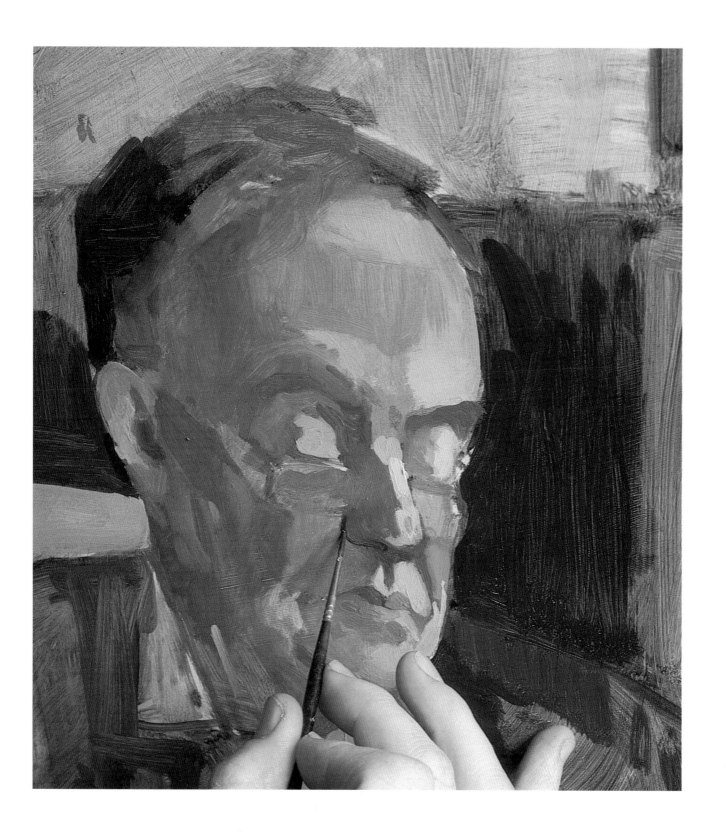

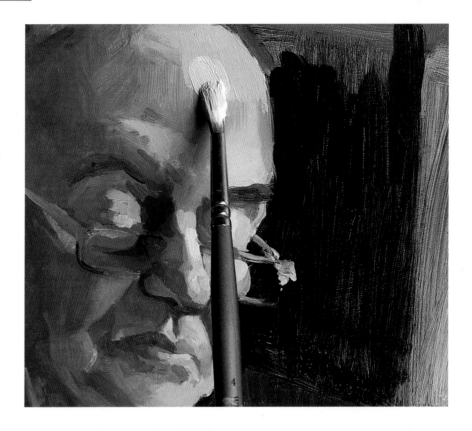

▷ **8** *The artist builds up the planes of flesh, introducing warm and light tones into the cooler underpainting. The new tones are mixed mainly from vermilion, cadmium yellow, yellow ochre, burnt umber and burnt sienna.*

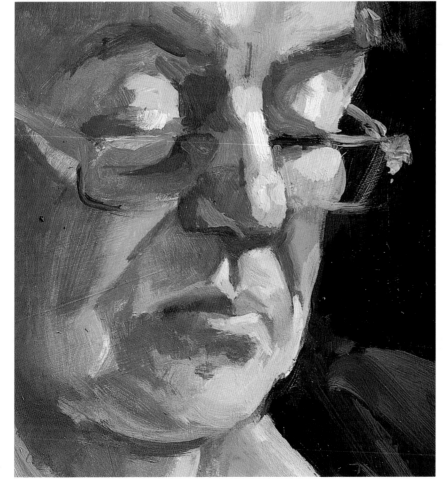

◁ **9** *The face is made up of broad planes of light and shade, loosely painted in warm and cool tones. By looking at the subject through half-closed eyes, the artist was able to pick out these planes more easily.*

▷ **10** *Finally, the background is completed, simplified into blocks of tone and colour.*

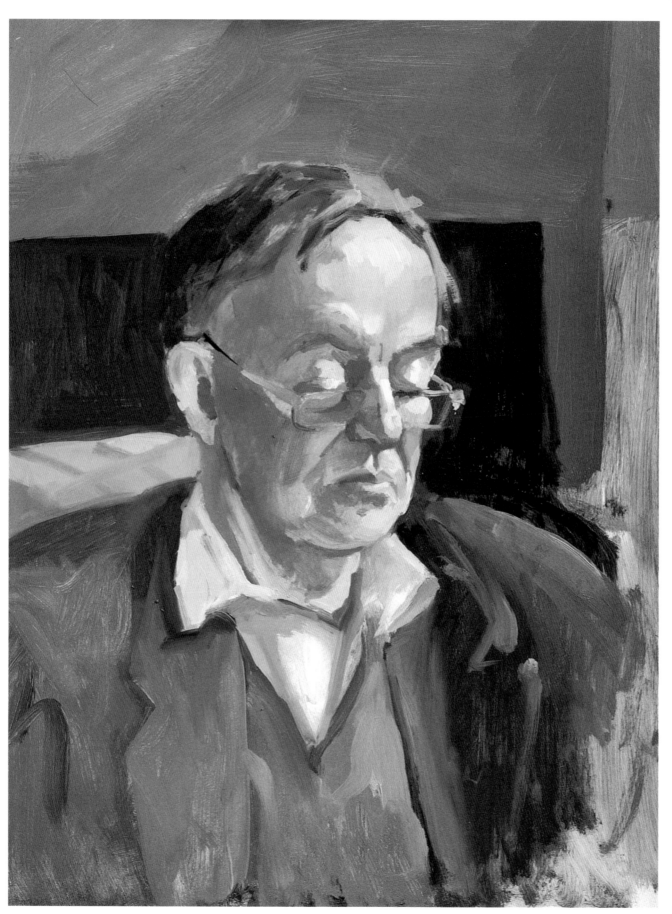

PROJECTS

PORTRAIT 'ALLA PRIMA'

When he is not painting, Humphrey Bangham designs and creates film-sets. The skill and versatility needed for this give him a flexibility that many painters do not have. The result is a wide repertoire of techniques and an enviable ability to create different effects and work in a variety of ways.

His first painting on pages 242–7 shows a classical approach to portraiture in oils. His second painting, illustrated here, demonstrates a very different approach. The palette is the same, but here there is no preliminary outline, no monochrome under-painting. Instead, the artist starts straight away by blocking in the main shapes and colours of the subject on a tinted canvas.

Alla prima

Taken literally, 'alla prima' means painted at one go or at one sitting. More generally, it describes the direct approach demonstrated in this painting.

Although no actual outline drawing was made prior to painting, the artist argues that the initial blocking in of principal shapes is in itself a type of drawing, albeit one which concentrates on volume rather than outline. He points out that the shapes are placed in relationship to each other; corrections are made by adjusting or moving those shapes; the background is painted up to and around the figure and, in effect, defines and 'redraws' the subject.

Humphrey Bangham works quickly, keeping the image fresh with a broad, general approach and constant reappraisal of the painting. Most of the time he uses large brushes, preferably stiff hog's-hair ones, occasionally switching to a finer sable brush for certain detail and 'key' line drawing.

Watching him work, it is noticeable how often he looks at the subject, his eyes moving almost constantly from sitter to canvas and back again. He frequently paints while looking at the subject rather than the canvas. Occasionally he looks at the subject through partially closed eyes in order to cut out some of the local colour and much of the distracting detail. This way, he says, you can see where the overall image is going wrong.

△ **1** *For this portrait, the model wears a pale shirt and sits against a blue background.*

△ **2** *The palette is the same as for the previous portrait, with the addition of cadmium orange, manganese blue and emerald green. The artist also uses turpentine and Liquin.*

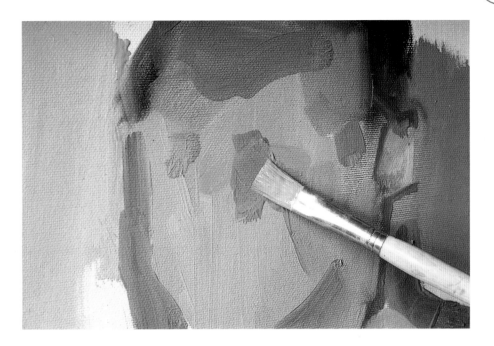

▷ **3** *The artist starts by blocking in areas of colour, starting with the background and broad flesh tones.*

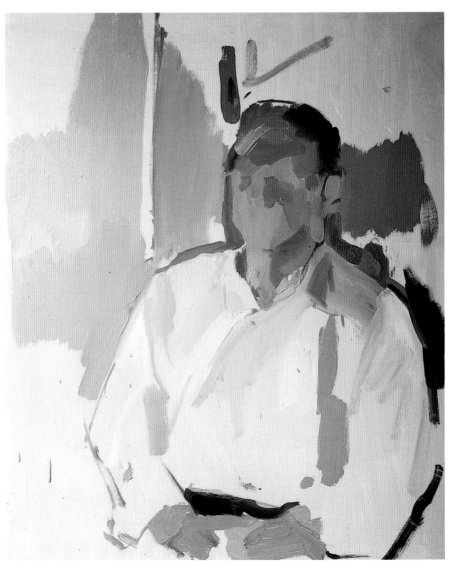

◁ **4** *Painting is kept general so that changes can be made. The shirt is painted in mixtures of emerald green, manganese blue and a lot of white.*

249

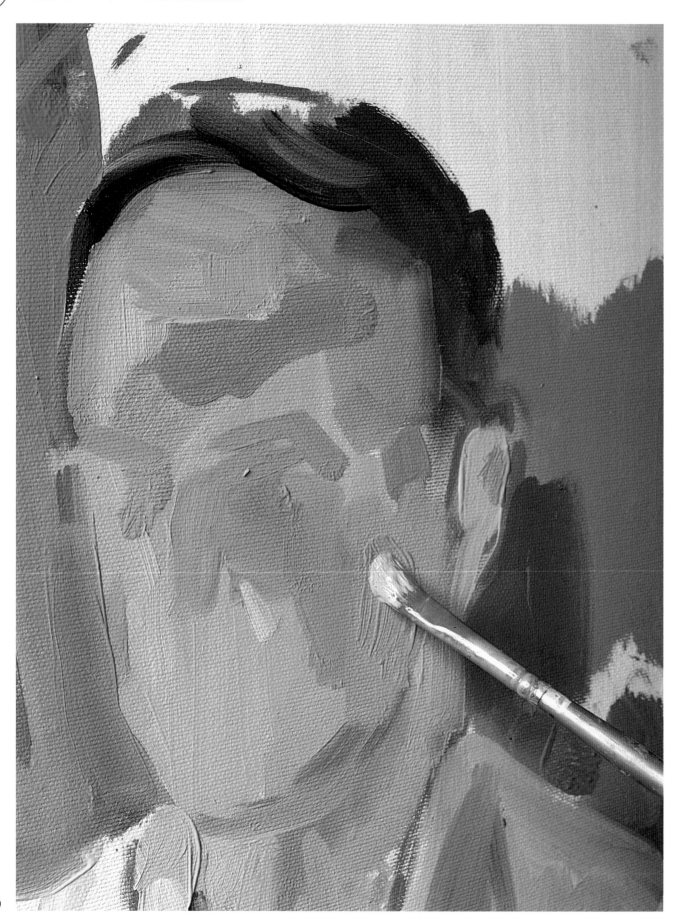

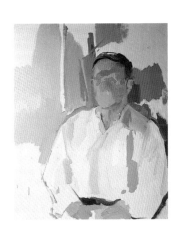

◁ **5** *Still working in broad terms with a large brush, the cool flesh tones are mixed mainly from raw umber and white.*

▷ **6** *Colour relationships are so far accurately established without detail and without the help of a linear drawing.*

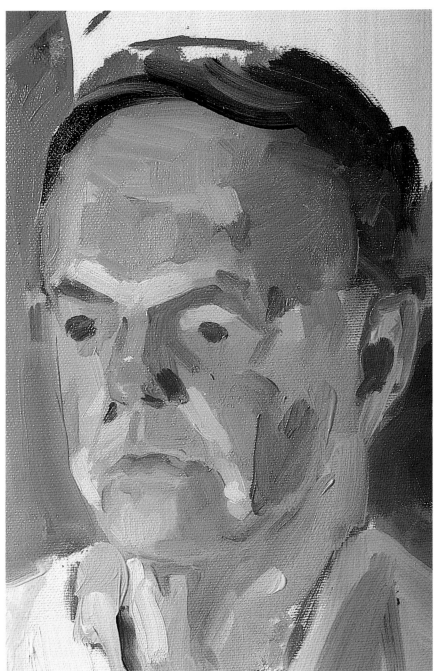

◁ **7** *The face is further developed in broad planes of warm and cool colour.*

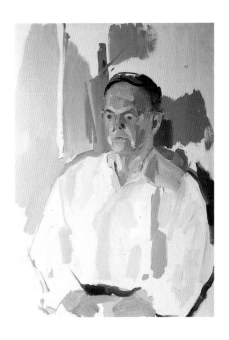

△ **8** *Care is taken not to overemphasize the eyes, established as flat areas of tonally relating mid-brown.*

251

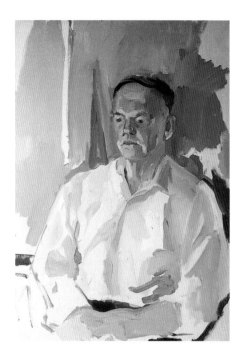

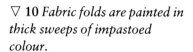

◁ **9** Working across the image as a whole, the artist introduces brighter colours, emphasizing the contrast between planes of light and shadow. Highlights and shadows are thus strengthened.

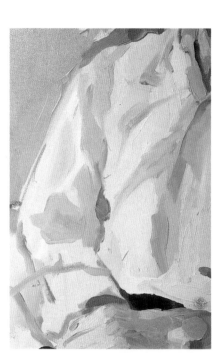

▽ **10** Fabric folds are painted in thick sweeps of impastoed colour.

▷ **11** The shirt is painted in three or four tones of blue. Each tone is loosely established as a flat shape.

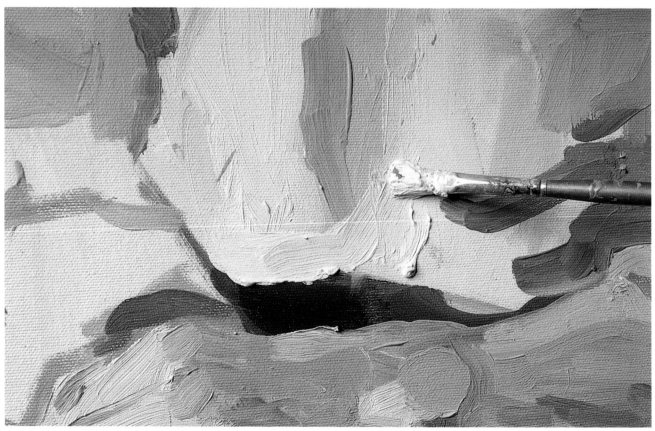

▷ **12** The completed picture is an arrangement of related tone and colour. 'To me the internal relationships are more important than being totally faithful to the subject. The result may be lighter or darker than the subject, but the overall tones should work in relationship to each other.'

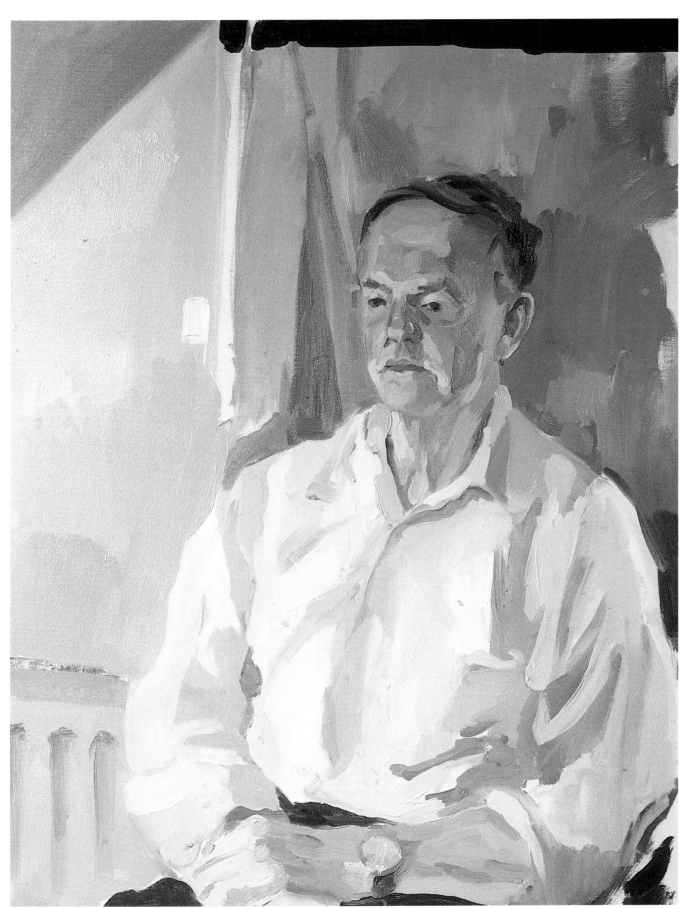

INDEX